Earthly Utopias

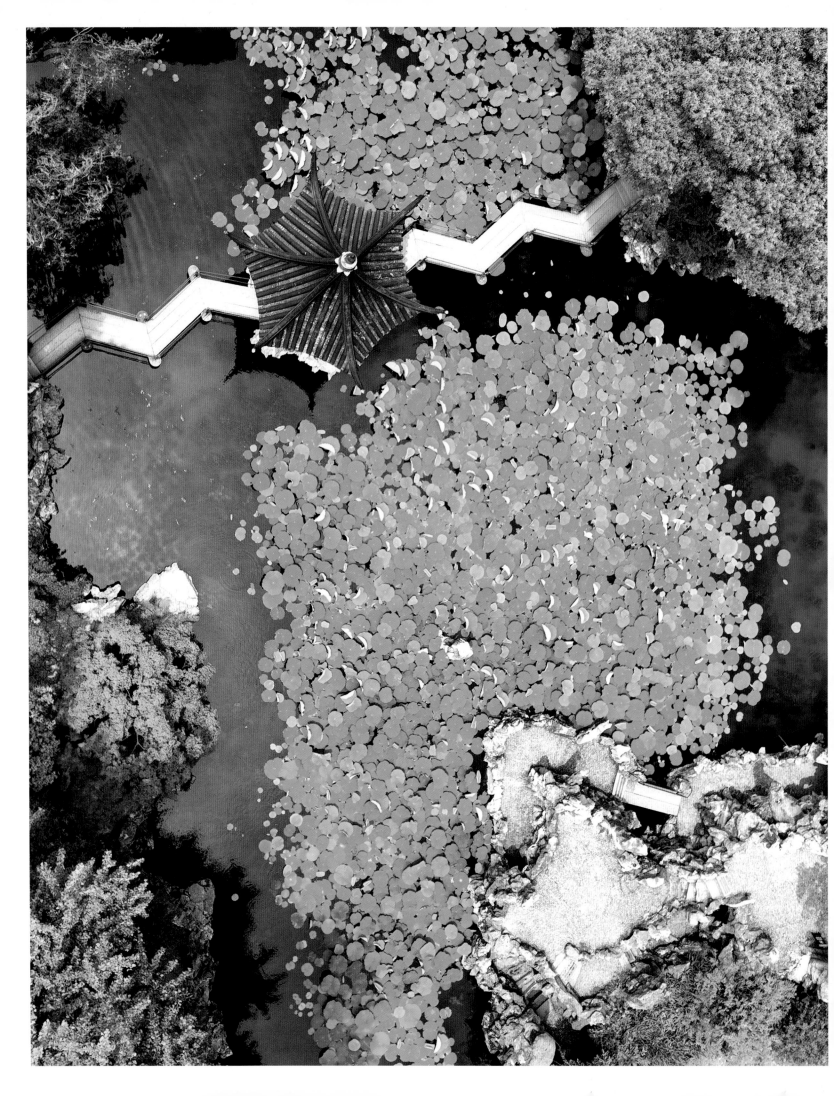

Earthly Utopias
Sacred Gardens of the World

Yolanda Zappaterra
with contributions from
Fran Paffard, Ruth Jarvis, Sarah Guy and Jan Fuscoe

FRANCES
LINCOLN

Contents

Title page: The Lion Grove Garden, China (pages 186–91).
Left: The Bishop's Palace Gardens, UK (pages 58–63).
Pages 6–7: Le Prieuré d'Orsan, France (pages 52–7).

Introduction

Time and time again, while writing this book, people asked me: How are you defining a 'sacred garden'? It's a question I was – and still am – unable to answer simply, but it did give rise to many interesting conversations and ideas around not just what makes a sacred garden, but how to define its three constituent elements: 'sacred', 'garden' and 'sacred garden'. In the twenty-first century, the meaning of 'sacred' is more complex than ever, and goes far beyond the word's most common association with our world's thousands of religious, denominational or faith groups. From pagan and alternative beliefs in crystals and cosmology to the Abrahamic faiths of Judaism, Christianity and Islam, via eastern religions such as Hinduism, Buddhism, Taoism, Sikhism, Shinto and Jainism, and syncretic religions like Santería, 'sacred' as an expression is so far-reaching as to be virtually all-encompassing. That breadth allowed for an enormous range within these pages, a range that grew even further when I began to look at how to address the definition of 'garden'.

Increasingly, modern garden design focuses less on planting and more on elements you wouldn't normally find in a garden. This is not a new thing, of course. The Zen gardens of Japan and Mughal gardens of India have for centuries been designed with plants as just one feature among other natural entities such as water and rocks, and handmade structures such as bridges and buildings, to create a balance of elements that combine harmoniously to engage the senses in equally pleasurable, reflective and spiritual ways. But a modern garden may employ all manner of unusual materials, such as urban detritus or aggressive or sustainable aggregates and substrates that connect the landscaped area with its socio-geographical place in time and space. Unexpected elements – such as a reclaimed shipping container, Corian water wall, charred wooden bench and etched metal gazebo – are just as likely to play a part in contemporary garden design as a decorative planted border or floral arrangement. Again, this expanded the definition of 'garden' in such a way that it enabled the inclusion of a few sacred gardens that some might

not define as gardens at all. The pagan garden designed by the artist Niki de Saint Phalle in Tuscany contains huge sculptures depicting the twenty-two Major Arcana figures from the Tarot deck of cards. They dance joyously across the landscape, incongruously and surreally at odds with the pencil conifers and olive trees we more commonly associate with that iconic part of Italy. And in Colombia's San Agustín Archaeological Park, South America's greatest number of pre-Colombian funerary megaliths create an unforgettable and strikingly harmonious 'garden' that's more parkland than horticultural, but invites the same meditation on the moving interface between mankind, spirituality and the natural world.

And then there is the question of a 'sacred garden'. Sala Keoku in Nong Khai, Thailand, is part sculpture park, part sacred garden, filled with a mix of natural and handmade gods and monsters. Many of its visitors come seeking the profound sense of spirituality that drove visionary artist and mystic Luang Pu Bunleua Sulilat to create the site, which venerates the Buddhist and Hinduist gods and beliefs he followed. The gigantic crystals that lie at the heart, literally and spiritually, of Australia's Shambhala Gardens may seem anachronistic to some, but the site has its devout followers, and is, for them, filled with spirituality and meaning. As is true of Nigeria's Osun-Osogbo Sacred Grove, where the mix of dense primeval forest, extraordinary sculpture garden, and the fact that it's one of the last remaining sacred groves of South West Nigeria have earned it UNESCO World Heritage status.

Is the memorial garden traditionally found in a cemetery a sacred garden? Almost certainly, by most definitions, but in determining which one to choose as a representative example, I opted not for a memorial garden in a cemetery space, but one in a public garden, which is used and enjoyed by the citizens of a town who have a real connection with the space: the Garden of Remembrance in the German town of Marburg, north of Frankfurt. Built on the spot where, on the night of 9 November 1938, the town's synagogue was destroyed as part of *kristallnacht*, or the Night of Broken Glass, the garden references its horrific history in a way that eloquently marks an absence but is filled with renewal and hope. Nothing about its design suggests a sacred element – there are no references to any religion or faith, or glimpses of the synagogue that was once here, and none of the elements you might expect to find associated with a religious space, but to my mind, as a landscaped space of reflection, renewal, hope and peace (both societal and personal), it is the perfect example of a sacred garden.

Across the globe in Japan, another garden bereft of any religious association performs a similar function for the thousands of people from around the world who seek it out. Bell Gardia, overlooking the Pacific Ocean in the Iwate Prefecture on north-east Japan's Tōhoku coast, was designed by Itaru Sasaki as a space in which he could communicate with his deceased cousin, finding solace and comfort in the act of having his thoughts being 'carried on the

wind' via an unconnected phone in a phone box at the heart of the garden. Word of it spread quickly, and Bell Gardia now acts as not only a beautiful space in which to connect with loved ones lost, but also as a confessional and escape from the physical world into the spiritual.

Given such inclusions, readers might – and hopefully will – take issue with many of the gardens gathered here as 'sacred gardens', but will also hopefully be persuaded that their place in *Earthly Utopias* is as much deserved as the gardens of English Cistercian ruins, priories and alms houses, or the extraordinary achievements to be found in Persian, Mughal and Islamic gardens, or the astounding Zen gardens of Kyoto and across Asia. Many examples of these are included within the following pages, drawn from all parts of the world and with their own unique stories.

From the UK, the Bishop's Palace Gardens in Wells has been home to the Bishops of the Diocese of Bath and Wells for 800 years. Across the English Channel in France, Le Prieuré d'Orsan, established by a priory of nuns belonging to the order of Fontevraud, was rediscovered by a pair of architects who purchased the buildings and 16 hectares (40 acres) and have restored the gardens to evoke medieval monastic gardens. The thousand-year history of Fontevraud Abbey in Chinon is intertwined with the history of medicine, tended as it was by monks who had a great knowledge of plants, and maintained the gardens for food, medicinal and spiritual purposes. In Japan, Kyoto's Ryōan-ji garden, belonging to the Myōshin-ji school of the Rinzai branch of Zen Buddhism, is considered one of the finest surviving examples of *karesansui* (dry landscape), a refined type of Japanese Zen temple garden.

For a world-class example of an Indian Mughal garden, the twelve terraces (one for each sign of the zodiac) of Srinagar's Nishat Bagh, the second largest Mughal garden in the Kashmir Valley, offer a stunning example of the Mughal belief in gardens as representations of earthly utopias in which humans co-exist in perfect harmony with all elements of nature. And there's no doubting the sacred nature of Haifa's Bahá'í Terraces (aka the Hanging Gardens of Haifa), in Israel, whose nineteen terraces represent the first eighteen disciples of the Báb and house the shrine of the Báb.

Another category of sacred garden included here is the biblical garden – chief among them Israel's Neot Kedumim (Oasis of Antiquity), set on the slopes of Mount Carmel. As a biblical landscape reserve it veers from lush oases to scrubland across 250 hectares (618 acres), which, as the founders' son Nogah Hareuveni eloquently puts it, 'embodies the panorama and power of the landscapes that both shaped the values of the Bible and provided a rich vocabulary for expressing them'.

From labyrinths and grottos to monastic herb gardens and geometrical patterns, the elements of religious gardens that have long been familiar in garden design are present in myriad inventive and expressive ways in *Earthly Utopias*, which above all explores the tradition of seeking spiritual

enlightenment through nature. It is, to my mind, a collection of gardens not only designed and informed directly by religious and spiritual teachings, but also, at sites such as Tresco Abbey Gardens in Britain's Scilly Isles and Connemara's Kylemore Abbey in Ireland, by the echoes of those teachings.

While the great Renaissance gardens of Italy and France – represented here by the Villa d'Este, Tivoli, in Italy and Villandry in France's Loire Valley – undoubtedly drew on the echoes of religious gardens, it's perhaps in peace gardens and cultural gardens that those echoes are to be found at their purest. Across the world they exist to promote tolerance and international understanding. In the USA's Sunnylands Center in California's Sonoran Desert and Cleveland Cultural Gardens in Ohio, the Hague Peace Garden in the Netherlands, Berlin's Gardens of the World in Germany, Melbourne's Milarri Garden in Australia, and New Zealand's Te Parapara and Hamilton Gardens in Hamilton, their earnest desire to reach out to local communities and visitors from further afield is surely at the heart of what a sacred garden should be.

So, what is a sacred garden? It may be a functional garden created by monks for sanctuary, medicine and food; the sacred bathing pools of Tirta Gangga in Bali; or the Islamic terraces of the Alhambra, suffused with symbolism and encouraging tranquillity and contemplation. Some are ancient sites full of myth, others have been lovingly restored from ruin, while some have been created in living memory in a bid to get closer to the Divine, be it through traditional religion or the worship of nature itself. Across cathedrals, monasteries and ruined abbeys; temples, mausoleums and shrines; forests, islands and deserts, in search of these earthly utopias, each garden serves as a prime example of how religion, philosophy and spirituality can inform and inspire beautiful garden design.

Pages 12–13:
Kylemore Abbey, Ireland
(pages 98–103).

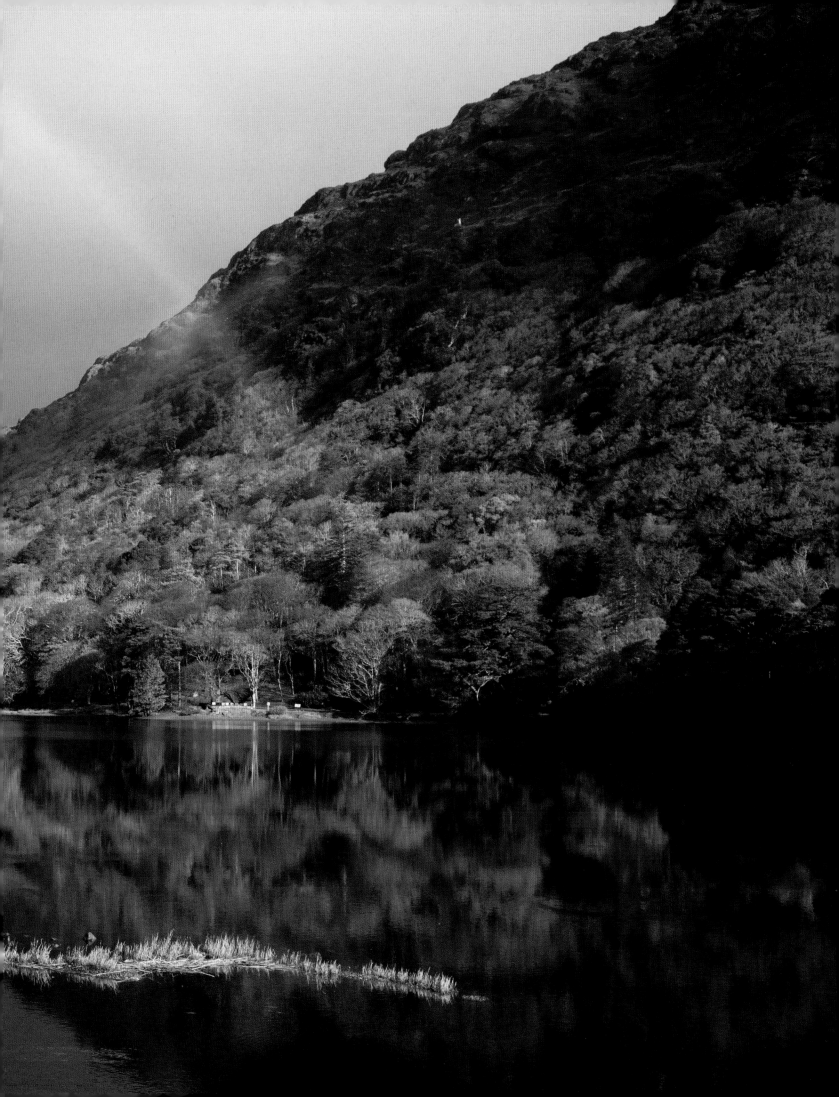

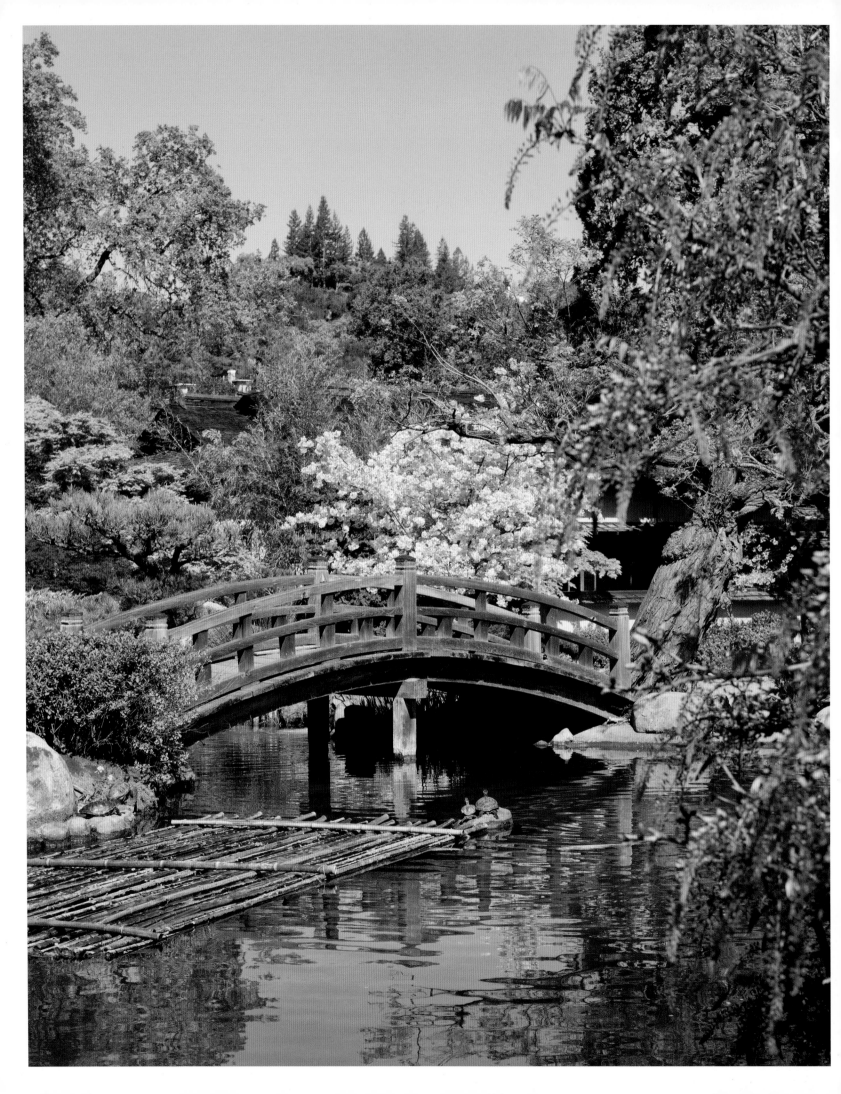

Hakone Estate and Gardens

California, USA

Over the course of a century, Hakone has moved from being a private garden retreat to a public space, while maintaining its essence as a Japanese garden where nature and art align to glorious effect. Such gardens draw on centuries of religious and philosophical thinking, and hope to create a spiritual – or at least reflective – experience. Plants and trees are trained and trimmed, water is channelled, and stones and gravel are carefully placed to create an idealized vision of the natural world. Spread over 7 hectares (17¼ acres), Hakone is one of the oldest Japanese gardens in the West; it's on the National Register of Historic Places, as well as being a member of the National Trust for Historic Preservation, both organizations having included the site on their registers to ensure that it's protected as an American site of significant historic and archaeological interest.

The gardens were established as a summer retreat by San Francisco philanthropists Isabel and Oliver Stine. Isabel was the driving force, having been inspired by the Japanese Pavilion in the 1915 Panama-Pacific International Exposition – when it closed, she snapped up many of the exhibition's plants and ornamental fixtures for the family's holiday home in hilly Saratoga, California. After visiting Japan in 1917 and gathering ideas from historic gardens there, she named her estate after Hakone, one of the towns she'd visited in the country. Set in the mountainous, spring-filled Fuji-Hakone-Izu National Park west of Tokyo, and offering astonishing views of Mount Fuji, the town clearly left its mark. Work soon started on Isabel's garden, led by master gardener Naoharu Aihara and architect Tsunematsu Shintani, and the garden we see today is essentially the one that was created then.

Opposite: A decorative bridge in the Hill and Pond Garden.

A victim of the Great Depression, the estate was sold in 1932 to Major Charles Lee Tilden, who added various features, such as the ornate main gate (the Mon), the wisteria arbour and various scenic pathways. His ownership saw the darkest period in the garden's history, when his (American-born, to Japanese parents) gardener James Sasaki and his wife and four children were sent to an internment camp in Utah for the duration of America's involvement in the Second World War. After Tilden died in 1950, Hakone changed hands several times until it was sold to the City of Saratoga in 1966, in order to maintain the garden as a single entity and open it to the public.

An immaculate garden like this requires constant attention, not only in the day-to-day upkeep, but also in the long-term enhancement of the landscape. The many years of multiple ownership meant that after the City took control, landscape gardener Tanso Ishihara and architect Kiyoshi Yasui were hired to devise an expansion plan alongside restoration work. Later, in 1987, the Bamboo Garden was added: it holds bamboo specimens from all around the world, including what was at the time the only tortoiseshell bamboo in North America. In the 1990s, a replica of a nineteenth-century Kyoto Tea Merchant's House was built to serve as a Cultural Exchange Center, where exhibitions and events could be held. Hakone also hosts various seasonal events, such as night-time viewing of the cherry blossom and summertime Japanese river lantern festivals (Toro Nagashi), in which people place candle-lit lanterns on the water, together with their prayers for peace. There are also regular Sunday tea ceremonies.

There are four main gardens: as well as the Bamboo Garden, there's the Hill and Pond Garden, the Dry Garden and the Tea Garden. The Hill and Pond Garden is the oldest garden (1918) and is built for wandering; there are eye-catching views everywhere you look, with tumbling waterfalls and ponds housing koi and turtles, and a decorative bridge. The Moon Viewing House has a veranda (*engawa*) from which visitors can look out over the beauty of the gardens; in September and October, the moon rises and sets with its reflection mirrored in the pond. One of several beautiful buildings on the estate, the house dates from 1918, and was constructed in the traditional manner, without nails.

In contrast, the Dry Garden is for looking, not strolling: it's a Zen garden,

Below: A traditional Japanese garden motif, the stone lantern, amid autumn colour.

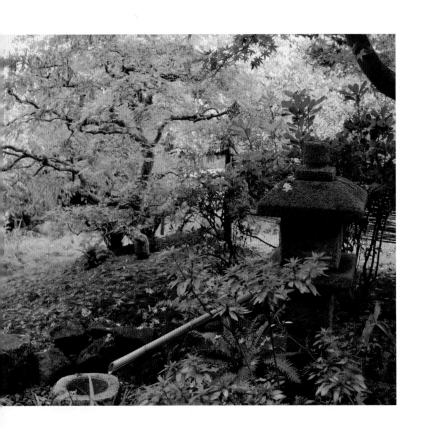

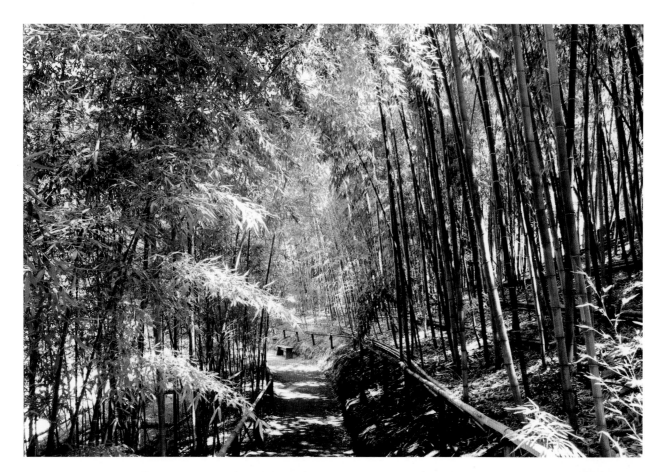

Left: The Bamboo
Garden.

Below: The Dry Garden.

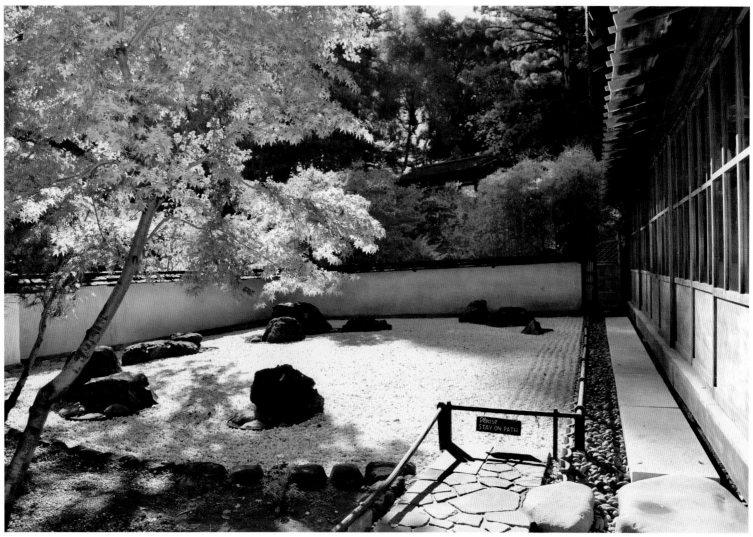

Above and opposite:
Moss and stepping
stones.

and intended for meditative gazing. A meticulous design features carefully raked gravel patterns and arrangements of boulders that represent islands and water, accented by mosses, trees and objects such as the stone lantern. Stone lanterns are a feature of Japanese gardens, and can be seen in various sites at Hakone, including around the koi pond. Originally religious votive lights, they came from China, via Korea, in the sixth century as part of Buddhist tradition (the light represents the teachings of the Buddha overcoming the darkness of ignorance). They began to be used at Japan's native Shinto shrines, first as spiritual aids, and then also to light shrines and temples. By the sixteenth century they started appearing in gardens and are now a much-loved feature of the Japanese garden.

The Tea Garden is a prelude to the tea ceremony rooms, but whether taking tea or not, the garden is a soothing space with moss, stepping stones and specialist trees, such as maples, hinoki cypress and black pine imported from Japan. Throughout the estate, the elements are carefully placed to create harmony and beauty whatever the month, with seasonal colour offered by cherry blossom, wisteria, azaleas, camellias and acers.

Hakone is a classical Japanese garden, in which calm, contemplation, quietness and peace are the driving factors. Today the estate is run by the Hakone Foundation, which as well as caring for the gardens, running cultural events and fundraising, also seeks to promote racial harmony and understanding.

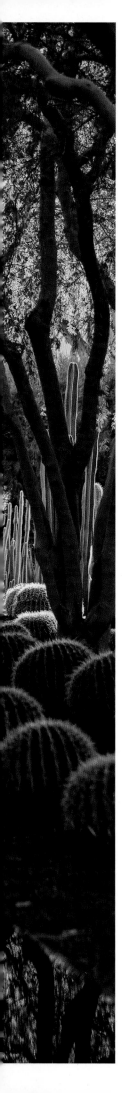

Sunnylands Center
California, USA

A retreat and major site of world diplomacy, the Sunnylands Center is a unique space of conference, seeking to promote international understanding. From Ronald Reagan to Barack Obama, Queen Elizabeth to President Xi Jinping, the centre has hosted an incredible array of influential names.

Set on the outskirts of Palm Springs in the Sonoran Desert, the modernist estate was commissioned by diplomat and philanthropist Walter Annenberg and his wife Leonore in 1963, intended as their winter retreat and a meeting place for the great and good. The family left the estate in trust for the nation, and in 2012 the visitor centre and 3.5-hectare (8½-acre) botanic garden opened to the public. The estate continues to host world retreats, but when those are not sitting there is free public access.

The garden was thoughtfully designed to celebrate the legacy of the Annenbergs, to promote contemplation, and to look forward into the twenty-first century. Unlike traditional Palm Springs gardens that rely on heavy water use, chemical fertilizers and exotic plants, the garden is sensitive to the delicate balance of life in the Sonoran Desert, and raises awareness of ecological issues. Sustainability is at the core of the design; utilizing water retention and reuse, irrigation systems, solar panels and the careful planting of shade- and heat-tolerant plants has seen the garden win eco awards.

The design of the garden is inspired by the Annenbergs' collection of Impressionist and Post-impressionist paintings, creating broad brushstrokes of colour and bold sweeping lines. The layout begins as a formal, geometric composition closest to the building and becomes progressively more organic towards the edges of the grounds, leading visitors through a series of tranquil spaces to emerge ultimately into meadows that form the perfect foreground for the glory of the mountains beyond.

Opposite: A garden designed to promote contemplation.

By the visitor centre, rectangular steel pools reflect the sky, and fountains sprinkle sound and water, while a broad circular lawn invites communal activities and doubles as an event space. Beyond the terrace, the paths lead out under trees into quiet nooks, with dramatic planting. The trees – palo breas and palo altos, sweet acacia and mesquite – are key to providing shade and form to the harsh desert landscape; well adapted to the dry conditions, they form groves and curving pathways and provide a lush backdrop to the startling plants. In spring the bright yellow flowers of the palo verde fill the tree's thorn-less canopy during its long flowering season; Costa's hummingbirds battle for the best branches to perch and nest; and the flowers are filled with the soft buzzing of dozens of delighted bees collecting pollen.

James Burnett, the garden's designer, aims for a multisensory experience: 'As you move through the landscape, you are aware of being under the dappled shade, next to the water; you hear the sounds, hear and feel the gravel.' The garden, like the ranch, is planned as a place to slow down, to step away from the hubbub. Under one grove of trees a labyrinth sits, a spiral planted with low mounds of wedelia (*Sphagneticola trilobata*) between the winding path, inviting the traveller to journey inwards and rest.

This is no conventional naturalistic design, nor is it a horticultural lesson – the desert plants are placed with mathematical regularity and in serried ranks with extraordinary impact. The golden barrel cactus (*Echinocactus grusonii*), like gigantic pincushions, are showstoppers planted in the dark scoria-mulched beds under the palo breas. The geometry and clean lines of modernism are reflected in the clear shapes of the landscaping and the architectural forms of the desert-friendly plants. Agaves

are everywhere, different species giving an array of sculptural forms, columns of artichoke agave contrasting with the upright vertical stems of blue torch (*Pilosocereus azureus*) and old lady (*Espostoa melanostele*), the interlocking ovals of prickly pear and the spherical cacti.

On the outskirts of the garden the trees fall away to reveal the wildflower meadow. This is overseeded annually to demonstrate the blooming of the Sonoran Desert. Starting in February, a variety of native wild flowers and bunch grasses begin emerging. The vibrant orange California poppy plays well off the bright yellows of the brittle bush and the desert marigold, but the field can range in colour from purples to oranges, whites and pinks, with a variety of combinations, popping with colour or echoing the muted tones of the distant mountains.

The gardens are intended to reflect the overall purpose of Sunnylands as a place of respite, a retreat from the cares of the world, but one that encourages discourse and mutual understanding. Many balances are struck here, between art and nature, humanity and nature, care for the Earth and care for its inhabitants, a historic house infused with the spirit of modernity. The director of the centre, Janice Lyle, reinforces these roles: 'It's a dialogue between the twenty-first and twentieth centuries about the ways in which natural resources are used and beauty is defined.' A pause for thought.

Below: A spiral path bordered with wedelia.

Pages 24–5: Desert plants reflect the Sonoran Desert landscape beyond the garden.

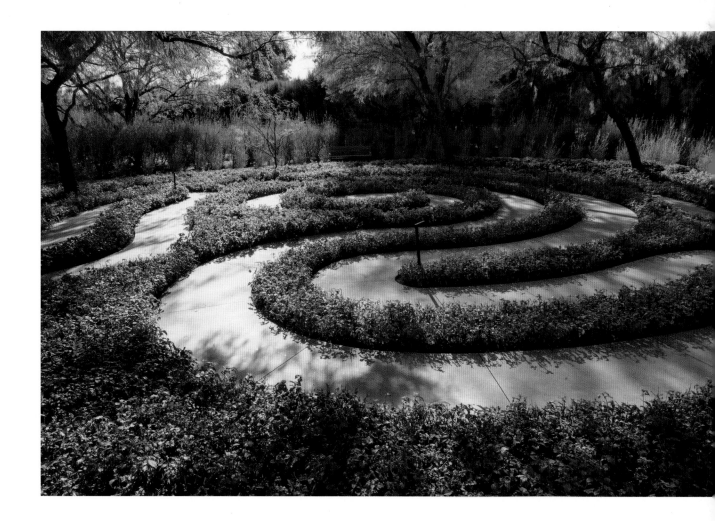

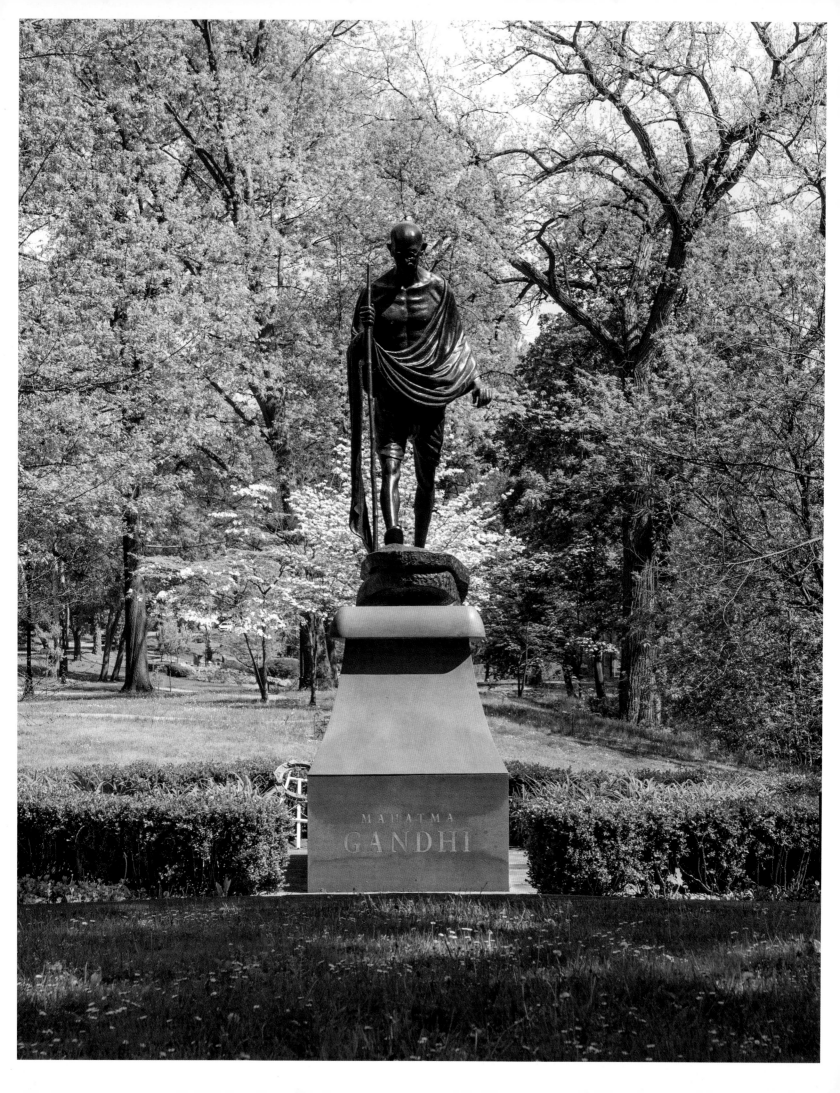

Cleveland Cultural Gardens

Ohio, USA

In a world where globalization seems to be contributing towards creating greater intolerance, bigotry and ethnocentricity, the Cleveland Cultural Gardens stand out as a beacon of hope and unity. Conceived as a collection of gardens – at the time of writing thirty-five, with eleven more in development – designed and cultivated by distinct cultural or national groups, they stretch for some 2.4 kilometres (1½ miles) along Martin Luther King Boulevard and East Boulevard in Cleveland's Rockefeller Park, and span the globe from Latvia and Syria to Vietnam and Ethiopia.

Forming a small part of the 103-hectare (255-acre) Rockefeller Park, designed by prominent landscape architect Ernest W. Bowditch and conceived in 1896, the first of the gardens was born twenty years later when local publisher Leo Weidenthal, a keen fan of Shakespeare, established a memorial garden for the Bard on the 300th anniversary of his death, setting in motion the idea of establishing additional gardens that would honour the artists and cultural icons of the USA's – and in particular Cleveland's – immigrant communities.

Weidenthal, working with Charles J. Wolfram and Jennie K. Zwick, founded the Cultural Garden League (now the Cleveland Cultural Gardens Federation) in the mid-1920s, with the first of its gardens, the Hebrew Garden, dedicated in 1926. Featuring a hexagonal Star of David, a pink marble fountain and memorials to Hebrew philosophers, the dedication was marked by the planting of three cedars of Lebanon. The German Garden was dedicated two years later, and in the decade that followed, an additional thirteen gardens would be added, a flurry that reflected the growing immigrant numbers in the city, which by then made up 30 per cent of its population.

Opposite: Gandhi in the Indian Garden, just one of Cleveland's thirty-five cultural gardens.

The second wave of Cultural Gardens was a more gradual affair, with just a handful of new gardens added from the 1950s to the mid-1980s. The early additions in this Cold War era addressed geoglobal conflicts, with rebukes of varying subtlety. At the heart of the 1966 Estonia Garden, for example, an abstract flame representing hope for freedom was a clear protest against the forced annexation and continuing rule of the USSR over the country. And Finland's original garden of 1958 was rededicated in 1964 to celebrate Finnish cultural identity, with a granite tablet dedicated to the spirit of the Finnish people.

A third wave of gardens in the twenty-first century, reflecting the composition of Greater Cleveland's new immigrant populations, also addressed geopolitical shifts – the original plan for the Yugoslav Garden was a partnership between delegations from the Slovenian, Serbian and Croatian communities, but Yugoslavia's dissolution in the 1990s led to the parallel dissolution of the garden. It would take twenty years for the three countries to have their own spaces. By contrast, the feuds of the real world are put aside at the intersection of Martin Luther King and East Boulevards, where the Armenian, Turkish, Russian and Azerbaijan gardens sit happily together. And most recently, the Syrian Garden features a replica of the Arch of Palmyra, since destroyed by Islamic State.

Many of the gardens include sculptural elements symbolizing a country's or culture's heritage and history, with statues including Dante in the Italian Garden; Goethe and Schiller in the German Garden; Gandhi in the Indian Garden; Mother Teresa in the Albanian Garden;

Right: The pylon in the Greek Cultural Garden.

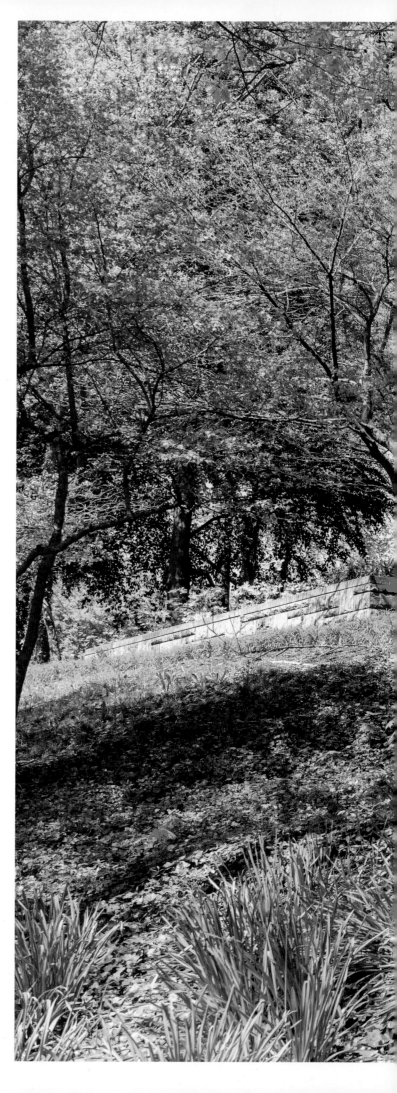

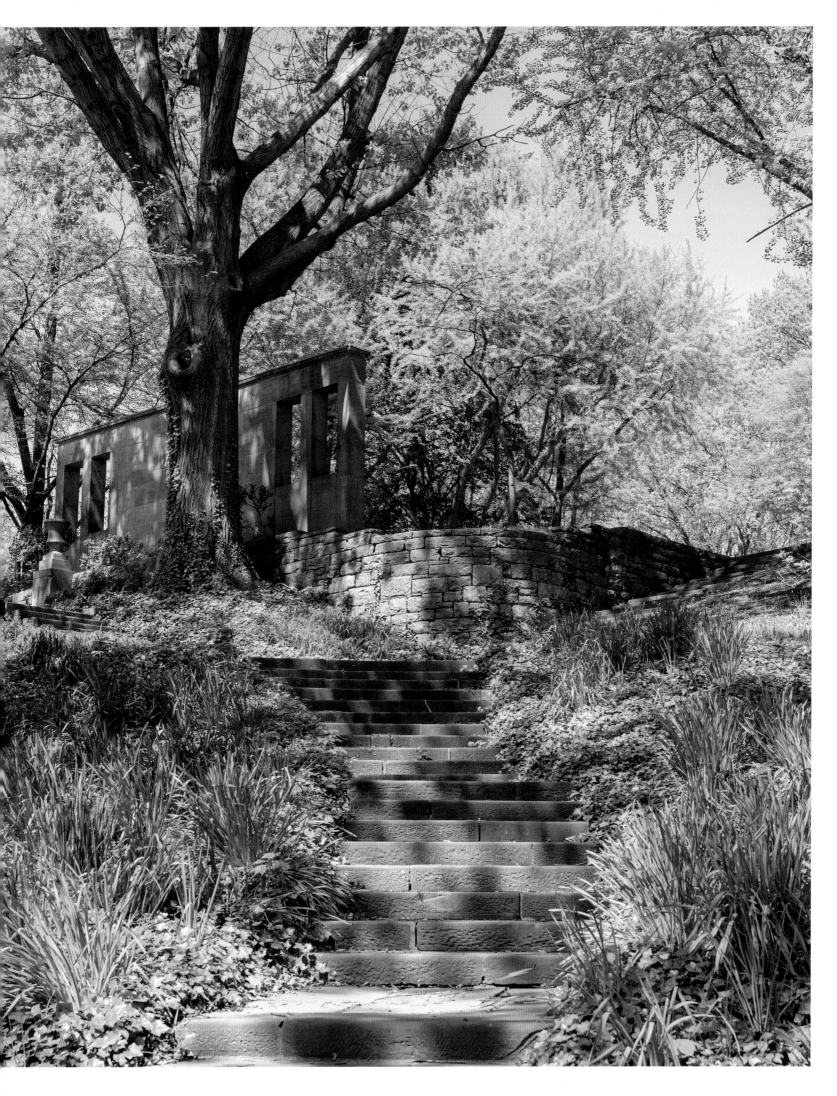

Above and right: Formal figurative sculpture and a sandstone walkway in the shape of a Celtic cross in the Irish Garden.

Chopin, Copernicus, Pope John Paul II and Marie Curie in the Polish Garden; and Franz Liszt in the Hungarian Garden. Of the more abstract sculptures, a standout piece is the Azerbaijani garden's 8-tonne, polished stainless-steel, bowl-shaped sculpture *Hearth* by Khanlar Gasimov.

Landscape design in many of the gardens also reflects national treasures, historical events, styles and symbols. In the Irish Garden, dedicated in 1939, a sandstone walkway in the shape of a Celtic cross is filled with grass and bordered in impatiens and geraniums. A lovely reflecting pool leading to a pylon symbolizes the wall of the Parthenon in the Greek Garden. The Renaissance-inspired Italian Garden includes a large fountain and two winding staircases leading down to an amphitheatre. Croatia's garden features a mini-waterfall connecting upper and lower levels inspired by the country's famous falls at Plitvice Lakes

and Krka Falls. And ongoing plans for the African American Garden site, dedicated in 1977, include a water feature that will recall the waterways travelled by so many on the path from slavery to freedom.

Many of the gardens' individual committees have used planting native to their home countries. In the British Garden, these have over the decades included mulberries, roses, daisies, ivy, sycamore and maples. The Greek Garden is home to 7,500 plants and 89 tree varieties, including myrtle, a plant with historic Greek origins, and spire oaks and sage, both common elements of the Greek landscape. The Carpatho-Rusyn Garden features Carpathian walnut and pine trees common to the homeland; the German Garden offers shady linden trees; and the triple-levelled Lithuanian Garden is filled with lush plants familiar to Lithuanians, as well as symbolism related to the country, including the large

stone Fountain of Biruta, representing the pre-Christian era of pagan worship.

Newer gardens and those in development continue to incorporate this mix of cultural, historical and botanical references to their homelands. It's planned that Pakistan's garden will feature four mini gardens, representing the country's four provinces, but also echoing the *charbagh* of Persian gardens. The first of three planned Latin American gardens – Colombia's (with Mexico and Peru to follow) – will use plants, flowers, trees and boulders to highlight the country's regions of rainforest, grasslands, highlands and coastal lowlands.

Cleveland's Brazilian, Filipino, Iranian, Jamaican, Macedonian and Georgian communities have expressed interest in establishing gardens, continuing what former president of the federation Sheila Crawford described as 'an outdoor museum that's a testament to peace through understanding'. The gardens, she said, 'illustrate our diversity and how we've worked together for 100 years'. Whether they'll last another 100 years is addressed by perhaps the most compelling addition of recent years. The Ethiopian Garden's 'When the Sun Gets the Moon', a mosaic tile piece from 2019, reproduces a painting by Ethiopian artist Zerihun Yetmgeta, and was created as an addendum to the garden's original mural, depicting Ethiopia through history. Climate change means the possible destruction of not just Yetmgeta's country, but civilization, and his piece, he says, is a plea from Ethiopia, where the human race began, to 'do better and avert this collapse'.

Below: The Ethiopian Garden's 'When the Sun Gets the Moon' mosaic from 2019.

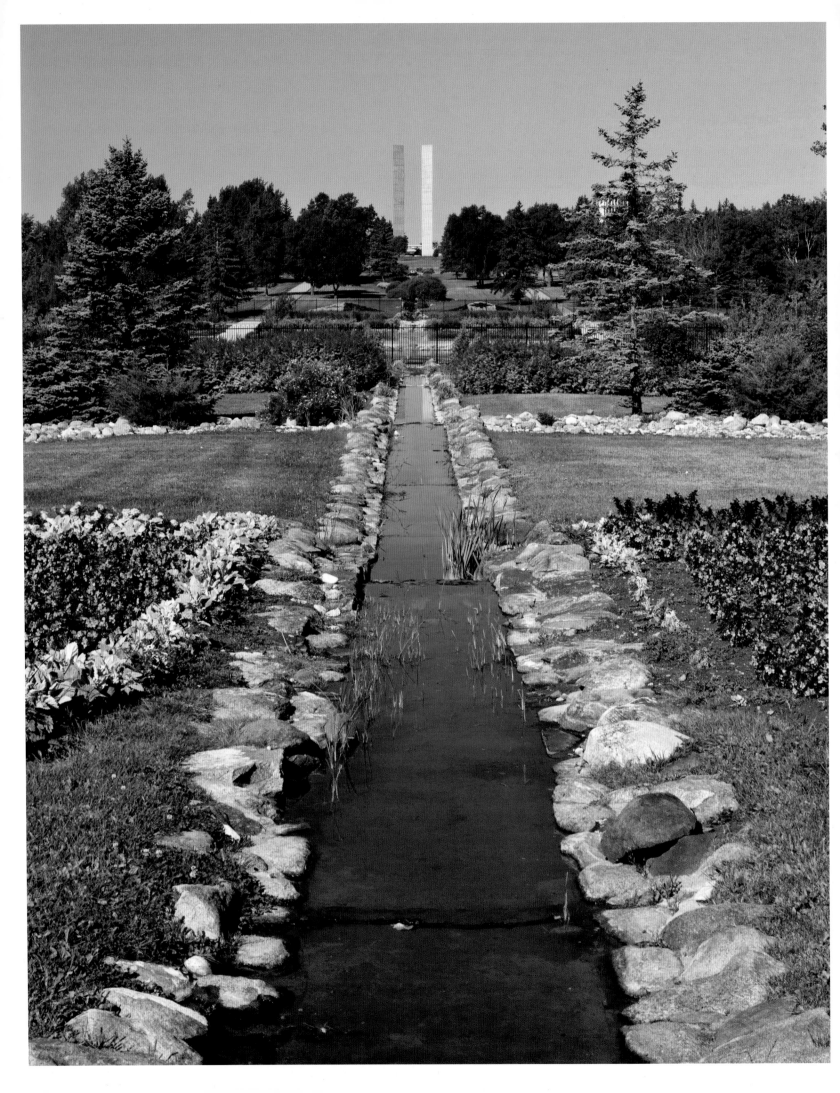

International Peace Garden

Manitoba, Canada & North Dakota, USA

Most gardens seek to be peaceful, but this is usually in the sense of providing a sequestered refuge from busy life or a setting for spiritual growth. A smaller subset aspire to co-opt nature as a medium for reflecting on peace specifically as the opposite of war: to foster international friendship and cooperation and assert the value of contemplation, shared space and the neutrality of nature and habitat above violence, individualism and aggression.

There are peace parks and gardens across the world, often founded to memorialize a particular event, conflict or treaty (on occasion controversially, given that history is written by the victors). The best-known of these at institutional level is the garden at the Peace Palace in the Hague (see page 76), but the largest and most active is situated along the Canada/US border, straddling the states of Manitoba and North Dakota in the geographical heartland of the North American continent. In these vast, sparsely populated prairie lands, the 930-hectare (2,300-acre) park's forest boundaries and several lakes are porous to wildlife (including deer, wild turkeys and elk). Moving inwards, the park transitions from perimeter wilderness via hiking trails, campgrounds and picnic areas to what, with moving sincerity, its creators conceived as the best that civilization can aspire to, including several memorials, arts facilities and formal gardens that compete in scale with the big horticultural hitters.

The International Peace Garden was conceived in 1928 by Canadian Dr Henry Moore, a Kew-trained horticulturalist, with the frontier location integral to the founding concept of celebrating the friendship between Canada and the USA and demonstrating that borders can be shared rather than contested. The project was inherently collaborative. Manitoba and North Dakota donated 587 and 360 hectares (1,450 and 890 acres) respectively to form the site, which was designed by landscape architect Hugh

Opposite: The garden's central feature, a water channel set in formal gardens, marks the Canada/US border. In the distance, anchoring the far end of the Peace Garden, is the Peace Tower, four identical 36.5 metre (120 foot)-high concrete columns, two on each side of the border.

Above and right: Brightly planted beds; a working clock at the entrance to the gardens.

Vincent Feehan and dedicated in 1932. Fifty thousand people turned up to watch the ground-breaking ceremony. Funds were raised on both sides of the border, from private donations initially, though civic and service organizations also contributed (and continue to contribute) after the Second World War brought a painful urgency to the principles of international peace and cooperation.

Much of the construction was undertaken in the 1930s by the US's Civilian Conservation Corps, the federal work programme that employed many thousands of young men on national infrastructure projects during the Great Depression of the 1930s. The US vernacular park architecture of low-slung buildings constructed in local wood and stone to meld with the landscape evolved during this period; here, granite from North Dakota's Turtle Mountains (visible from the park) was widely employed, along with timber from Manitoba. This style, and the formality of design and plantings, highlights an earnest civic idealism that feels a little dated but still moving in

the twenty-first century. Canada still holds citizenship ceremonies here, while North Dakota subtitles itself the 'Peace Garden State'.

The straight line of the Canada/US border is the civic and geographical core of the park, marked by a water channel, dotted with fountains and reflecting pools and enclosed within a 10-hectare (25-acre) rectangle of formal gardens and lawns featuring brightly planted beds, often in symbolic designs. A large, working floral clock marks the entrance, along with visitor facilities and monuments; a peace chapel anchors the other end, a stately 800 metres (½ mile) away. En route are a sunken garden of perennials and ornamental shrubs, a modernist bell tower, a pavilion and ten twisted girders salvaged from the 9/11 site, which form a stark and striking memorial to the terror attack. There is a palpable sense of reverence here, and an affecting moral aspiration. Over 80,000 flowering plants fill the garden; the annual plantings change every year, with the exception of the ever-present

floral representations of the Canadian and US flags. Visitors can enter the park and cross the international boundary without undergoing border checks, but each country has an immigration post where papers are shown on the return (or onward) journey.

The vast site includes several other gardens, including a pollinator garden, kitchen garden and 'All-American Selection Garden', where new seeds are tested. There's a recently rebuilt conservatory, too, with a significant collection of cacti and succulents – it's especially popular in winter, when groomed cross-country skiing trails operate in the park's back country. With canoeing and kayaking, hiking and cycling, children's areas, a campground and cabins for rent, the site is much more than a formal garden of commemoration.

The spirit of peace is also interpreted in art installations and cultural events. Sculptures are scattered through the gardens, including seven 'peace poles' donated by Japan, inscribed with the legend 'May peace prevail' translated into twenty-eight languages. The events roster includes arts and crafts workshops, musical entertainments, Indigenous storytellers and the long-established International Music Camp. Coupled with its message of peace, tolerance and understanding, these community-focused events surely elevate the International Peace Garden to the realm of a utopian space, one to be treasured, revered and enjoyed in equal measure.

Below: Seven peace poles donated by Japan, inscribed with the words 'May peace prevail' in twenty-eight languages.

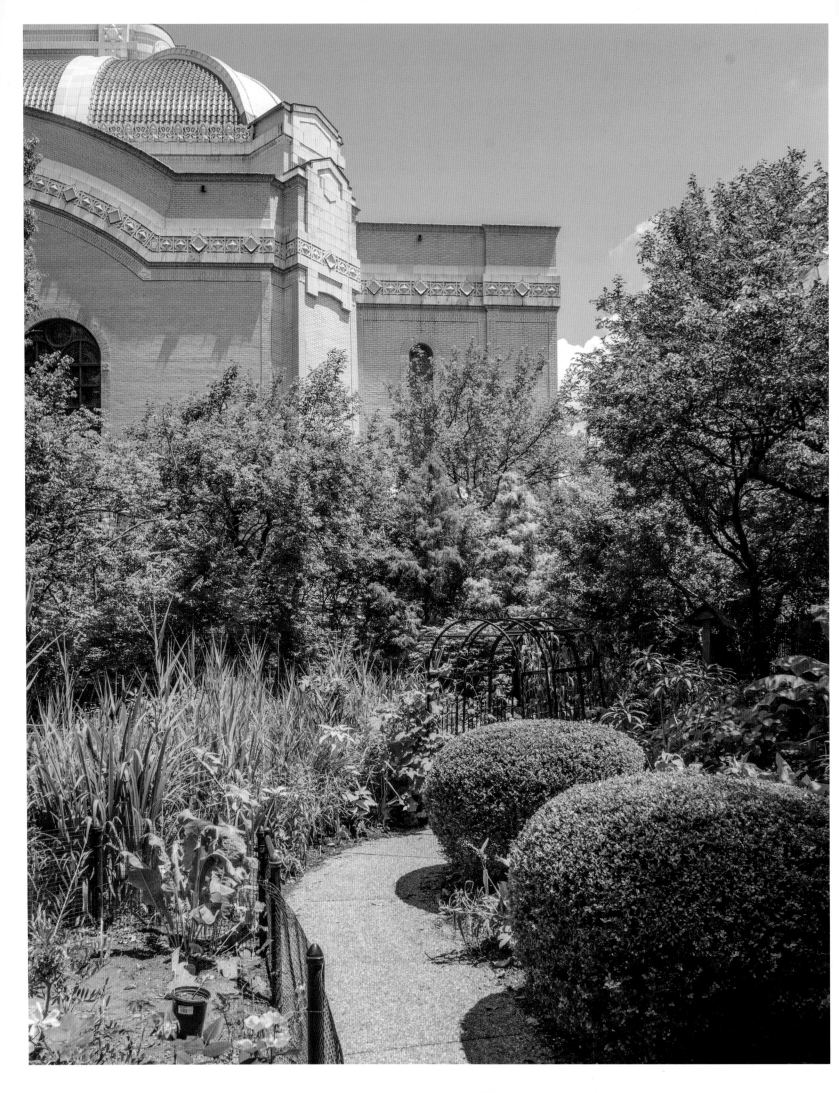

Rodef Shalom Biblical Botanical Garden

Pennsylvania, USA

Biblical gardens – gardens specifically related to Christianity and Judaism – are to be found across the world. From the Lynn Canal in Juneau, Alaska, to South Korea's now-abandoned Songdo Bible Park, via the Salem Biblical Park in Paarl, South Africa, and the Palm Beach Bible Garden in Australia, their varying forms take in everything from materializations of the Bible and recreations of gardens from biblical times to representations of scenes from sacred texts and Holy Land replicas. All of these are to be found in numbers in the USA, where the biblical garden first emerged in the early twentieth century as one that would connect botanical science with biblical literacy.

In Tucson, Arizona, the Garden of Gethsemane, founded in 1938, features replica depictions of the Last Supper, Gethsemane and other New Testament scenes, while at The Walk at Shields, founded in 1924 in Indio, California, twenty-three statues depicting fourteen scenes from the life of Jesus are spread through a date farm. A particularly playful garden created as a way of bringing multigenerational families to the word of Christ can be found in Lexington's Biblical Mini-Golf in Kentucky, where holes invoke the Days of Creation, Noah's Ark, Garden of Eden and the Star of Bethlehem.

The most authentic biblical gardens, defined as gardens made up of plants mentioned in the Bible, are equally well represented in the USA, spanning the country from the West Coast's Ojai's tranquil biblical garden at the Ojai Presbyterian Church, where fifty varieties of trees and plants mentioned in the Old Testament include feathery bulrushes, nettles and myrrh, to the East Coast's Cathedral of Saint John the Divine, New York. Here, in a small inconspicuous space towards the rear of the cathedral's 4.5 hectares (11 acres) of land, a wide range of plants referenced in the Bible can be found, among them quince, which some say was the 'apple' in the Garden of Eden; irises, a biblical symbol for Israel; sage, which served as a model for the menorah; and a Judas tree (a redbud).

Opposite: More than 100 temperate and tropical plants from biblical times make up the garden.

But it's in the less well-known Oakland area of Pittsburgh, Pennsylvania that one of the USA's best biblical gardens is to be found – the Rodef Shalom Biblical Botanical Garden. Established in 1987 behind the Rodef Shalom Temple, which houses Pennsylvania's oldest Jewish congregation, it remains one of the largest biblical botanical gardens in North America, and is certainly one of its most moving in terms of experience. That's perhaps because its genesis lay in the personal passion of its co-founder Irene Jacob, a botanist and keen gardener who conceived the space with her husband and fellow gardening enthusiast, the Rabbi Dr Walter Jacob, around the theme of ancient Near East agriculture and horticulture.

With a background in horticulture that included teaching economic botany and the publication of a range of books, including *Botanical Symbols in World Religions* and *Plants of the Bible and Their*

Below: A waterfall flowing into a miniature Sea of Galilee.

Uses, it's clear that Irene knew more than most people about the subject of ancient Israel and its botany, and in 1987, a year after co-publishing *Gardens of North America and Hawaii: A Traveler's Guide* with Walter, the pair designed and opened the Rodef Shalom Biblical Botanical Garden with more than 100 temperate and tropical plants from the era, grown in a setting reminiscent of the Holy Land.

All the plants are labelled with their biblical, common and scientific names, and accompanied by the biblical verses in which they're referenced – for example, chamomile represents the 'flower of the field' mentioned in the Book of Isaiah. There is also symbolism in the essence of the landscaping, with a cascading waterfall flowing into a miniature Sea of Galilee from which flows a bubbling stream, representing the River Jordan, meandering through the garden to end in the Dead Sea, which is surrounded by a small Negev-like desert. Papyrus reeds flank the miniature river, and a herb garden illustrates what ancient Israelites would have grown for their food. It's instructive and informative, but above all it's contemplative and spiritual, the various elements working together to create a space of harmony and tranquillity.

It's clear that the garden is a labour of love, but it's also a labour of commitment and hard work; due to two-thirds of the plants being Mediterranean or tropical, they have to be removed to greenhouses before the frost arrives in autumn, then returned to the garden in late spring, limiting the period the garden is open to just three months. New plants are introduced as they are found – including one caper bush thought to be extinct.

Combining these two aspects of biblical gardens – authentic planting in the form of oleander and grapevines, and the sense of what it would have been like to walk through the vegetation of the world of ancient Israel – is what makes Rodef Shalom such a standout example of the genre. To experience the space, learning about the plants referenced in the Old Testament – including unexpected foodstuffs such as flax, millet, chickpeas, wheat and barley, along with the anticipated herbs, olives, dates, pomegranates, figs and cedars – is truly special, an experience that feels as though it's giving you genuine insight into what it must have been like to live in that time.

To further heighten that sense and understanding, activities such as lectures and tours augment the collection of biblical plants each summer, when the garden also puts together an imaginative and informative special display. In 2015, for example, Paradise on Fifth Avenue (referencing the garden's address) saw the now-retired Rabbi Jacob create two miniature paradise gardens, one showing a patch of grass surrounded by rose bushes (Christian) and the other a desertscape with tiles and semi-tropical plants common in Islamic gardens. And in 2022, The Healing Garden featured plants mentioned in the Torah, the Qur'an and the New Testament that have healing powers for the mind, body and spirit – such as aloe, almonds, pomegranate and even a frankincense tree. By including the quoted texts from the different Abrahamic religions, the garden was endeavouring to illustrate and 'remind us that as adherents of the Abrahamic religions, we are more alike than we are different'. It's hard to imagine a more fitting purpose or aim for a biblical garden.

Above: Walkways and planting are designed to be contemplative and spiritual.

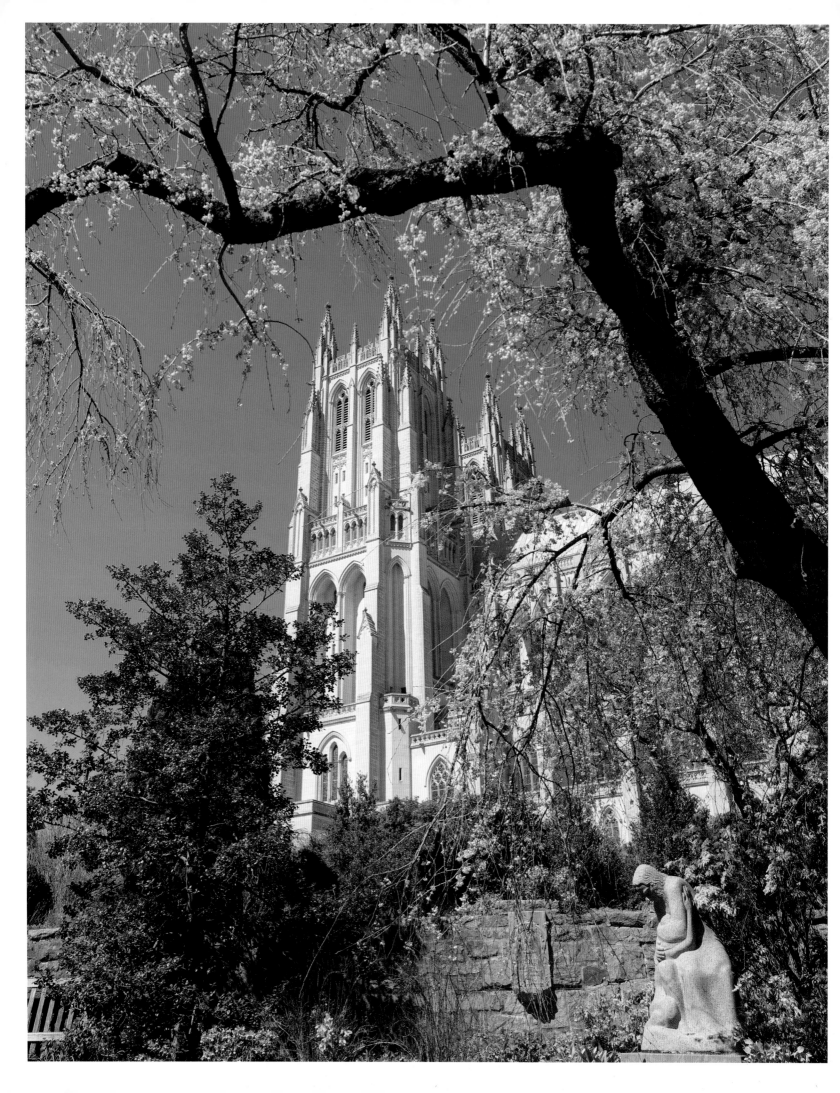

Bishop's Garden, Washington National Cathedral

Washington DC, USA

L ike all good cathedrals, the Washington National Cathedral, officially the Cathedral Church of St Peter and St Paul, was almost a century in the making. Its construction began in 1907, when President Theodore Roosevelt helped lay the foundation stone, and ended in 1990, when George H.W. Bush oversaw the laying of the final stone atop the towers.

But the idea of a great cathedral in Washington DC actually goes back to the inception of the city itself in 1791, when American-French military engineer Pierre Charles L'Enfant developed the basic plan for the city, and envisaged in it a 'great church for national purposes'. His vision would start to be realized almost a century later, in 1893, when a congressional charter authorized the building of a monumental fourteenth-century English Gothic-style church that would be an appropriate space for the funerals of the nation's presidents, but one also dedicated to religion, education and charity for all. And it would require suitably grand grounds, with a range of different spaces and themes, and plants of historical religious significance as well as those native to the mid-Atlantic region.

Those grounds, Cathedral Close, today comprise 23 hectares (57 acres), surrounding the cathedral with everything from intimate memorial gardens and a 2-hectare (5-acre) oak and beech forest to a terraced outdoor amphitheatre and extensive lawns bounded within diverse borders – an abundant gathering of the natural world that takes in everything from pollinator-friendly spaces to havens for migratory birds. At its heart, closest to the cathedral itself, lies the walled Bishop's Garden, filled with plants and planting associated with Christianity for thousands of years, including

Opposite: A Yoshino cherry tree in blossom.

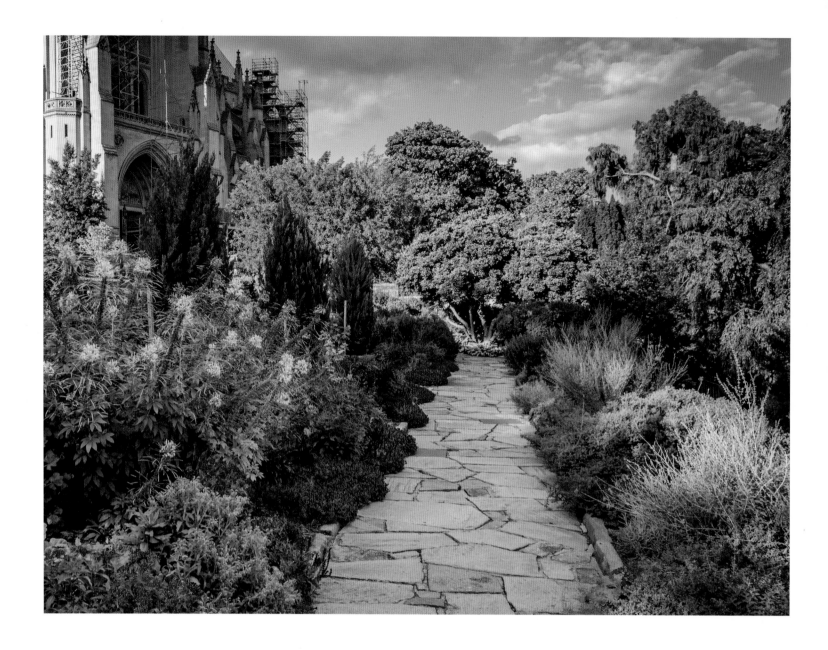

cedars and fig trees whose origins trace back to the Holy Land, and two soaring Blue Atlas cedar trees which arrived as seedlings from Palestine in 1902.

Terraced into the south side of Mount Saint Alban, the Bishop's Garden was laid out in 1928 to the design of Frederick Law Olmsted, Jr, and while originally intended as a private space, was soon opened to the public, its design developed and expanded by landscape designer Florence Brown Bratenahl. She created many of the focal elements – including the Norman Court, where Christian

motifs and symbols abound: a medieval bas-relief carving depicts the crucifixion of Christ, and a thistle (an emblem of the Virgin Mary in the Middle Ages) is carved above a beautiful fountain.

Beyond the Norman Court lie many more sacred motifs and references, both in the structure of the Bishop's Garden and its planting. At the heart of the Hortulus, for example, a ninth-century baptismal font – reported to have come from the Abbey of St Julie in the Aisne, France – is surrounded by geometric beds planted with herbs and

flowers that would have been found in early medieval monastery kitchens and infirmary gardens. A rose garden sits opposite a round-headed cross inscribed with the sacred monogram of Jesus and a quotation from Psalms. The sundial bed, filled to bursting with bright annuals and bulbs, is centred around a pomegranate tree – a symbol of resurrection and everlasting life in Christian art. In the St Catherine Pool, bright orange fish dart in a beautiful cross-shaped pool fed by a sandstone stepped fountain and backed by a fifteenth-century granite bas-relief depicting four figures, including St Catherine. And in the Upper Perennial Border, a stone wall contains three more fifteenth-century bas-relief panels depicting martyrs and saints.

Such religious references put Christianity very much at the heart of the Bishop's Garden, but it's the planting that gives it its soul. Here are dense, deep borders filled with perennial plants – alliums, peonies, hellebores, lilies, asters, dahlias and coreopsis – in warm hues. There is the Finial Garden, in which beds are planted with hydrangea, holly, lady's mantle and bugleweed. Down at the base of the sweeping Pilgrim Steps, the Lower Perennial Border is all blue and white, courtesy of iris, blue salvias, echinops, agastaches, buddleias, lavender, nepetas, larkspur and sage.

Rigorous historical research went into the planting to ensure the gardens would be filled with plants typical of a medieval cathedral or religious site. The Hortulus planting, for example, was based on plants drawn from a list of Emperor Charlemagne's in 812, and cited by Abbot Walahfrid Strabo in his poem 'Hortulus', written in 849. But the planting is

Left: The entrance to the Bishop's Garden.

Below left: A medieval religious bas relief.

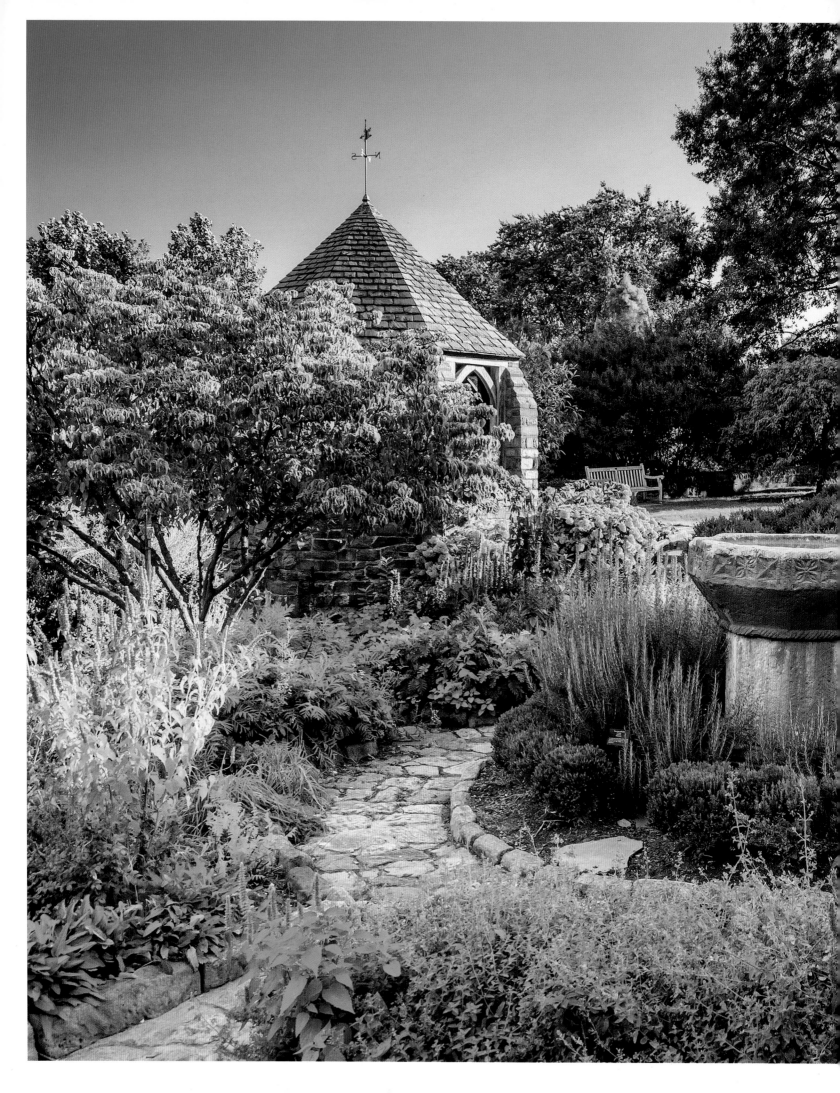

not a slave to the past and historical accuracy; it reflects our modern times too, with the cathedral's contemporary gardeners adding and replacing plants to accommodate a changing climate, create specific wildlife habitats and engage younger visitors.

Handmade objects in the garden are equally well thought out, with medieval sculptures and religious architectural elements drawing the eye constantly around the spaces and contrasting with the bright planting as well as offering functionality – a wonderful example being the twelfth-century column capital from the demolished Abbey of Saint-Marcel-lès-Chalon in France that serves as a lovely birdbath on the east end of the Upper Perennial Border. And it's not all ancient; the wrought ironwork, much of it made by Polish-born artist Samuel Yellin during the first half of the twentieth century, is exquisite, particularly in the Yellin Gate and the weather vane he made for the Shadow House, an octagonal gazebo festooned with climbing roses.

Cathedral Close's other spaces have their own quiet pleasures and distinct characters, and even in areas where there is little public interest, sacred associations are to be found. But its crowning glory is undoubtedly the Bishop's Garden, a space that remains as relevant and enchanting to twenty-first-century garden enthusiasts as it did to their twentieth-century counterparts.

Left: A twelfth-century column capital from a demolished French abbey repurposed as a bird bath in the Upper Perennial Border.

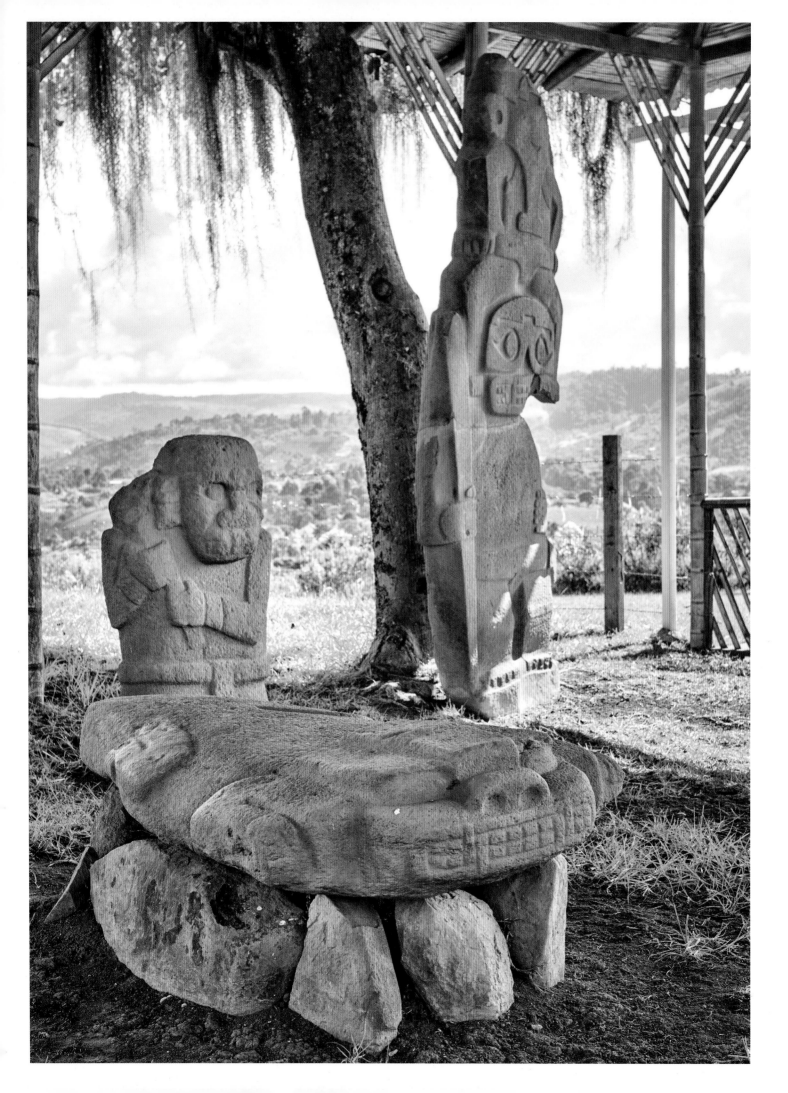

San Agustín Archaeological Park

Huila, Colombia

Peru's Sacred Valley, the heartland of the Incan empire and home to Machu Picchu, is undoubtedly well known, but South America has another valley sacred to ancient civilizations that might be less famous but is similarly impressive – in some respects even more so. It contains the continent's greatest number of pre-Colombian funerary megaliths, of exceptional sculptural beauty and placed very deliberately in a setting that itself was regarded as sacred, and which has been further landscaped by human hands to enhance its spiritual impact, both by its ancient creators and by the founders of the present-day San Agustín Archaeological Park. The park is a garden more in the parkland sense than the horticultural, but invites the same meditation on the moving interface between mankind, spirituality and the natural world.

Colombia's mother river, the Magdalena, flows 1,600 kilometres (1,000 miles) northwards along the valley between the Andes and the coastal mountain range. Its indigenous name is Guacacollo, 'river of tombs', and, near its headwaters in the tropical highlands of Huila province, the area around San Agustín contains an extraordinary quantity of grave sites and giant funerary sculpture from three millennia (up to about 1350 CE), most of them unexcavated and little studied. The UNESCO site covers three separate properties in the valley, San Agustín, Alto de los Ídolos (24 kilometres/15 miles away) and Alto de las Piedras, a short drive further on.

The beautifully presented main site has the most impressive collection of sculptures and curated visitor experience, with its winding paths and visitor centre (the sculptures at Ídolos and de las Piedras are less numerous but of high artistic

Opposite: Pre-Colombian funerary megaliths placed in an ancient sacred site.

Pages 48–9: The valley of the Magdalena River, in which the UNESCO site is set.

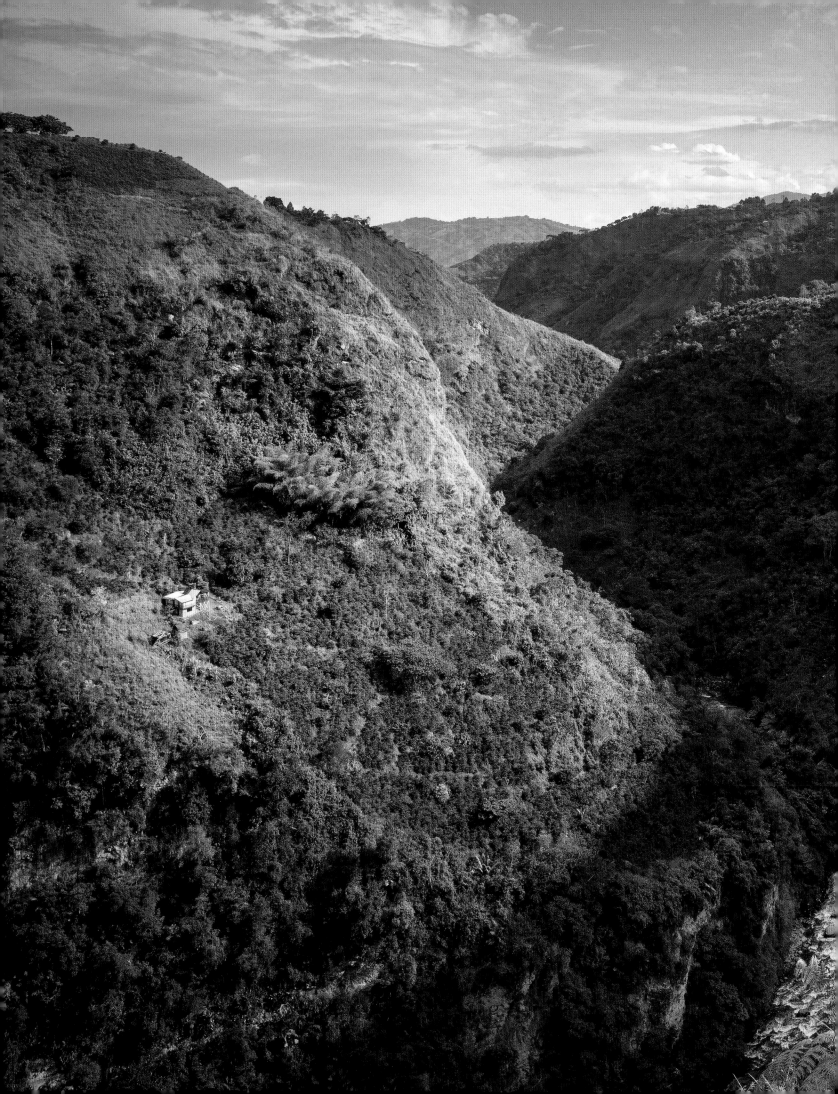

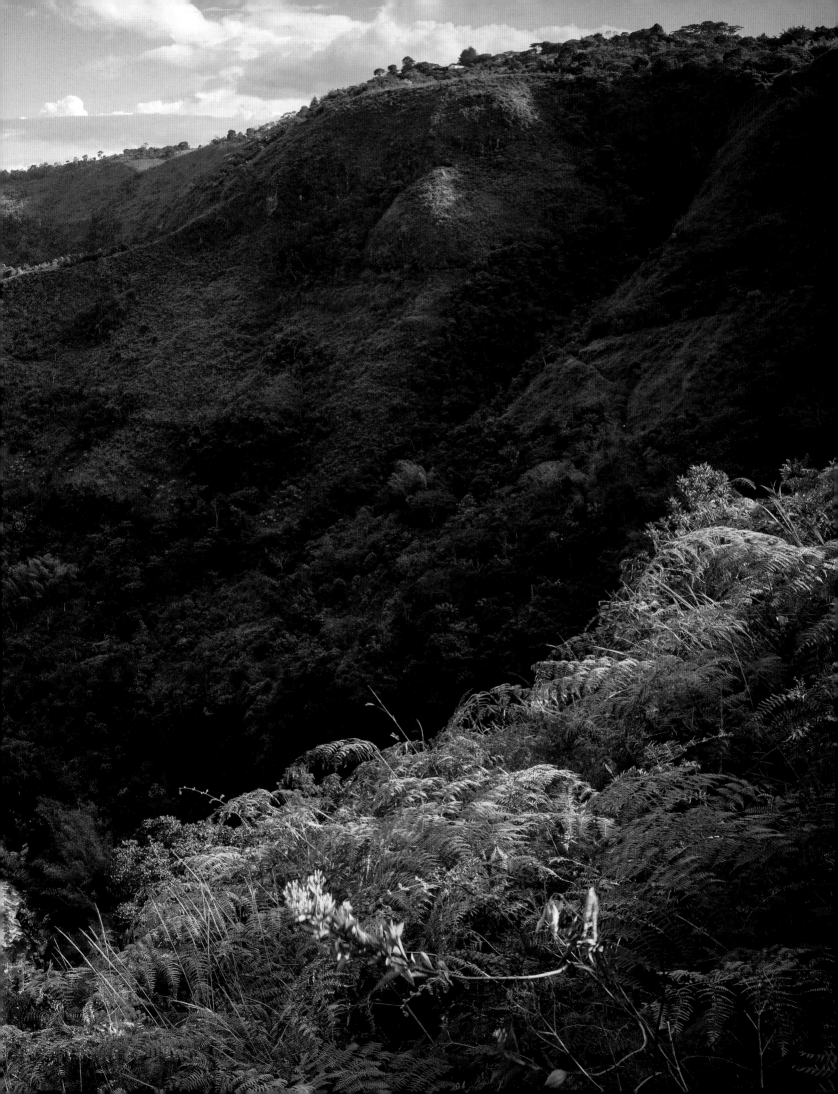

quality, notably one at de las Piedras comprising a fantastic beast made up of half-man, half-crocodile squatting atop a religious figure). As virtually nothing is known about the civilizations that created them, contemplating the sculptures – many of them disturbing, arcane images of animals and human birth and death – and earthworks is as much an artistic and mystical experience as an intellectual one. The impact of the giant graven birds, 7-metre (23-foot) dolmens supported by carved figures reminiscent of the caryatids that hold up the Acropolis's Erechtheion temple, impassive flat-faced figures delivering a baby or playing a snake-like pipe, among dozens of other statues, makes the walk through the main site feel like a spiritual journey. This spirituality is emphasized further when crossing the Magdalena, its bed hand-incised with ceremonial channels and animal shapes by the area's early inhabitants. It is thought to have been a religious site – easy to believe when the light animates the running waters, which in turn animate the serpentine etchings. While there are no formal plantings as such, the gardens here are attractively landscaped over multiple levels, with the local tropical flora including a variety of low-growing palms, a treasure trove of orchids of various shapes and hues, banana trees, and several ground-cover plants recognizable as the conservatory and pot plants of cooler climates.

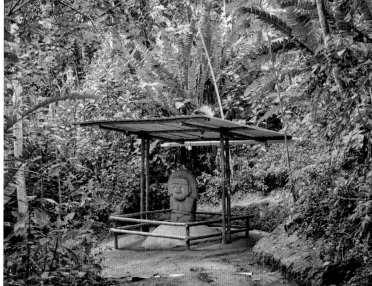

The sculptures are shaded by shelters, which offer visitors – and the sculptures – some protection, though it is notable how little the elements have eroded the fine tool-work and elegant lines; they are comparable in terms of both

Top right: Local tropical flora includes a variety of orchids.

Centre and bottom right: Statuary across the site.

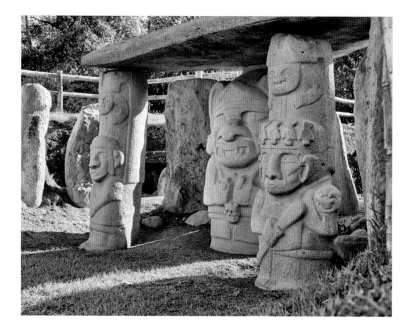

artistic and artisanal skill with the best sculptures of the Western medieval world (albeit with more of an Easter Island aesthetic).

San Agustín is in a coffee-growing area, with haciendas lining the route to the park, and once you have arrived the discreet little coffee stall in the mid-level of the park makes some fine fresh brews, including a spicy cinnamon blend. For visitors, sipping on one of them while marvelling at the meaning of the surroundings, and discovering how the monuments were placed to follow the giant outlines of coiled serpent-lizards at the visitor centre, offers an added attraction. But even experiencing the site remotely via its images, this beguiling blend of ancient and modern civilizations surely illustrates mankind's seemingly timeless desire to create representations of faith, belief and spirituality in a way that, three millennia later, are still deeply embedded within us.

Below: Covered statues in expansive open parkland.

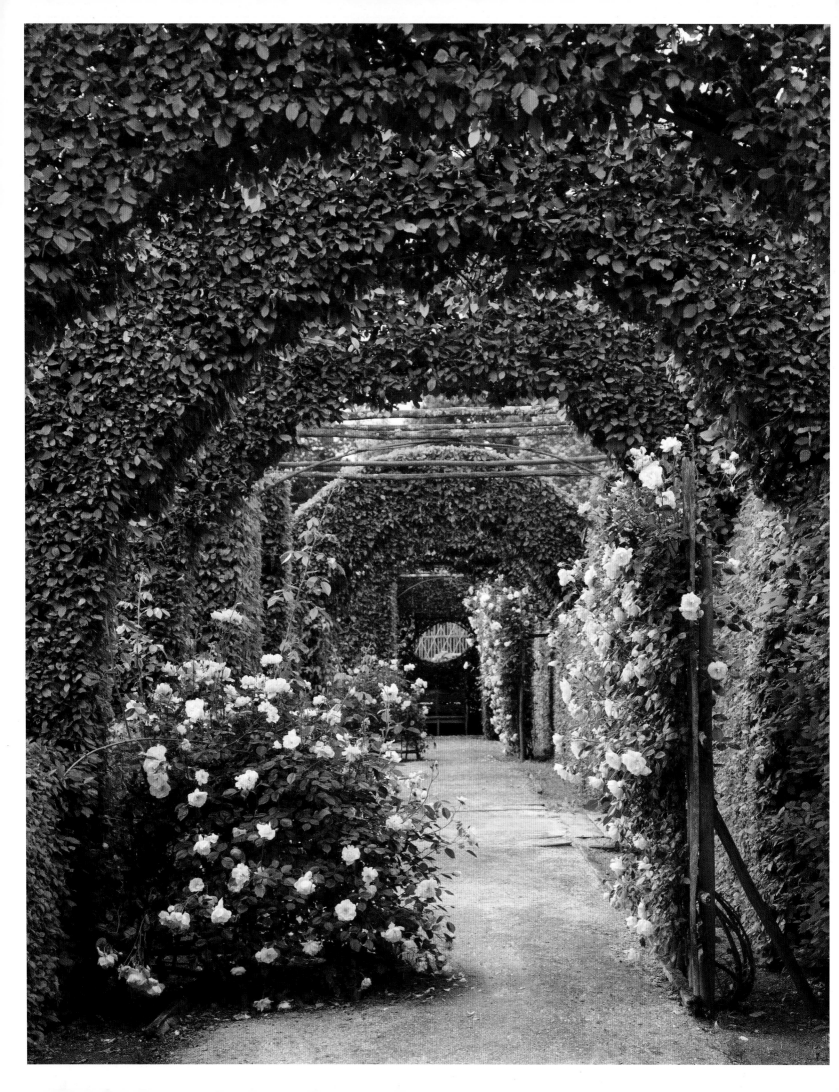

Le Prieuré d'Orsan

Cher, France

'Have nothing in your house that you do not know to be useful, or believe to be beautiful,' William Morris advises. At the Priory of Orsan, that principle is expressed to its fullest extent – but in a garden rather than the home, in line with the precepts of early monastic garden design. Far from being archaic and irrelevant, its tenets of practicality, visual pleasure and the spatial representation of spiritual quest translate beautifully into the modern world and bring visitors a sense of peace, pleasure and harmony that transcends any one religion.

Orsan's gardens occupy a rural site in the agricultural province of Berry, a limestone plateau circumscribed by a lazy loop of the young Loire – not coincidentally. The priory is a couple of hundred kilometres (125 miles) upriver from Fontevraud Abbey (see page 104), in the heartland of the more mature Loire Valley; Orsan was founded in 1107 as one of its satellites. Fontevraud was no ordinary abbey but the crucible for the radical ideas of Robert d'Arbrissel, a charismatic hermit, penitent and itinerant preacher who established the principle of women-only orders led by an abbess, living alongside a separate contingent of male priests, there to facilitate the women's spiritual needs. D'Arbrissel is recognized as laying the ground for the proliferation of convents, where not only could the abbesses become significantly powerful, but women excluded from the secular male establishment could flourish and develop their skills, gardening and herbalism included. Fontevraud was envisaged as an 'ideal city', and included people of all social backgrounds. Orsan, made in its image, is not only a spiritual site but a political one, too.

D'Arbrissel established the Orsan priory with the intention that it would foster the Christian message in Berry, and his last wish ensured that this mission would continue after his death there in 1116. His body was solemnly transported downriver to Fontevraud, but his heart was preserved as a relic in Orsan's church, where it is said to have brought about many miracles. Today's garden commemorates D'Arbrissel by

Top right: Heart motifs reference the heart of Robert d'Arbrissel, a charismatic hermit, penitent and itinerant preacher whose heart was preserved as a relic in Orsan's church.

Bottom right: Unexpected sightlines create a playful air in the garden's design.

building heart motifs into its design: a chair back, the shape of a plant and, perhaps most beautifully, a campsis vine trained into the outline of a heart on the building's old stone, trailing red flowers like drops of blood.

The original priory lasted nearly 500 years, until it was destroyed in France's religious wars; the French Revolution put an end to the religious function of its replacement and several of its buildings were destroyed. Orsan's modern-day story began in 1991, when the property, by then a run-down farm, was bought and restored by two Parisian architects, Patrice Taravella and Sonia Lesot. No plans existed of the former gardens, so the pair reconceived the concept of monastic gardens to borrow from the past while gently grafting on a more modern sensibility. The design evolved organically – the garden started off with a simple shady tree for a hot day – but was soon informed by visits to contemporary religious houses and medieval manuscripts and tapestries.

The gardens are laid out geometrically, the different areas forming a grid defined by yew and hornbeam hedges and shaded walkways. This is typical of medieval gardens, meant not only to be functional but beautiful in their order and simplicity. In a spiritual context they invite contemplation, with the separate garden 'rooms' representing the labyrinthine route to salvation. Orsan's design throws in some playful spins on this by including blind alleys, secret arbours, unexpected sightlines, topiary walls, windows and doors, and peepholes presenting, perhaps, a surprising glimpse of a bay tree in a garden beyond. The creators' architectural background is evident in this evolution of 'green architecture', as they called it.

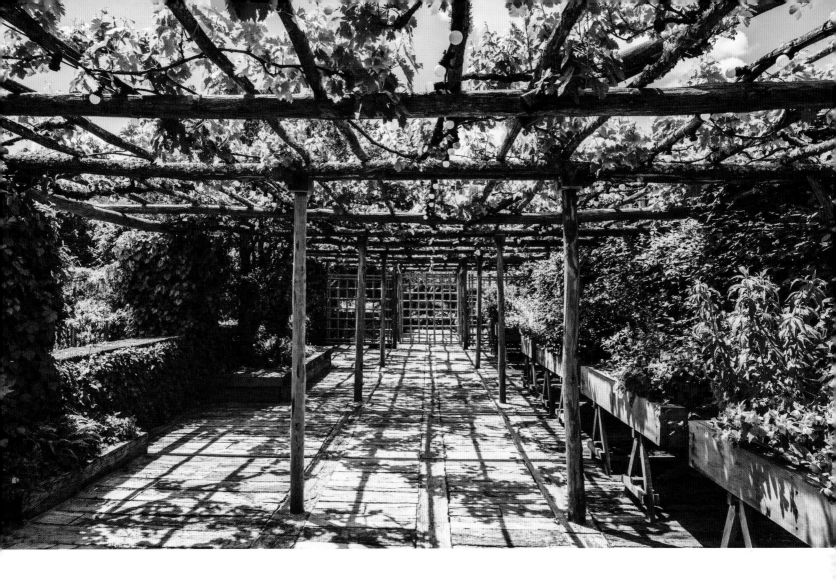

The rectilinear design also facilitates the incorporation of the cross motif, another monastic style. This is seen most notably in the four square beds surrounding a stone fountain (symbolic of the four rivers of paradise), lined by hedged galleries, which sketch the footprint of the priory's original cloister, long lost. The plantings change, but there are currently lawns, shrubs and vines. Mixed cultivation is characteristic of medieval gardens, and common here (there's a bed of wheat set in a lawn), the concepts of farm and garden being inextricable and co-planting conducive to pest control. Some of the same design principles can be seen in the gardens of Mont Saint-Michel, much smaller but still in possession of the original cloisters.

The gardens have a dozen or so sections, including two 'potagers' (kitchen gardens), a simple labyrinth planted as an apple orchard and carpeted with bulbs in spring, a physic garden, 'bocage' pasture dotted with oaks, and a flower meadow on the perimeter. The beautiful Jardin de Marie collects together rose varieties dating from the Middle Ages, traditionally cultivated for the decoration of sacristies, all in white and grown in a traditional *hortus conclusus* enclosed garden: impenetrable, to symbolize virginity, as depicted in Christian art.

The structures of the garden are as interesting and considered as their layout, with a wide range of supports and recreational elements incorporating wood,

Above: Structures in the garden incorporate wood, dead plants and roof tiles, reflecting its reuse and recycle ethos.

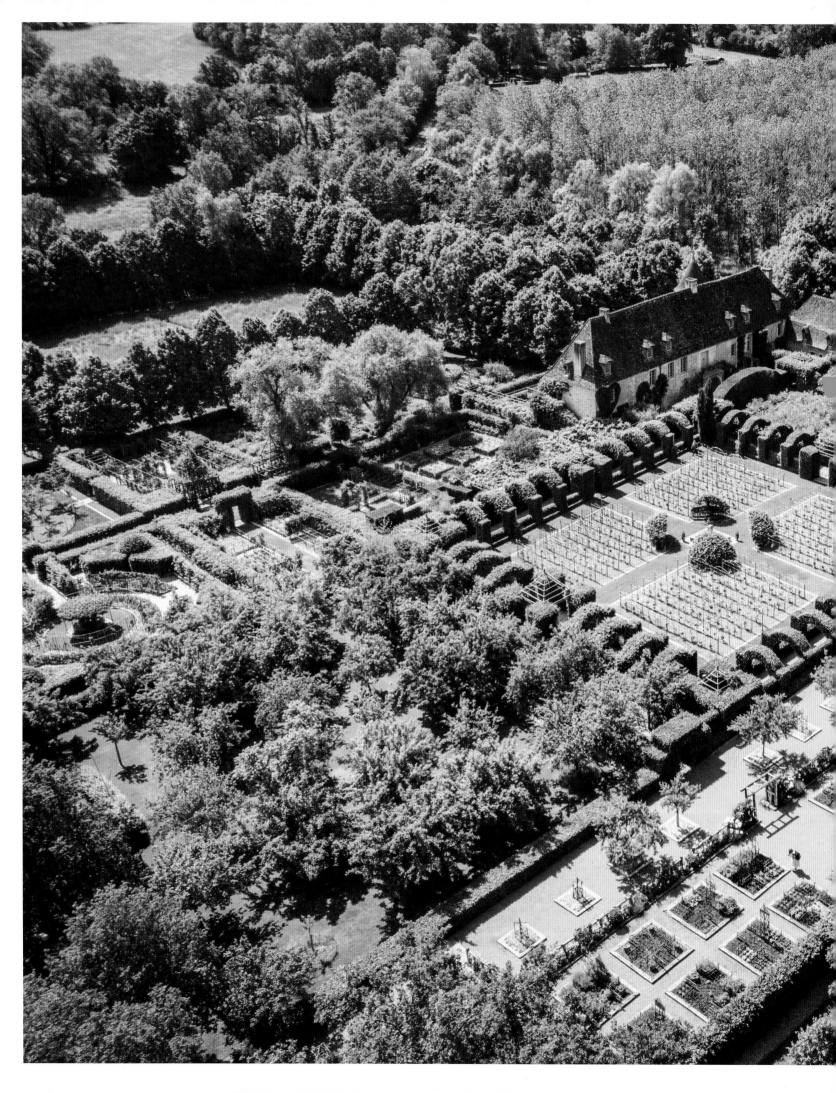

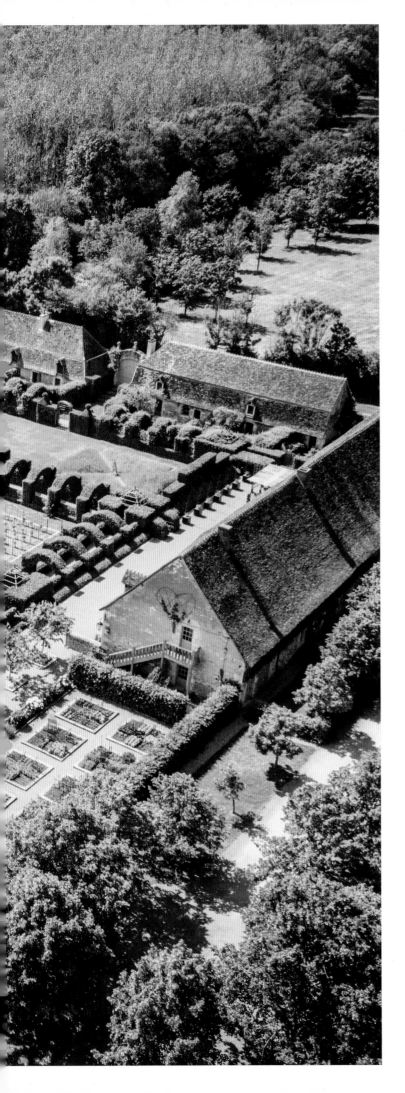

dead plants and roof tiles from the garden in an aesthetic that both reflects monastic practice and chimes with today's ethos of reuse and recycling, bringing with it a certain contemporary 'brocante chic'.

Orsan's plantings change and evolve, but they typically draw on the plants, herbs and vegetables of the medieval period, many of them – aniseed, lovage, poppy, gourd, leek – found on the list of ninety trees and plants that Charlemagne recommended for cultivation in his empire. All are chosen for a reason, whether edible, medicinal or symbolic (daffodils to represent the resurrection, daisies for humility, the white Madonna lily). The Royal Horticultural Society singles out, among others, agapanthus, alliums, dahlias and magnolias; there are collections of hostas, heathers, hellebores and mint (100 varieties and counting); thistle and lavender beds; quinces and currants; and a selection of *jolie-laide* vegetables such as 'red warty thing' pumpkins (yes, that is their official name) and frilly chard.

The current owners, Gareth Casey, the British fashion designer, and local Frenchman Cyrille Pearon, have adopted a policy of social and environmental responsibility (in line with D'Arbrissel's 'ideal city'). They have discontinued the use of pesticides and brought in new eco-friendly techniques such as minimizing mowing and pruning. In addition, they see the garden as educational, encouraging conversation between staff and visitors and labelling many of the plants with pretty slate markers. There are workshops on techniques such as basketwork, rose care and natural vegetable gardening. As a result, the gardens feel newly relevant and are becoming popular among a younger audience.

Left: Four square beds surrounding a stone fountain (symbolic of the four rivers of paradise) are one example of the cross motif used throughout the garden. The bounding hedged galleries sketch the footprint of the priory's original cloister.

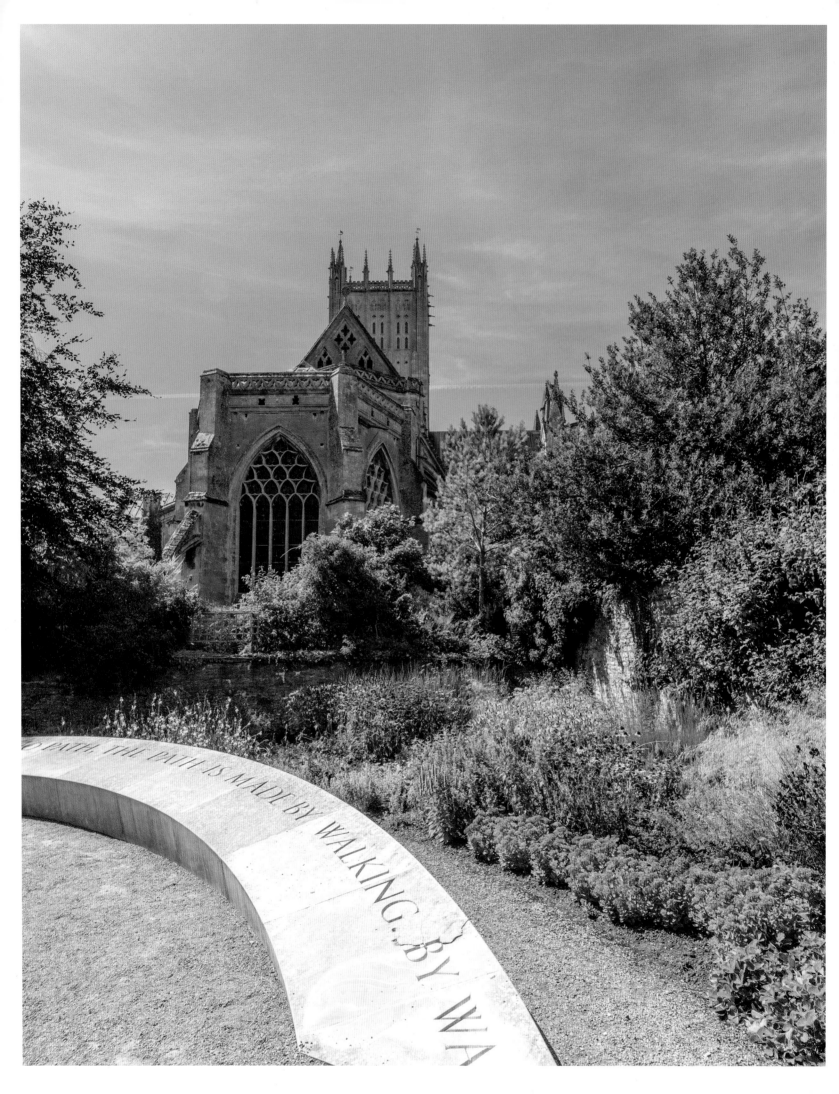

The Bishop's Palace Gardens

Somerset, UK

Medieval Wells is one of those cities – and it is a city, despite its tiny size and petite population of some 10,000 souls – that international visitors imagine all of England to look like. Lying picturesquely at the foot of the Mendip Hills, its pretty cobbled streets and market square are dominated by the impressive cathedral, which everyone gravitates towards as though being pulled by some supernatural force. If you visit, don't resist that pull, for it's a spectacular building, beautifully complemented by the nearby Bishop's Palace, whose five diverse gardens and arboretum combine to create a very special garden.

Evidence suggests that gardens here actually predate the palace, which was built adjacent to the cathedral from 1210 and has been the home of the Bishops of the Diocese of Bath and Wells ever since, with many of those bishops having altered and added to the 5.5 hectares (13½ acres) of planting to create what we see 800 years on. The first known gardens are thought to have been a medieval deer park surrounding the palace, and 'The Camery', planted with orchards, a herbarium and kitchen gardens providing food for the Bishop and staff, all nourished by the adjacent springs, or wells, from which the city takes its name.

Over subsequent centuries different gardens came and went, as cathedrals, cloisters and bishops' dwellings were erected, torn down, rebuilt and remodelled, and different bishops reshaped planting and design in line with prevailing fashions. What the Bishop's Palace gardens offer now is drawn largely from the last few centuries, in particular the nineteenth-century work of Bishop George Henry Law, and much of the landscaping is taken up with secular concerns such as a croquet lawn, wedding spaces and film location spaces. But the presence of the palace, wells and nearby cathedral still create a space that

Opposite: The Garden of Reflection, whose sweeping 12-metre (39-foot)-long curved stone bench is carved with an inscription on the nature of wandering, taken from *Campos de Castilla* by Spanish poet and playwright Antonio Machado.

has something for all-comers, with the latter a constant reminder of the gardens' religious heritage.

Law's work is seen at its purest in the South Lawn. Here, taking inspiration from old Victorian prints and the ruins of the great hall built by Bishop Robert Burnell between 1275 and 1292, the Bishop set a mix of beds and borders across wide open lawns dotted with specimen trees and shrubs – among them mulberry, Indian bean trees, black walnut, Lebanon cedar and ginkgo – then added climbers to create a space which, surrounded and sheltered by the ramparts, is perfect for strolling and even picnicking.

Law was instrumental in creating what, for many, is the most spiritual of the gardens. Found across the moat on the far side of the East Garden, the Wells Garden is a peaceful mix of lawns, borders and pools filled with the water of the springs. Strolling among these

spaces, their lush, rich mix of planting determined by the moisture of the ever-present waters of St Andrew's Well, where if you peer down you can glimpse the bubbles from the spring emerging at the base of the pool, is serenity itself.

The East Garden contains its own spiritual echo in the form of a row of Irish yews planted in a modern parterre that replaces a nineteenth-century one which contained twelve Apostle yews. The delicate scent of roses, bright dahlia beds and riotous colour of hardy perennials flowering through summer into autumn make this sensual space joyful. But they also create a fascinating contrast with the new knot garden, created in 2019 and loosely reflecting a planting style of the seventeenth century, focused on grasses and traditional and medicinal plants like sage, lavender and santolina.

Beyond the pools lies the equally modern but more formal Garden of

Bottom left: The ruins of the Great Hall.

Bottom right: Specimen trees sit in wide lawns.

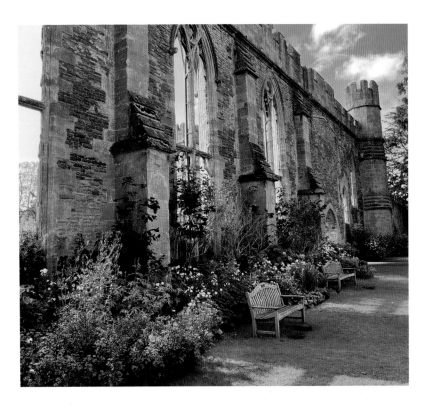

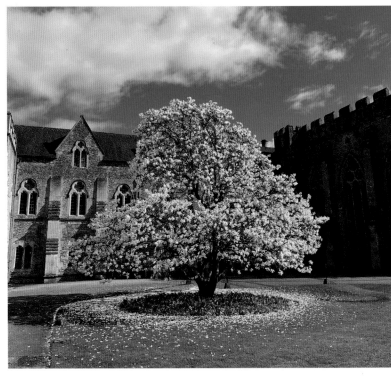

Reflection, opened in 2013. Grasses and perennials viewed from the gently curving 12-metre (39-foot)-long stone bench create a strong sense of tranquillity, but it's the glade of eighty-five silver birches underplanted with wildflowers that your eye keeps coming back to – that, and the arresting views of the cathedral.

It would be easy to overlook the garden furthest from the palace, but in spring and autumn, when nature's cycle of life and death is at its most visible, the colour, scents, sounds and sculptural forms of the arboretum come into their own. Created in 1977 to commemorate Queen Elizabeth II's Silver Jubilee, the arboretum's recent focus on wildflower planting creates a carpet of delicate colour, particularly in spring, when snowdrops, primroses, bluebells and violets burst through the seemingly dormant soil.

The mix of these differing gardens alone would make the Bishop's Palace a wonderful site. Add the impact of the constantly glimpsed cathedral, an ever-present reminder of the site's religious importance, and the experience is genuinely moving. Though the best view of the cathedral is found by not looking up, but down, into Bishop Law's pool, created in the 1830s. On a still day, the mirrored reflection of the cathedral in the water is utter perfection.

Above: The East Garden, whose parterre features the original urn dating from the former parterre laid out in the mid-1800s.

Pages 62–3: Bishop Law's Wells pool, created in the 1830s.

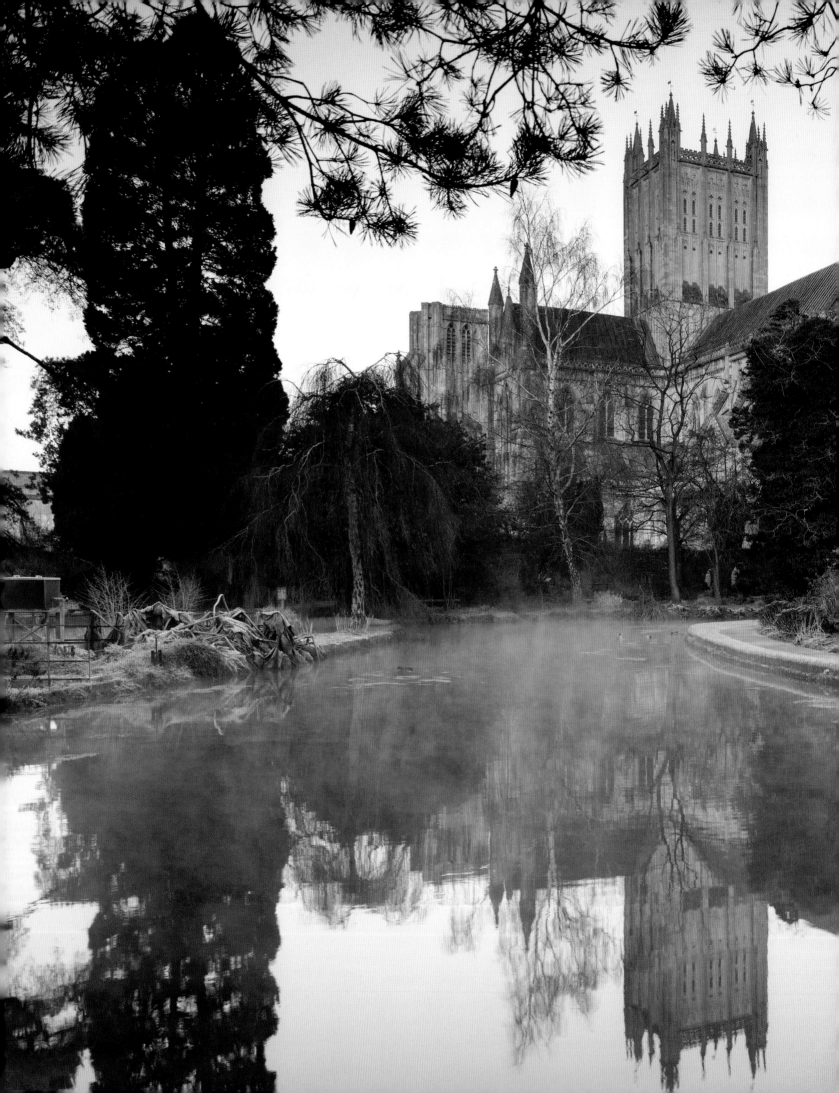

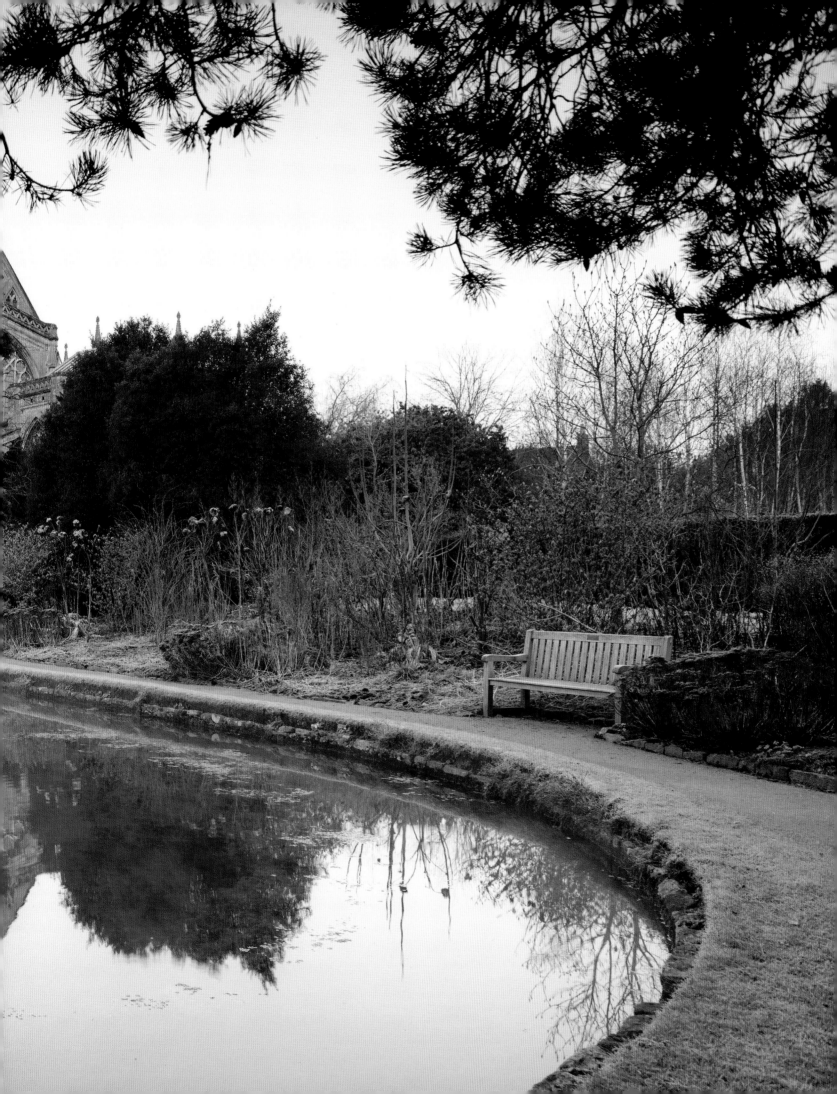

Marburg Garden of Remembrance

Hesse, Germany

Personal memorial gardens have been with us for centuries. Across the world, bereft parents, spouses, offspring and lovers have immortalized their dearly departed with contemplative spaces for reflection and remembering – perhaps the most famous example being the gardens of the Taj Mahal, built in 1631. And many cemeteries have memorials to fallen soldiers and gardens of remembrance.

But it's only in the last century that remembrance gardens and parks memorializing tragic events and atrocities have become part of our landscapes, notably in the USA, Ukraine and Japan, where gardens at Ground Zero in New York, the Contamination Zone at Chernobyl, and the Hiroshima Peace Memorial Park respectively act as stark markers and reminders of earth-shattering events whose victims demand to be remembered not just in history, but in the very earth itself.

One such garden, in the German town of Marburg, north of Frankfurt, does this with serene grace in an understated elegy to the millions of European Jews murdered by the Nazi regime. It is built on the spot where, on the night of 9 November 1938, the town's synagogue was destroyed as part of a monstrous act that would come to be known as *Kristallnacht*, or the Night of Broken Glass, after the shards of broken glass that littered thousands of streets through Germany and Austria the following day.

Along with 266 others, Marburg's synagogue was razed to the ground, its ruins covered with soil and grass as the decades passed, with just a small stone memorial placed on the site in 1963. Then, in 2009, the town held a competition to turn the site into a more meaningful memorial space. Düsseldorf-based landscape architects Scape, working with artists Oliver Gather and Christian Ahlborn, won, and in

Opposite: Integral to the memorial garden are hundreds of red rose bushes, the only flower permitted within the city walls of ancient Jerusalem.

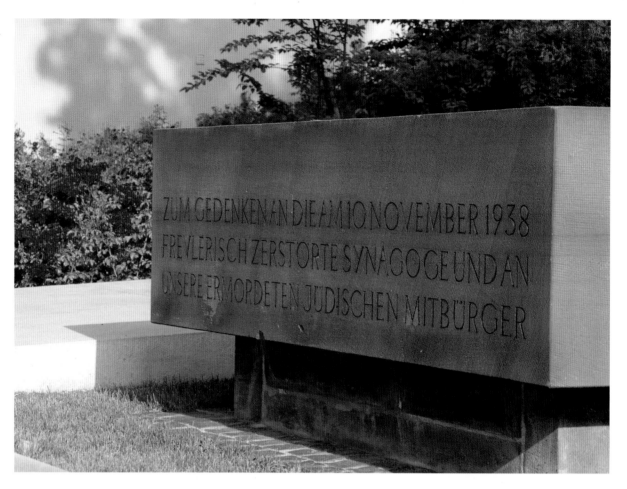

Right: A simple commemorative stone in the corner of the garden marks the date of the synagogue's destruction.

Below: The quadrangle's shape marks the former assembly hall of the synagogue.

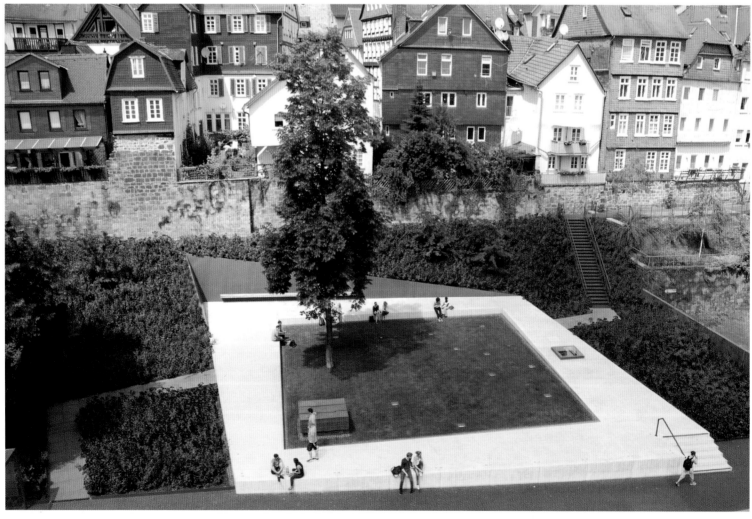

2012 set about creating a Garden of Remembrance whose make-up would implant the event it memorialized firmly and emotionally in the town's landscape, but also be a relevant and accessible space for Marburg's twenty-first-century citizens. Among the materials used would be glass, but other sombre and austere elements such as stone, steel and concrete would be utilized too, notably in creating different levels around an angular concrete frame whose jagged form would allude to the very shards of glass *Kristallnacht* is named for.

But Scape's winning space was not going to be a mini version of Peter Eisenman's dark Holocaust Memorial in Berlin, for bordering the concrete frame on three sides would be hundreds of bushes bearing riotous red roses, the only flower permitted within the city walls of ancient Jerusalem. Here, they would act as an arresting and joyful counterpoint to the stark frame and plain green lawn contained within it.

Ten years on from its completion, the garden teems with life. People sit on the concrete frame or the grass of the quadrangle, shaped to mark the former assembly hall of the synagogue, or kneel on the grass to gaze into ten embedded glass cases containing personal memories of the Marburg townsfolk, some old, some new. As components of the art project Zettelkasten, they are designed to create a continuous and ongoing dialogue with the community through frequent changing of the quotes, one of which simply reads: 'I can still remember the path well, past the town hall and then down the steps to

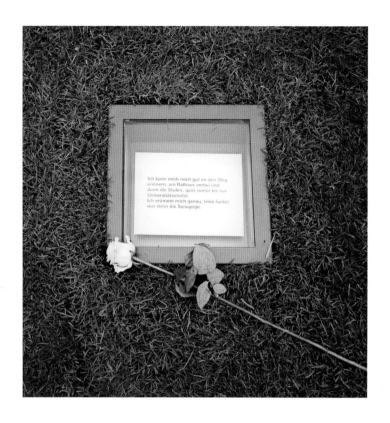

Universitätsstraße. I remember exactly, down on the left was the synagogue.' A larger glass panel, set into the concrete frame, offers a glimpse of the well-preserved remains of the synagogue's recently excavated *mikveh*, or ritual bath.

Through its design and art, the memorial garden clearly and eloquently marks an absence, both literally in the empty frame and metaphorically through the quotes and ghostly echoes visible beneath one's feet. But thanks to the planting and updating of the quotes, it is filled with renewal and hope, making it a vibrant, powerful space that is successfully integrated into the life of Marburg's past, present and future community.

Above: Embedded in the grass, glass cases contain personal memories of the Marburg townsfolk.

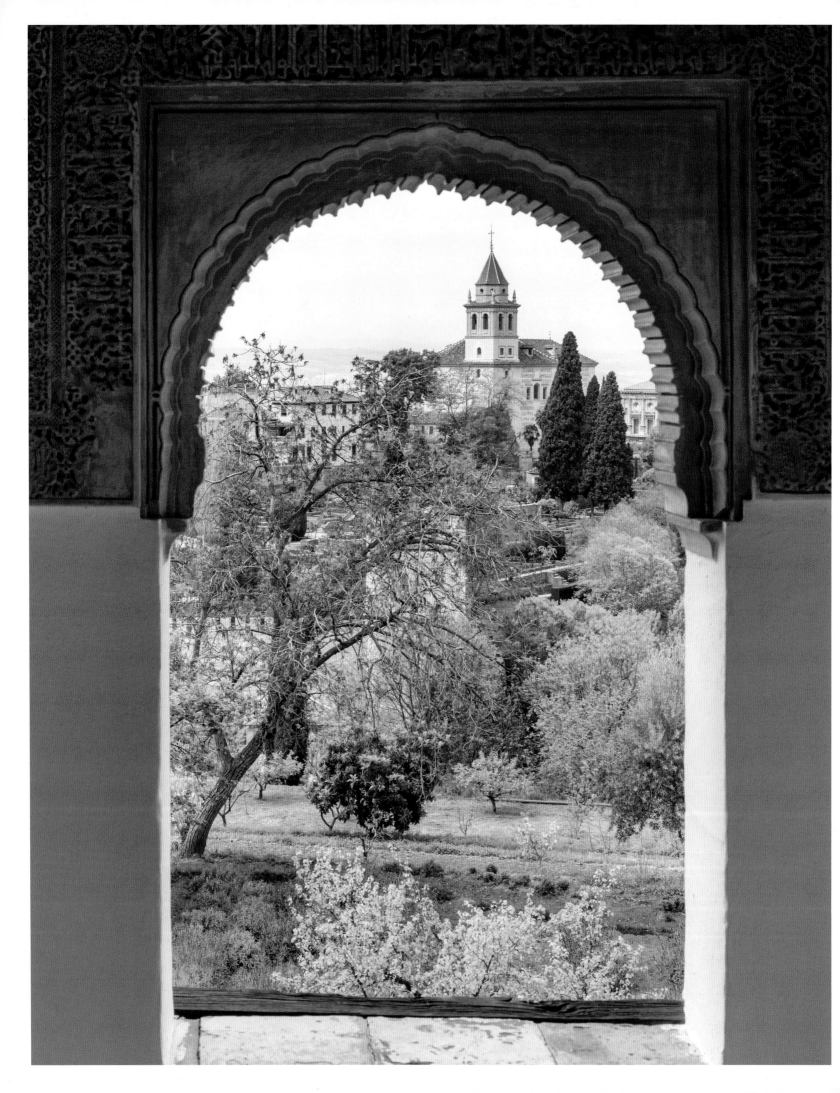

Alhambra

Andalusia, Spain

Perched high above the city of Granada, with the mountains of the Sierra Nevada as a backdrop, few gardens are more iconic than those of the Alhambra palaces. A legacy of the medieval days when Moors ruled Spain, the gardens of the Alhambra and Generalife palaces are considered some of the most inspiring and influential Hispano-Islamic gardens in the world. As places of tranquillity, contemplation and heavenly beauty, all of these gardens were designed to evoke the idea of paradise on Earth.

The gardens originated in the thirteenth century when the Nasrid rulers brought their knowledge of horticulture and experience of Roman engineering to the Sabika Hill and the neighbouring Cerra del Sol, the Hill of the Sun. The 'paradise garden' of the Middle East was reimagined here, creating not just one but many garden rooms.

When the Moors were driven out of Spain by Ferdinand and Isabella, the king and queen took over the palaces, and later the Holy Roman Emperor Charles V added his own palaces and gardens to the site. In the following centuries, the buildings fell into disarray and were used as prisons, hospitals and even to house cattle. It wasn't until the nineteenth century that the American writer Washington Irving, camping out in the Alhambra, argued for their restoration as a national monument. Today, the rambling complex of palaces and gardens has been renewed with some Victorian and twentieth-century additions, creating a mosaic of past and present Islamic and Hispanic traditions.

The original Moorish Nasrid palaces were surrounded by beautiful courtyard gardens, blending ornate architecture with the geometry of the Islamic garden designs. Across the ravine was created the Generalife Palace, a retreat for the Sultans from the court,

Opposite: View of the Alhambra from the Generalife gardens.

with its own stunning gardens. The name is thought to stem from Yanat-al-Arif, meaning 'the garden of the architect', a poetic reference to Allah, the creator, or architect of the world. The gardens, like all Islamic gardens, are suffused with this symbolism, with flowing water, lush vegetation and geometric patterns all representing the idealized concept of a heavenly garden.

Visiting the gardens begins with a towering army of cypresses that replaces the original stone wall and curves around the hill, leading you down to the palaces. Beyond this, the exploration of the gardens is a labyrinthine process, weaving in and out of the complex of palatial courtyards and up and down myriad terraces. Within the Nasrid palaces lies the famous Court of the Lions, with its stone fountain and rills of water dividing the floor following the Islamic *charbagh* principle of a quadrilateral garden layout based on the four gardens of paradise mentioned in the Qur'an. Beyond this lies the Court of the Myrtle, with its extensive pool and simple beauty of reflection. This leads on to the Jardín de los Adarves, the gardens of the mirador, bursting with magnolias, orange trees, rose bushes and palm trees, and, at the western end, a viewing platform giving amazing views over Granada. In the Patio de Lindaraja, the belvedere also gives a viewpoint across the valley. Here the Renaissance Spanish influence blends with the Islamic as the symmetry, clipped hedges and fountain feel at once both paradise garden and knot garden – certainly a peaceful retreat. Each palace has its own original gardens, so the Patio de Machuca is a part of the Renaissance

Right: Partal Palace and its gardens.

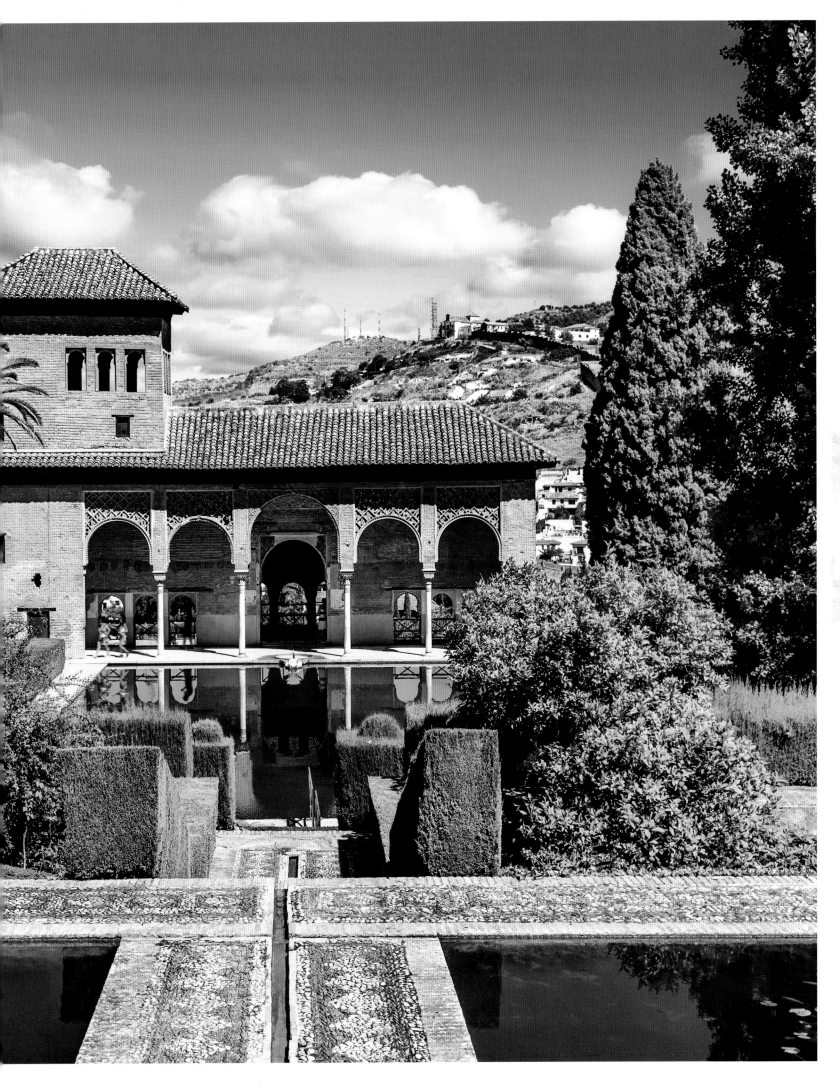

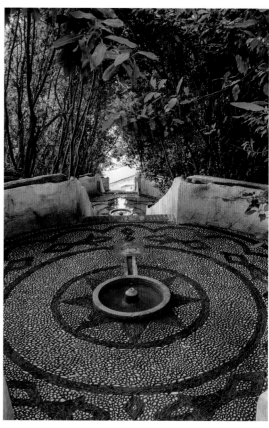

Above: The Generalife gardens.

Above right: The Escalera del Agua.

Mexuar complex, while its evergreen hedges and pools chime with its Moorish neighbours; the design incorporates a *nymphaea*, a Roman spring thought to encourage nymphs to dwell there.

Although every garden has its charms, the crowning glories of the Alhambra complex lie in the Generalife gardens. Water is a key feature of Islamic gardens, symbolizing creation, and it is everywhere here. An astonishing feat of medieval engineering, waterwheels, pumps and conduits transport water up the hill for fountains, channels, pools and rills. One unique achievement is the Escalera del Agua where three flights of stairs have a hand rail on each side down which a rill of water runs, a water channel runs beneath the centre of the steps, and a

small circular pool and fountain is found on each landing. The stairs are canopied by laurel trees to create a visually arresting spectacle, combining eloquently with the sensory impact of rippling streams and the shock of the icy water in the scorching Andalusian heat.

The Patio de la Acequia, or garden of the irrigation ditch, is one of the most enchanting gardens, a 40-metre (131-foot) pool with rows of arching water jets. It is flanked on either side by myrtle hedges, flower beds and colonnades, and filled with the scent of roses and jasmine. On the west side the arched windows give framed vignettes of the mountains.

Next to the Patio de la Acequia is the Jardin de la Sultana, another serene interior space with channels of water

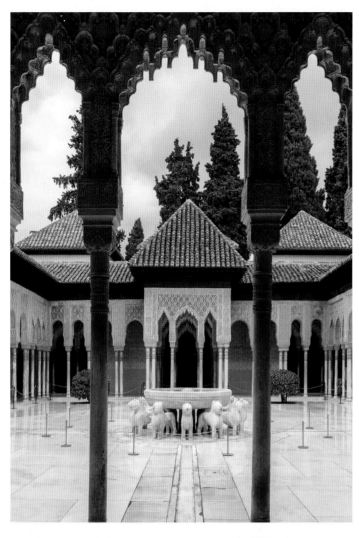

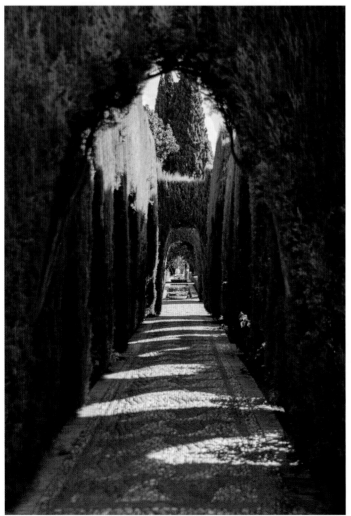

surrounding a platform with yet more water, square ponds and fountains. Everywhere the sound and sparkle of water droplets fills the air. In this garden, legend has it, Moryama, the wife of the last Sultan Boabdil, secretly met her lover in the shadow of the cypress. On hearing of this, Boabdil had the knight and many of his kinsmen slain, and the remnants of the cypress tree can still be seen in the garden today.

The more recent renovations of the Generalife's gardens, the lower and upper gardens, are sympathetically designed, retaining the pleasing symmetry, pruned evergreens and familiar planting, but they also reference the original uses of the gardens as orchards, herbal and vegetable gardens, and in between the clipped hedges there is looser, more modern planting, with roses, lavenders and rosemary. Fruit trees abound, almond, cherry, pomegranate and quince adding both beauty and usefulness.

The Alhambra dances between a sense of enclosure, with serene green rooms shutting out the world, and vast vantage points and dizzying vistas of the world below and beyond. Originally the Alhambra would have had all trees cleared from the hilltop to ensure clear sight of any enemy advance, but now dense woods surround the palaces, including English elms planted by the Duke of Wellington during the Peninsula War, when the British occupied Granada and parts of the palace were used as soldiers' barracks. In spring they're filled with the sound of nightingales, and year-round the gardens hover above the elms like a shining treasure amid the greenery, set, as the Moorish poets described them, like 'a pearl in a sea of emeralds'.

Top left: The Court of the Lions.

Bottom left: Clipped hedges create shaded paths.

Pages 74–5: The Patio de la Acequia.

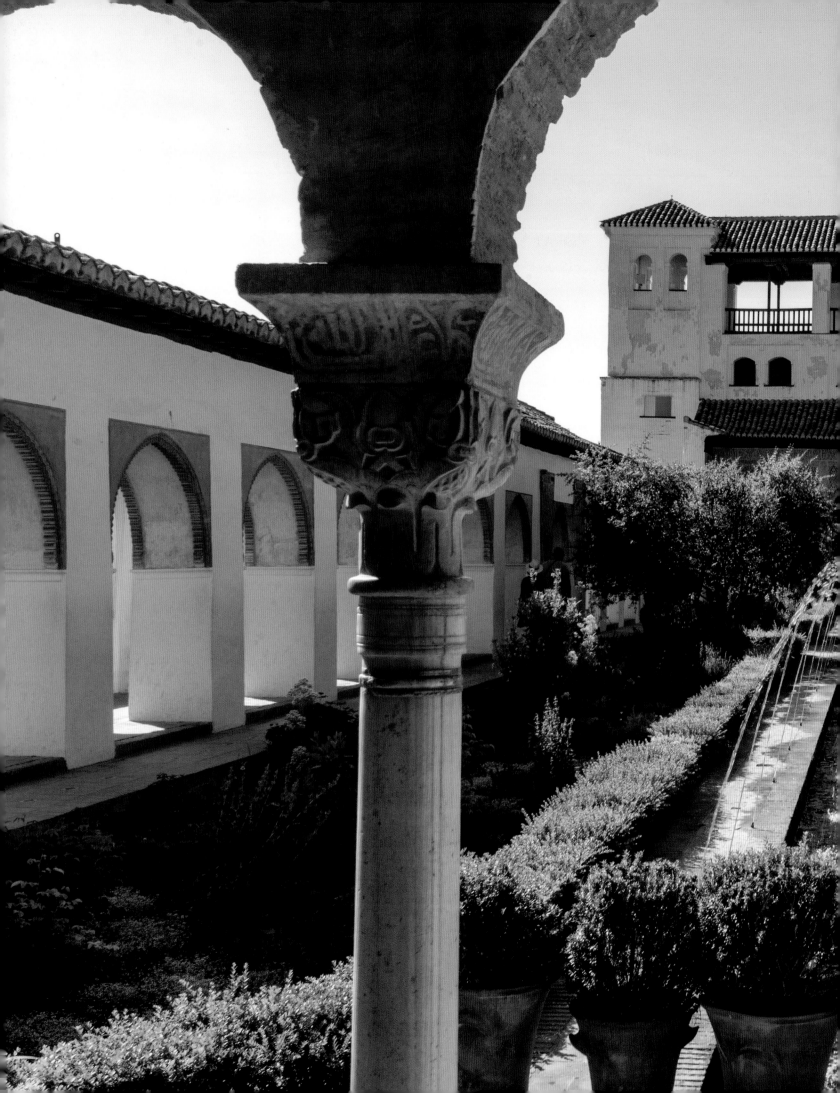

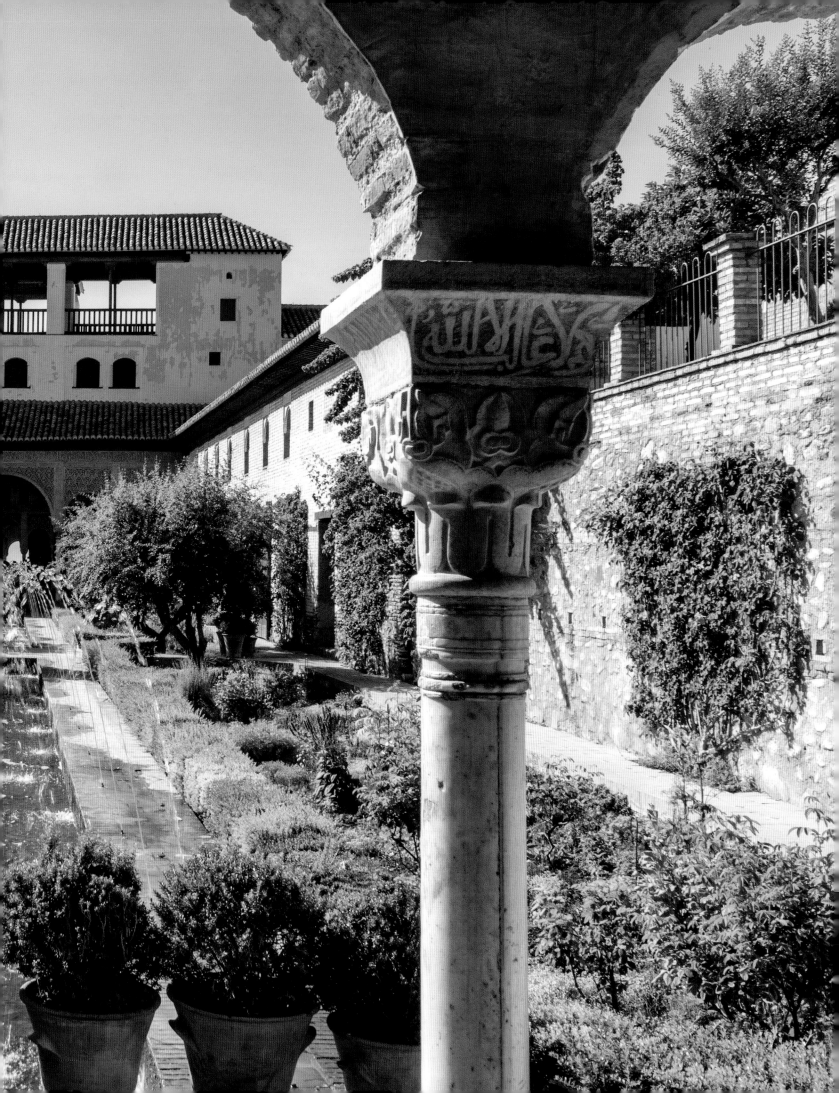

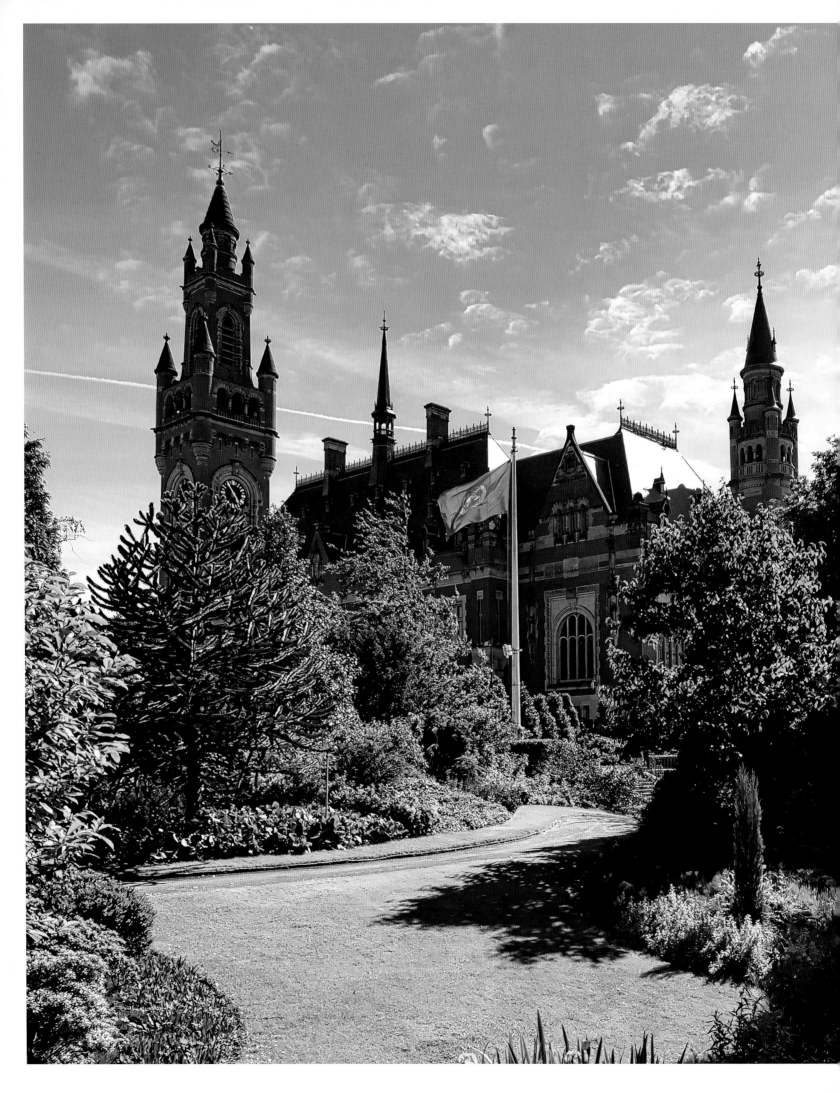

The Hague Peace Garden

The Hague, Netherlands

The garden as a symbol for peace may be an ancient idea, but it was the last century that prompted a proliferation of secular peace gardens that not only commemorate past conflicts but also seek to promote the ideal of a peaceful future across the globe.

One of the first and most notable of these gardens is in The Hague. In 1903 Andrew Carnegie funded the Peace Palace, housing the International Court of Justice and surrounding it with gardens. It would be easy to associate the International Court of Justice with retribution and the punishment of war crimes, but Carnegie was determined that the role of the palace was to be a 'temple of peace', and the gardens to reflect this. A competition to design the peace gardens was held and won by the somewhat unlikely figure of Thomas Mawson, a leader of the Arts and Crafts movement in England.

Built on the site of an existing palace and parkland, the original gardens incorporated the sand dunes that provided defence from the sea. Mawson redesigned the gardens to surround and reflect the majesty of the palace. By working organically with the existing Sorghvliet park, including a barrier of ancient and majestic trees, Mawson created a garden that is sheltered from the west by dunes and trees, giving feelings of security and serenity. He made forest walks that link the formality of the inner gardens with the natural world beyond and hark back to its former life as royal hunting grounds. Sweeping lawns draw the eye upward to the buildings, punctuated by typically Dutch swathes of tulips in season. The lawns and beds flanking the garden have a calming symmetry and formality, box hedges border geometric flower beds, and the brick of the buildings is mirrored in the brick terraces that surround them.

Left: Lawns flow into less formal gardens in Thomas Mawson's design.

Clearly ahead of his time, Mawson believed firmly in nature and humanity working together; the buildings connect effortlessly with the lawns, and these flow seamlessly into the less formal gardens, which merge in turn with the forest backdrop that keeps the gardens an oasis from the surrounding city. Beyond the terraces the garden divides, still with symmetry, into pathways, flights of steps and rills. Here, a quintessentially English Arts and Crafts style holds sway, providing more intimate spaces and views. The sand dunes are now undulating hillocks, providing shelter for tender species and vantage points giving vistas across the garden.

Water as a key condition of life is a fundamental element of the garden's underlying iconography. A natural water course was remodelled as a meandering stream, the Haagse beck, which is spanned by elegant bridges and feeds the central lily pond where golden carp languidly revolve. Another major feature is the Rosarium, a spectacular garden brimming with roses, signifying love. Everywhere symbolism abounds, but in an understated way. The symmetry of the paths and walkways is intended to represent equality and balance between nations and people. The *Nymphaea* water lilies in the pond symbolize purity and peace. Mawson decreed that plants should be thornless (apart from the roses) in a bid to create a gentler world, and trees and shrubs with small leaves were deliberately chosen to allow the light to filter through.

Throughout the gardens are carefully placed sculptures referencing the themes of peace and international cooperation. From the extraordinary Polar Bear Fountain from Denmark to the harrowing *Le Spectre de la Guerre* donated by Chile, they remind spectators of the horrors of war and the eternal vigilance needed for

peace to prevail. Most recently, the World Peace Flame and Pathway were unveiled, a simple flame housed in a column of stone, and a modest stone pathway with donations from 197 countries from around the world, including such poignant pieces as a part of the Berlin Wall, and a brick from Robben Island where Nelson Mandela was imprisoned. This reaching out across nations and borders seems integral to the spirit of the peace garden.

The powerful idea of a garden for peace has spread across the world but takes on many different forms. The International Peace Garden that straddles the Canada/US border (see page 32) is another extraordinary example of cooperation. In contrast, the Paleaku Gardens Peace Sanctuary of Hawaii combines cosmology and tropical verve. Claimed to be the world's first galaxy garden, the gardens incorporate a Native American medicine wheel, sand paintings, mazes and Hawaiian petroglyphs. Here, native ginger plants and heliconias, frangipani and lotus are a backdrop to individual shrines dedicated to all the major world religions.

Across the globe in Pakistan, the Taangh Peace Garden is a smaller community-inspired project led by activist Rubina Bhatti and inspired by Sufism, dedicated to promoting harmony, gender equality and human rights. The garden provides a safe space for reflection and for celebration, particularly for those marginalized or abused.

Moving from the grandiose to the eccentric, few peace gardens can rival the oddity of the one-man project that is the Temple of Tolerance in Ohio. Built by Jim Bowser as an ongoing project, part rock garden, part outsider art, several backyards are combined to create a temple complex that encourages people from all walks of life to come together, and has relics as diverse as Shawnee boundary posts and a countertop from a bank robbed by John Dillinger, stone dragons from Ireland and a Tree of Life built by kids from the local neighbourhood.

From the majestic to the downright quirky, the human desire for peace continues to drive us to create these spaces committed to a more tranquil world. In an increasingly global and interdependent society, the garden as a sanctuary and a place of hope and acceptance seems a positive response to hostility and conflict.

Below: A natural water course remodelled as the meandering stream, the Haagse beck.

Buckfast Abbey

Devon, UK

A simple and succinct line from the Bible's Psalm 114 connects visitors with Buckfast Abbey, an expansive abbey and working monastery set in a sheltered valley on the edge of Dartmoor National Park in the south-west of England: 'I will walk in the presence of the Lord.' It makes clear the degree of spirituality and faith that underpins every aspect of an abbey church and monastery originally founded in 1018 CE, it's thought by King Cnut. Almost a thousand years on, after a turbulent history of wealth, dissolution, ruin, demolition, use as a quarry and wool mill, and construction of a Gothic-style castellated mansion, in 1882 the site was purchased by a group of French Benedictine monks who refounded a monastery on it.

More than 140 years on, a much restored fourteenth-century tower is the only remaining part of the pre-Dissolution monastery, along with a small community of Roman Catholic Benedictine monks who still live their lives according to the ancient Rule of St Benedict, which revolves around the practices of prayer, work, study, hospitality and renewal. Everything they do, from beer-making and bee-keeping to community interaction and gardening, is centred around their faith and a set of tenets built on a tradition of monastic healing and care that dates from St Benedict's sixth-century text that emphasized hospitality, charity and care for the sick.

Buckfast's sense of hospitality extends to keeping half of its 14-hectare (34½-acre) garden open and free to the public as a collection of individual gardens, including lavender, sensory, physic and millennium gardens, all tended by an eight-strong team of gardeners who oversee a site partly modelled on medieval plans but also modernized by the Rathbone Partnership, which advises on landscaping.

Of the public gardens, it's Buckfast's Physic Garden that holds the most interest as a working monastic garden with a history stretching back centuries. A fine example of the apothecary garden first established in Europe's monastic institutions during the reign of

Emperor Charlemagne (r.800–14), it is integrally connected with the Benedictine Rule, with plants grown not only for healing but also food and clothing.

The original Early Middle Ages physic gardens contained a wide range of plants acknowledged today as having a wealth of beneficial properties – among them echinacea for boosting the immune system; peppermint to aid digestion and relieve headaches; chamomile for its anti-inflammatory and soothing properties; sage for its antibacterial properties and relief of sore throats; thyme as an antimicrobial herb used for respiratory issues; calendula for its skin-healing properties; yarrow for its astringent and anti-inflammatory properties; St John's Wort for depression and soothing; meadowsweet for stomach acid; comfrey for its anti-inflammatory properties and to promote the healing of wounds and bone injuries; rosemary for improving memory and concentration; and of course lavender for its calming properties. And many of these weren't used just as natural remedies; their uses stretched also to room scents, dyes and of course culinary ingredients.

It's a long list of plant names familiar to all for their beneficial properties, and many of them can still be found in Buckfast's Physic Garden, where the plants grown in four areas – medicinal,

Below: The garden's many spaces are overseen by an eight-strong team of gardeners.

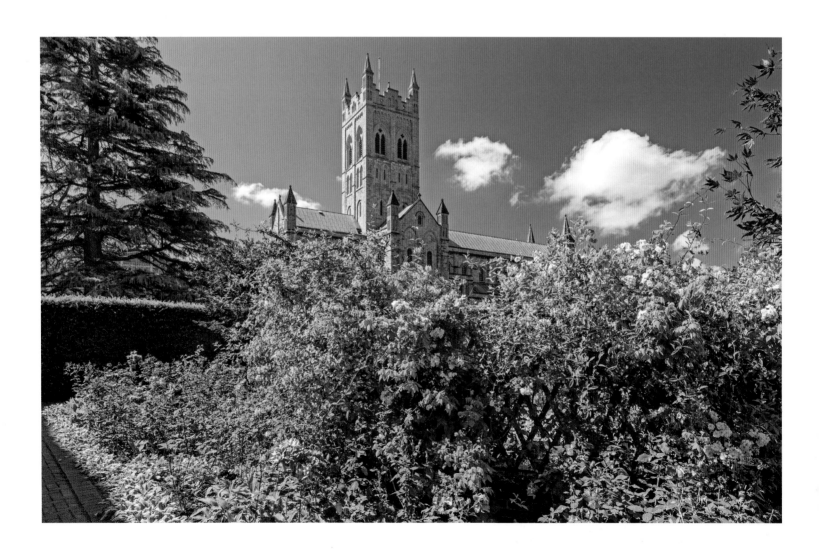

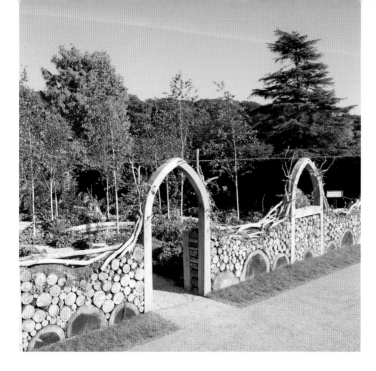

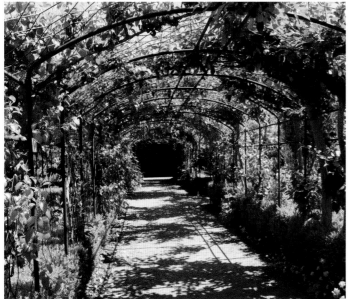

culinary, household and poisons – are used to ensure the wellbeing and healthcare of not only the monks themselves, but also their visitors, via lotions, teas and other products sold in the abbey's shop – including a fortified tonic wine, honey beeswax made by the monks, and other items made by religious communities around the world. The 'poisons', however, including monkshood (fatal if ingested) and lovage (which can cause kidney damage) are wisely confined to an island in the middle of a small pond. It all combines to create a beautiful garden, thanks in part to the low arched arbours that break down the four spaces. Acting as trellises, these are filled with vines and trees, including apple, fig, honeysuckle, medlar, pear and quince, pruned back hard to ensure plenty of flowers and fruits, but also to make those fruits easily accessible.

Beyond the Physic Garden, the 150 varieties of shades and colours on show in the gorgeous Lavender Garden are always popular, as is the Sensory Garden, designed to stimulate the senses of sight, smell, hearing and touch, and laid out with water features including a gently gurgling fountain emerging from a mill stone surrounded by numerous roses. The Millennium Garden, created to commemorate the 1,000 years since the abbey's founding, also has water at its heart, with its circular pond surrounded by hostas, foxgloves, ferns and other low planting, bound within a ring of silver and white Himalayan birch trees and hazel. The resulting colour combination of blue, white and silver makes the garden the very embodiment of tranquillity and harmony.

In all the gardens, local community involvement, environmental considerations (in this case conservation, recycling,

Top left: A boundary wall echoes the arches of the original abbey.

Centre left: Low arched arbours act as trellises filled with vines and trees.

Bottom left: The lavender garden, featuring 150 varieties.

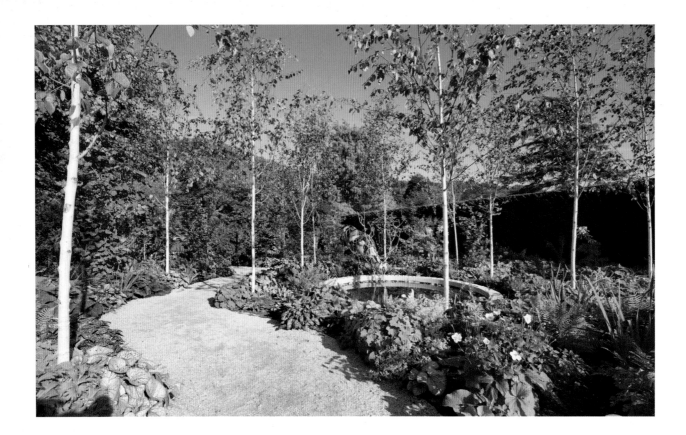

composting and improving green space) and good gardening practice mixed with creativity and innovation reflect practices that are centuries old, including bee-keeping. While there's no evidence to conclusively date the origins of bee-keeping at the abbey, it's likely that, in keeping with other medieval monasteries, bees were kept here before the Dissolution of the Monasteries as a valuable source of sugar and wax, as well as for medicinal purposes. But it was only after the refoundation of the monastery in 1882 that the custom was re-established, and some forty years later, at a request of the government, it played an integral part in replacing hundreds of bee colonies across Britain that had been wiped out by an epidemic. It did so under the care of a teenager, Brother Adam Kehrle, a German monk who had arrived at the Abbey in 1914, aged just twelve, and five years later created

a disease-resistant breed of honey bee, now known as the Buckfast bee. Kehrle continued to work with his bees at the abbey until 1990, aged ninety-three.

These days, Buckfast's bees are more teachers than producers, with the abbey's forty hives – some of which make up a community apiary – the focus of workshops, courses and honey bee experiences. But honey and beeswax do play their part in keeping the abbey self-supporting, along with a farm where vegetables are grown and livestock are kept, a gift shop, bookshop, restaurant and, of course, a plant shop curated to align with the garden themes at the abbey. For visitors who have faith, the sense of being in a sacred space, and possibly the 'presence of the Lord', is surely felt in this special garden; for everyone else, the sense of being in a space connected to the natural world and community is just as palpable.

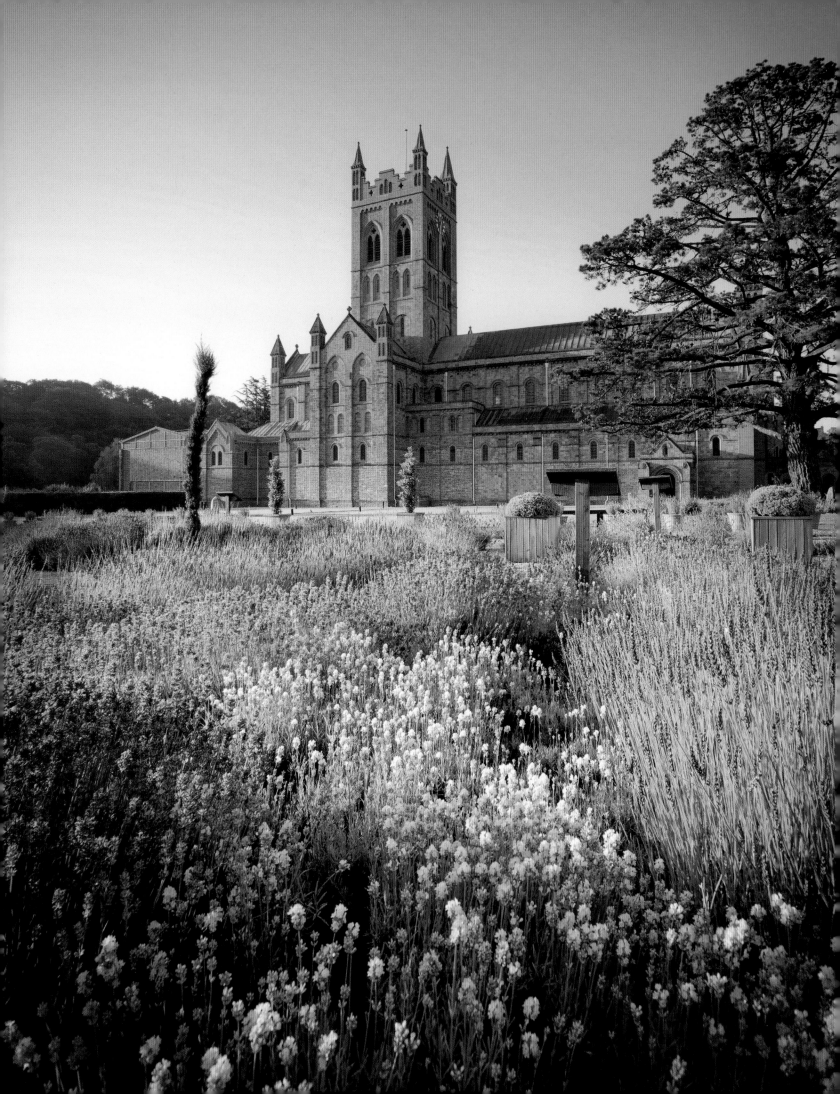

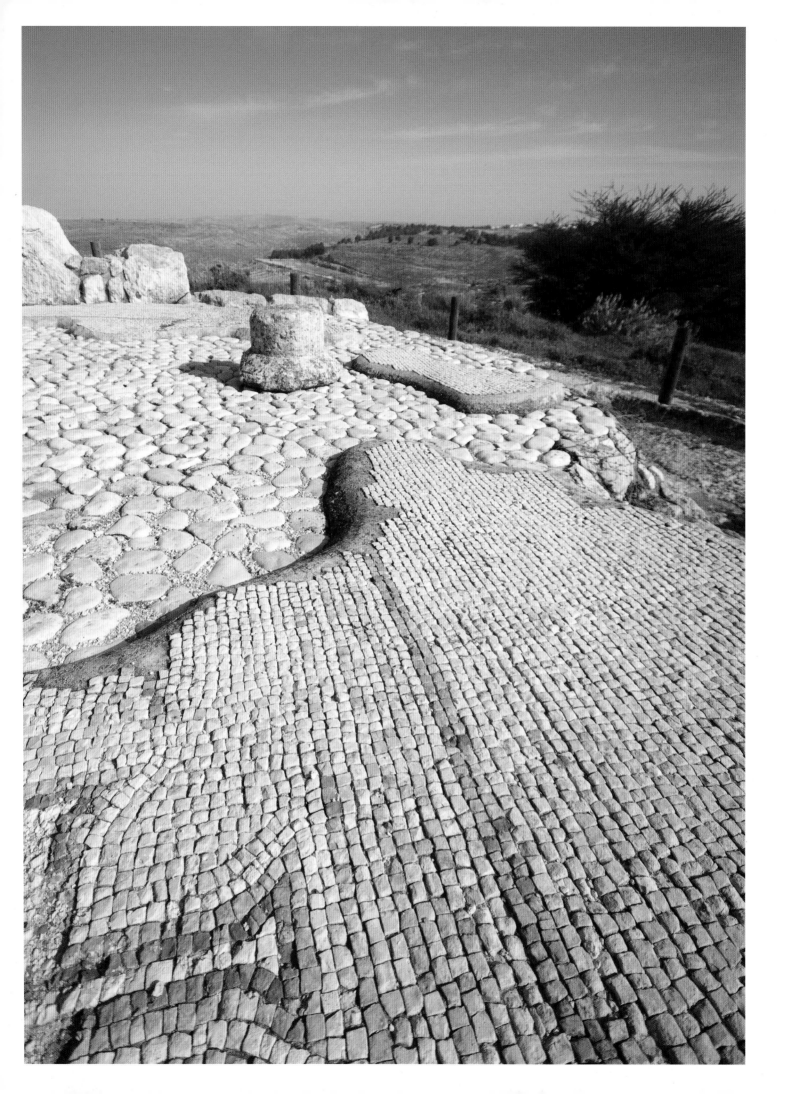

Neot Kedumim Biblical Landscape Reserve

Central District, Israel

One of the many types of biblical gardens to be found around the world has been covered elsewhere in this book (see page 36), but Israel's Neot Kedumim (Oasis of Antiquity) is a 253-hectare (625–acre) biblical landscape reserve which is completely unique – not least because its location makes it perfect for recreating the physical setting of the Bible, complete with the plants, shrubs and bushes that would have filled its landscape 3,000 years ago.

The origins of the reserve go back more than a hundred years to the 1920s, when Russian immigrants Dr Ephraim and Hannah Hareuveni arrived in Israel with a dream of building a place that, as their son Nogah would later put it, 'embodied the panorama and power of the landscapes that both shaped the values of the Bible and provided a rich vocabulary for expressing them'. Nogah's passion for the project echoed that of his parents, whose love of nature and the Bible led them to found the Biblical-Talmudic Botanical Museum at the Hebrew University in 1926. But while they were unable to realize the larger vision they had for a 'Garden of the Prophets and Sages', in 1964 Nogah was able to expand on this with the commencement of Neot Kedumim, a reserve made up of natural and agricultural landscapes filled with hundreds of biblical plants. The idea was to connect botany with the parables of the Bible and the prophets, an idea that had many supporters, including the then Israeli Prime Minister David Ben-Gurion, who allocated land near Modi'in, halfway between Jerusalem and Tel Aviv, for the project.

Nogah had his work cut out – the scrubby landscape was badly eroded and there was no running water, so thousands of tonnes of soil were brought in, reservoirs were dug to catch runoff rainwater, ancient terraces were restored, and hundreds of varieties of plants propagated and planted – including cedars (from Lebanese seedlings), almond trees and date palms from the Golan Heights, the coastal plain, the Negev Desert and

elsewhere. But Nogah and his parents' ideas went further than simply recreating the landscape of the Bible; they wanted to teach visitors who came to the reserve what life was actually like in ancient Israel, and so divided it into four different areas named for their textual sources – the Forest of Milk and Honey, the Dale of the Song of Songs, Isaiah's Vineyard, and the Fields of the Seven Species. The planting in all four is related to their specific texts from the Bible: for example, the seven species are drawn from Deuteronomy 8:8, where the Israelites are told the land they would enter would be filled with wheat, barley, grapevines, fig trees, pomegranates, olive oil and honey (from date palms). And across all four areas, Nogah and his team recreated ancient wine and olive presses, wells, cisterns, water wheels, ritual baths and even a threshing floor, offering experiential learning through hands-on demonstrations

and workshops showing how these would have operated and been used.

Being able to see and learn about these ancient agricultural and cultural practices – among them harvesting grain and olives, ploughing and sowing a field, shepherding, parchment preparation, olive pressing, pita baking, goat herding and tree planting – in such an authentic setting enriches the visitor experience profoundly, and it's even possible to have a biblical-themed lunch comprised only of ingredients that would have been available two to three millennia ago.

A particularly endearing aspect of the reserve is its inventive approach to education. The trail of the Torah-commanded holiday Sukkot, characterized by the erection of *sukkah* huts, is dotted with all manner of the huts made of branches: tall, short, adorned with a grapevine as a roof (*schach*), one

Below: Working elements include ancient wine and olive presses, wells, cisterns and water wheels.

atop another, and even, out on the lake, a *sukkah* on a boat being a great example.

It's these aspects of Neot Kedumim – the ability to learn and discover for oneself what the land and life on it was genuinely like, and the symbolism and significance to the Abrahamic faiths of plants and trees such as date palms, olive, almond, sycamore and oak trees, myrtle and caper bushes, sage and hyssop – that leave a lasting impression.

The botanic garden itself houses some 950 species of ancient Israel plants, wild plants and crops of traditional agriculture across fourteen themed gardens. Set along a route whose beginning is marked by the common caper bush, the series of imaginative thematic gardens includes a seasonal pool with a unique ecosystem of plants and animals; a garden divided into the twelve months of the year showing the annual flowering cycle of Israeli wild plants; a vegetable garden filled with the traditional vegetables and legumes of ancient Israel; a medicinal and herb garden; a space showing the ancient wheat varieties of the Land of Israel; a nectar plant garden and honey centre; and even a garden of wicks and oils. These are constantly being added to, with, at the time of writing, a beach garden, wild vineyard and garden of colours under construction.

Fifty years on from Nogah's realization of Neot Kedumim, the space is a well-organized tourist attraction that can be experienced as part of a group tour run by knowledgeable park guides, or as a self-guided tour, with map in hand and four trails to follow – including an accessible one – through the different sections of the park. Thanks to the guides and hundreds of signs along the trails featuring written verses and quotes from the Mishnah and Talmud, or Midrashim, answers to hundreds of questions from the sacred texts are to be found here, offering a rich experience for followers of Abrahamic religions, but also anyone interested in botanical history.

Above: The reserve is made up of natural and agricultural landscapes.

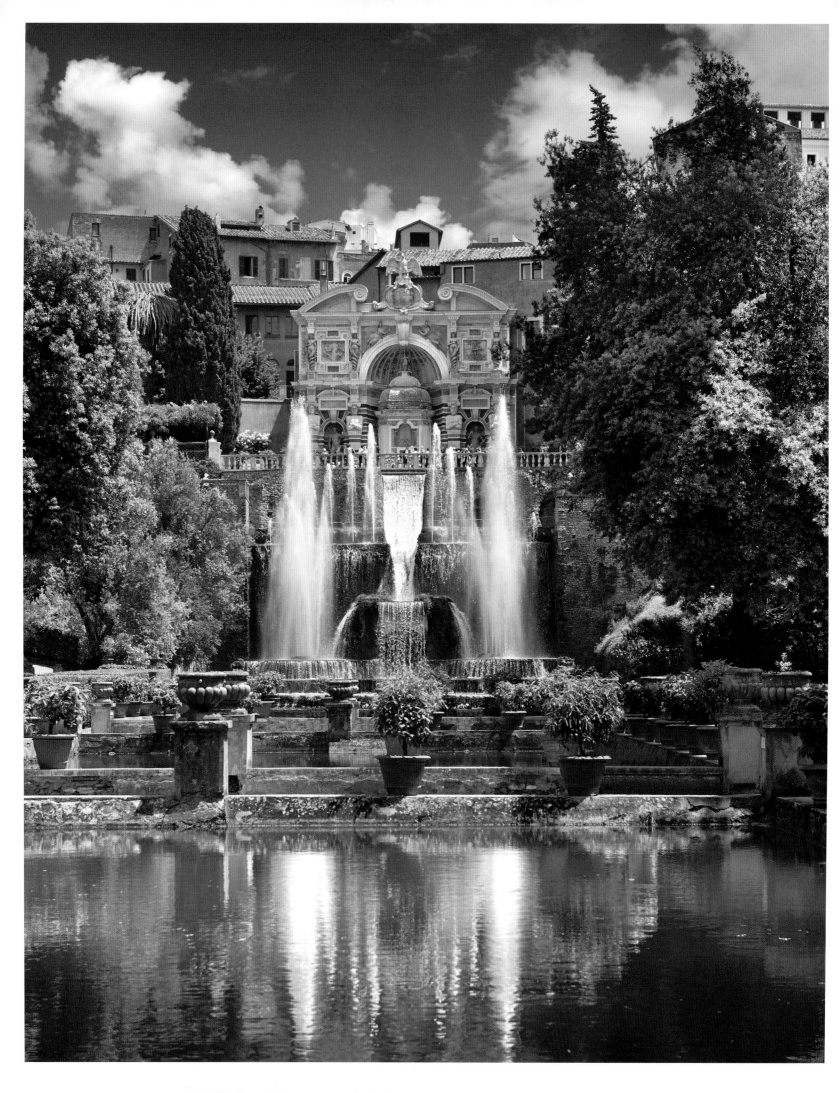

Villa d'Este

Lazio, Italy

I taly's Renaissance gardens – the likes of Villa Lante in Bagnaia, Palazzo Farnese in Rome, the Boboli Gardens in Florence, and Villa d'Este near Rome – may not feel like they have much of a relationship with the sacred, but make no mistake, these grand designs were built by their wealthy Catholic owners as manifestations of God's gift to mankind, as outlined in the Book of Genesis (1:26–31), in which He gives us dominion over the Earth and nature. Other elements from religion featured too, among them a secret garden symbolizing Heaven on Earth and, most arrestingly, the use of water as a representation of the four rivers of life, a symbolism which appears in many religions and belief systems.

Arguably the first Renaissance garden, the garden court of the Villa Belvedere was actually built by a Pope, Julius II. But it was the Villa d'Este that became the ideal that many subsequent gardens sought to emulate, a spectacular garden that remains justly lauded today. Its creators wove their magic with water, fashioning hundreds of water features, from jaunty spouts to majestic waterfalls, all staged in a steeply sloped, precisely planted terrace garden. In combination with the Sanctuary of Ercole Vincitore (second century BCE) and Villa Adriana (the villa of Emperor Hadrian, second century CE), it made the wider Tivoli region an essential stop on the Grand Tour, and the setting has inspired numerous artists, including Corot, Fragonard, Piranesi and Turner; Liszt too was enchanted by it, composing several piano pieces after visiting the estate. Today, unsurprisingly, it's a UNESCO World Heritage Site and one of Italy's most visited gardens.

The villa was built between 1550 and 1580 on what was originally a convent – today's courtyard is where the cloisters used to be – by Cardinal Ippolito II d'Este.

Opposite: The Fountain of Neptune below the Fountain of the Organ.

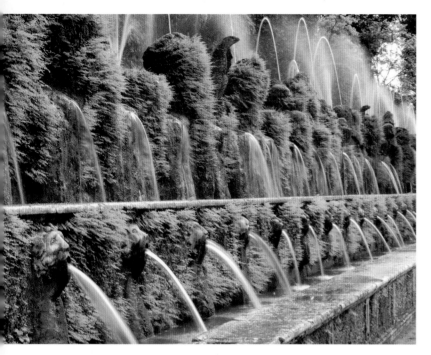

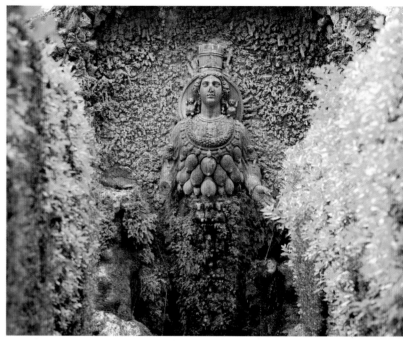

Above left: Hydraulic engineers created systems that relied on gravity, rather than pumps, to operate the famous *giochi d'acqua* (water tricks).

Above right: The Fountain of Diana of Ephesus, or Mother Nature.

Opposite (top): The Oval Fountain cascades from its egg-shaped basin into a pool set against a rustic *nymphaeum* (a grotto shrine dedicated to water nymphs).

Opposite (bottom): The precise geometry and handsome landscaping of the garden are intended to make the villa appear central.

Made Governor of Tivoli in 1550, he was set on a grand residence, and as he had the money to indulge his passion for the finer things in life, no effort or expense was spared. The ancient Villa Adriana nearby was plundered for its marble and statues, and the Aniene river was diverted to supply the 4.5-hectare (11-acre) estate. Renaissance all-rounder Pirro Ligorio was employed to transform the house and grounds, helped by an array of architects and artists. He also relied on the era's finest hydraulic engineers, who created systems that used gravity, rather than pumps, to operate the numerous water features, including the famous *giochi d'acqua*, or water tricks, such as the Fountain of the Owl, which uses water pressure to make a statue of a group of birds sing and fall silent when a nearby mechanical owl turns to look at them. Not surprisingly, the process took years, and the complex wasn't completely finished when the cardinal died in 1572. The estate had mixed fortunes in the intervening centuries, but was acquired by the Italian state after the First World War, and a major restoration began in 1922. Many of the more portable statues had disappeared or been sold by then – today, some of them can be seen in the Capitoline Museums in Rome.

As befits a Mannerist (late Renaissance) garden, there are gods, goddesses and classical references everywhere. The story of Rome is woven through the garden; most obviously at the Fountain of Rometta, which shows ancient Rome in miniature, but the overall symbolism can be seen in more subtle ways too. For example, the Hundred Fountains path represents the aqueducts that originally supplied water to Rome: a series of nearly 300 spouts, stacked in three channels, feeds the water down the rows.

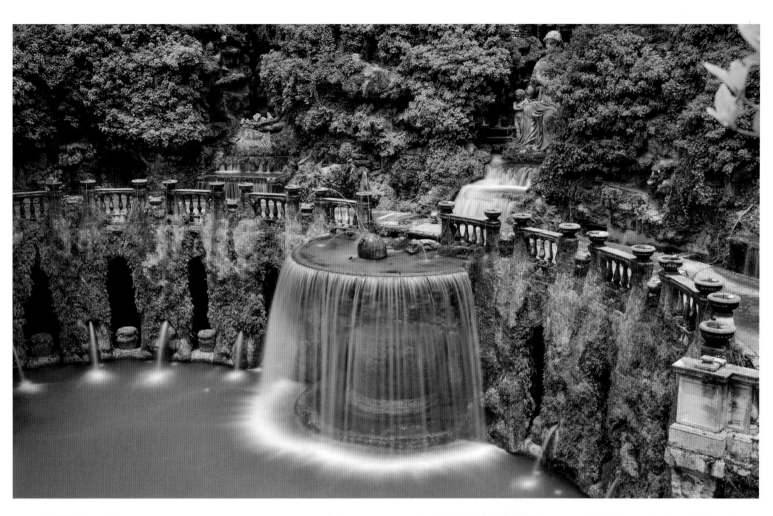

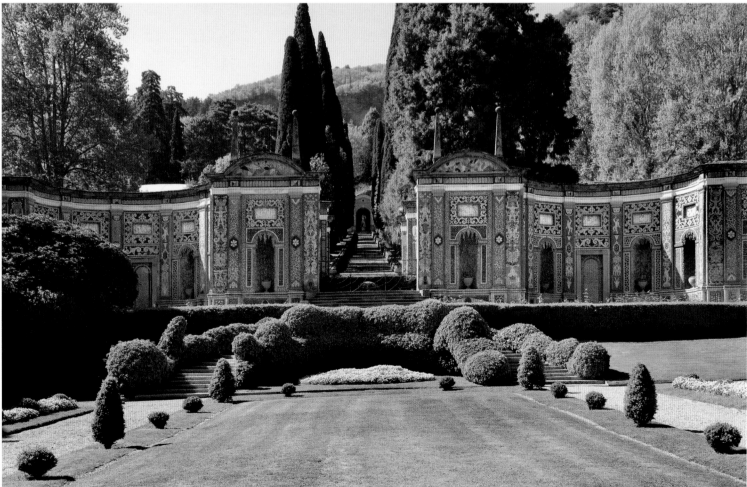

There is jasmine growing on the columns of the terrace porch, and two magnificent sweet osmanthus trees which blossom twice a year. Other plants include topiary hedges, bamboo, azaleas, camellias, oleanders, rhododendrons, hydrangeas, laurels, pittosporum and a variety of rose bushes, which adorn the railing of the lake terrace. The trees include chestnut, magnolia, wisteria, olive, palm, cypress, pine, holly, privet and medlar. Beds of spring daffodils and pansies are replaced in summer by begonias and impatiens. The water

staircase is adorned with cypresses and magnolias.

At the top of the garden is a long terrace, the Vialone, separating the richly decorated house from the garden, and offering a panoramic view of the gardens and the countryside beyond. Steep slopes cut with steps and pathways lead down from the villa through an amphitheatre-shaped and handsomely landscaped space. The precise geometry of the garden is cleverly arranged to make the villa appear central. It's the extravagant water features that really impress,

Below: The Rometta Fountain, with its statue of Rome Victorious.

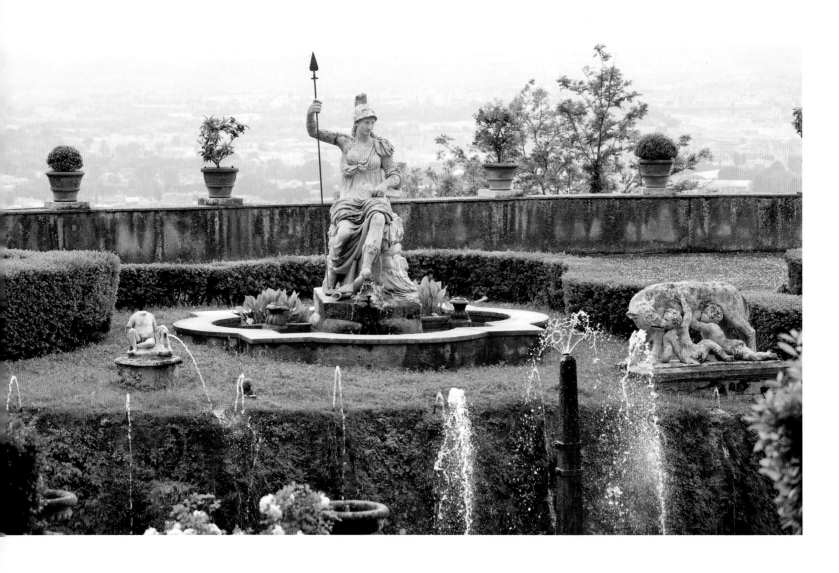

however: fountains, grottoes, waterfalls, pools and water jets are everywhere, and a particular pleasure in the heat of an Italian summer.

The theatricality of the gardens is nowhere better displayed than in the Oval Fountain, one of the first designed by Pirro Ligorio. Water is intended to captivate and entertain here, with spouts coming from all directions as well as from the main cascade, and falling into a giant ornamental basin. The fountain also has its own grotto, the Grotto of Venus, originally constructed as a respite from the sun. There are many grottoes in the garden – the Cardinal's Walk, a long terrace, holds several. In the centre, in the Loggia of Pandora is a *nymphaeum* (a grotto shrine dedicated to water nymphs); the original mosaics and statues of Pandora and Minerva are long gone, and in the nineteenth century it was converted into a Christian chapel.

Another aquatic delight is the Fountain of the Organ, designed by French engineer Luc Leclerc (who also designed the ingenious Fountain of the Owl). He was assisted by his nephew Claude Venard, who invented the organ mechanism, in which a complex water-powered process caused a series of pipes to open, allowing air through to produce the sound. The delicate structure deteriorated over the centuries, but painstaking restoration work brought the music back to life in 2003. These days, 144 pipes play four short pieces of late Renaissance music; it's enchanting today, and must have been mind-blowing in the late sixteenth century. Water from this fountain then pours into the Fountain of Neptune below, creating quite a spectacle.

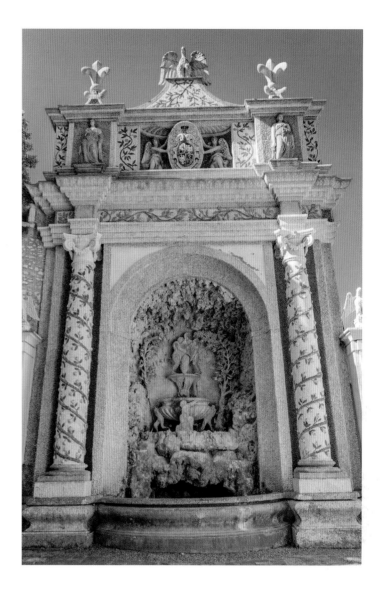

There are rivals to Villa d'Este for the accolade of greatest Renaissance garden – such as the influential but long-gone Belvedere courtyard garden in the Vatican, and the still-thriving Villa Lante in Bagnaia, which also employs grand water features to great effect – but this really is a garden like no other, a synthesis of setting, architecture and hydraulic engineering, woven through with classical allusion and mythic story-telling.

Above: Detail of the Fountain of the Owl.

Pages 96–7: The Fountain of the Tripod on the Vialone terrace, with views of the garden and Roman countryside beyond.

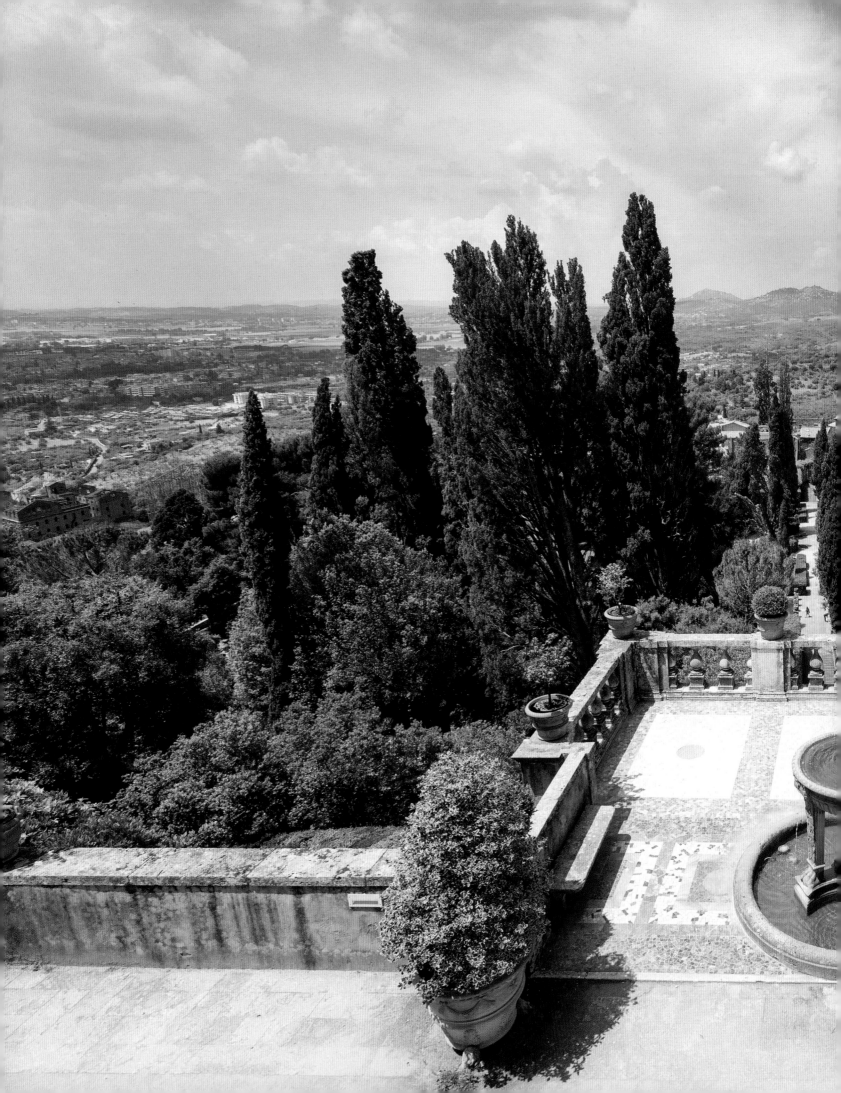

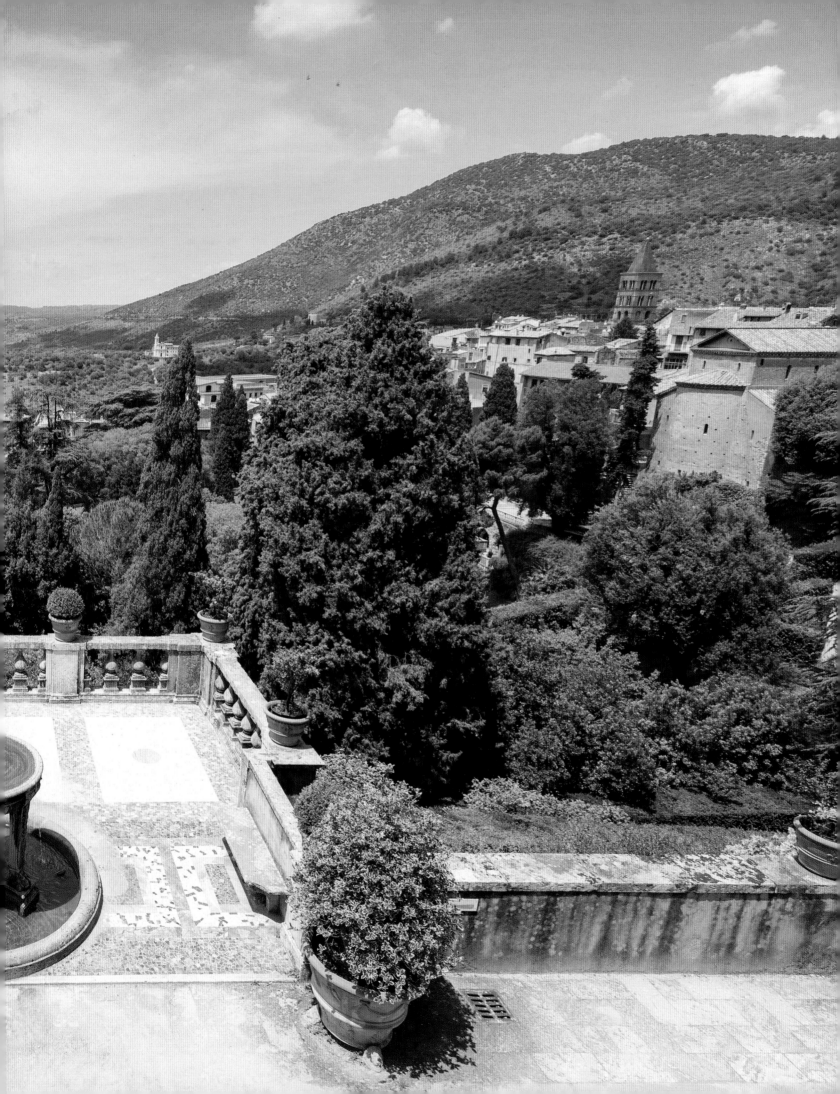

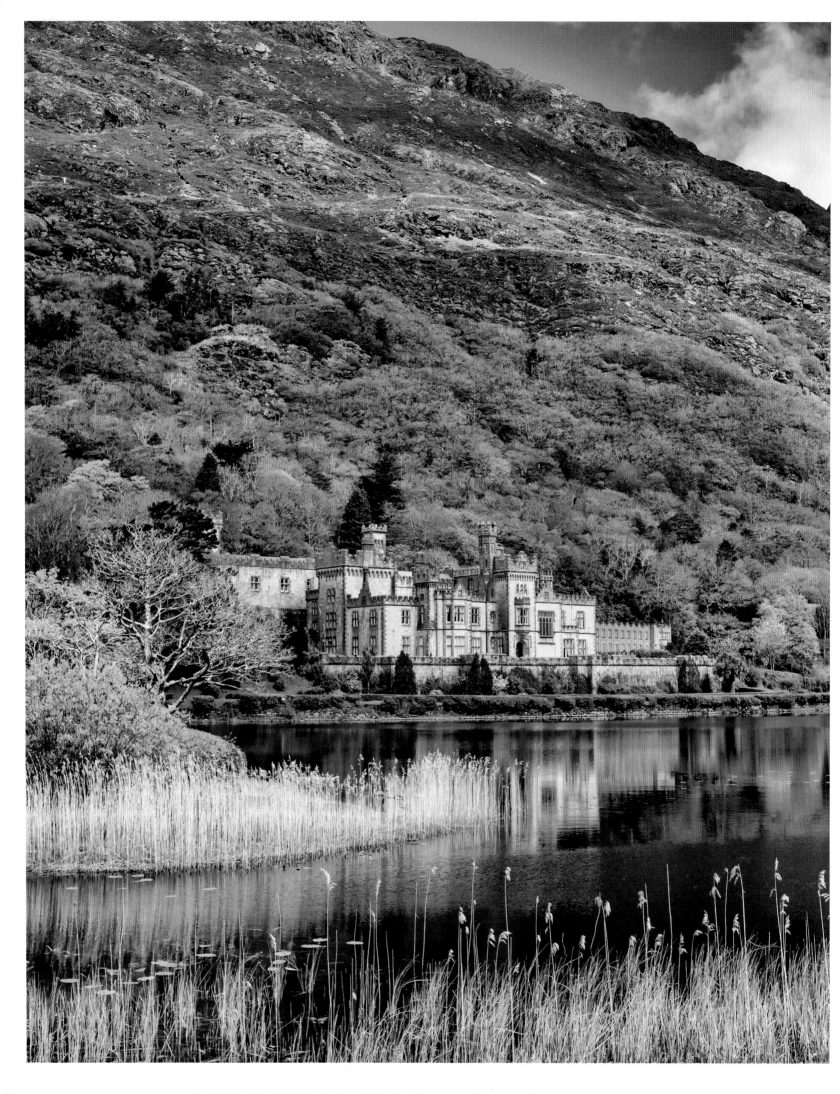

Kylemore Abbey

County Galway, Ireland

Set bucolically on the banks of County Galway's Lough Pollacappul, with the Connemara National Park visible in every direction and Duchruach Mountain rising up behind it, Kylemore Abbey has one of the most beautiful settings imaginable. Unusually, it didn't start life as an abbey, having been designed in the 1860s as a castle estate by James Franklin Fuller for the Manchester merchant and Member of Parliament Mitchell Henry. A century on, it still retains its faux Gothic stately home mien, complete with turrets, towers, parapets and battlements, and a small but arresting chapel nearby built as a memorial to Henry's wife Margaret, who died of dysentery aged forty-five while they were on holiday in Egypt. Yet it's here that a small order of Irish Benedictine nuns now help tend to a walled garden whose roots lie in European monastic gardens of old, while adding modern touches that keep the abbey up to date in this wild and beautiful part of Ireland.

The Irish Dames of Ypres, founded in the western Belgian town in 1665, with roots dating back to 1598 and ties to Ireland from 1682 (via Ypres Abbey's rededication as a house for Irish Benedictine nuns that year, and the appointment in 1686 of an abbess from the Butler family of County Kilkenny), bought and took charge of the 4,050-hectare (10,000-acre) estate on 30 November 1920 for £45,000. Early that December, the community of twenty-three nuns made their way from Wexford to Galway, and Kylemore Castle became Kylemore Abbey. Previous owner Henry, a keen gardener, had died ten years earlier, leaving behind a glorious Victorian walled garden and twenty-one heated greenhouses, in which a workforce of forty gardeners cultivated and grew everything from figs and bananas to melons and grapes. But with a smaller workforce and many mouths

Opposite: Built as a private castle estate, Kylemore Abbey now houses a small order of Irish Benedictine nuns.

Above: The vegetable garden features Victorian-era plants like cardoon and salsify alongside potatoes, root vegetables and cabbages, all grown using traditional farming methods.

vegetable garden, herbaceous border, fruit trees, a rockery and herb garden to the other. As a heritage garden, plant varieties are all from the Victorian era – varieties from pre-1901 – with bedding changed twice a year.

The main gate to the walled garden opens directly into the formal flower garden, with a geometric design based on archive photographs from the 1870s and tricolour beds known as ribbon beds planted in strips down the sides. All of it is contained by an original boundary wall made of Scottish red brick and Irish granite, which is not just decorative; the wall protects the garden from frost and wind, with the brick absorbing the heat of the sun during the day and releasing it back into the garden in the evening. Such warmth helps to ensure that the espalier apple and pear trees grown along the wall thrive despite the ferocity of the weather coming from the Atlantic Ocean less than 5 kilometres (3 miles) to the west.

Lovely as the formal flower garden is, it's the vegetable garden, containing herbal and medicinal gardens, that holds the greater interest. Its setting, between a fernery to the east and rockery to the north, with views beyond the wall to the countryside and mist-shrouded mountains, blurs the boundary between these handmade gardens and the rugged untouched landscape, creating a space that seems to welcome the divine. Exclusively Victorian-era plants like cardoon and salsify mingle with more recognizable potatoes, root vegetables and cabbages, all of it grown using traditional farming methods – including the use of seaweed, farmyard and green manure as fertilizer, and companion planting to deter pests. Over the years, more modern but equally

to feed – not just their own but the girls who attended the international boarding and day school run here from 1923 until 2010 – the nuns' focus was less on these past glories and more on the workaday and highly productive kitchen garden, along with a nearby beef, dairy cattle and poultry farm, resulting in the slow but inexorable deterioration of the 2.5-hectare (6-acre) site.

Fast-forward a century and the abbey garden of Kylemore is resplendent once more, thanks to restoration work carried out with the aid of documentary evidence detailing the landscaping and planting of the original site. Divided in two by a mountain stream are decorative and productive spaces, with the reinstated formal flower garden and some of the glasshouses, along with the head gardener's house and the garden bothy, to one side of a stream, and the

Left: Summer blooms in the flower garden.

Below: The formal flower garden, with a geometric design based on archive photographs from the 1870s.

natural pest control includes spreading coffee grounds, but these days, the garden's role is more of an educational and show garden than a provider of food and herbal remedies to the nuns and schoolgirls who were close to self-sufficient during their tenure here.

Beyond the gardens, the wider estate at Kylemore is a natural world idyll, one whose 405 hectares (1,000 acres) can be explored via everything from mountain hikes to lake and riverside walks. But it's the range of woodland routes that really convey the special atmosphere of this beautiful part of Ireland. The Henry family chose the location for their home with great care, but also took care to ensure that the estate would remain a special place for visitors for centuries to come. Over several years they planted 300,000 native, non-native and specimen trees from all over the world, and the nuns have continued their work with the planting of more than 10,000 ash and oaks. The result pays homage c the natural history of a site that was once home to an ancient native woodland – one that gave its name to Kylemore, which is derived from the old Irish place name 'Coill Mor', meaning 'big wood'. A woodland walk here reveals the wonderful intricacies of the symbiotic relationship between the land, its plants and its wildlife, offering a sense of the wonder of nature at the macro level. And coming across the diminutive, understated cemetery containing the small graves of the nuns who've died here since 1927 is deeply affecting.

Right: The estate, with its native, non-native and specimen trees from all over the world.

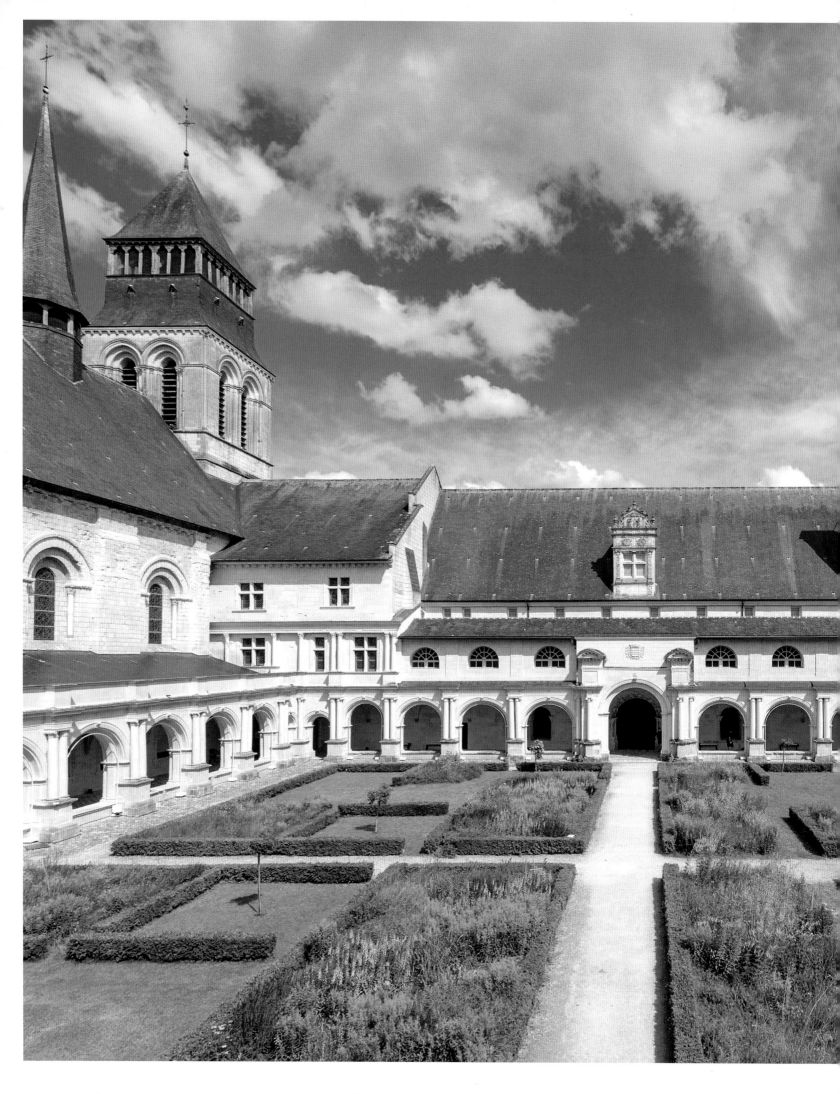

Fontevraud Abbey

Maine-et-Loire, France

T he Loire Valley has no shortage of stunning places of worship, from beautifully proportioned Romanesque buildings like the tenth-century village church of Cravant-les-Côteaux in Vieux-Bourg, and the small rock chapel of Notre Dame de Lorette in the Vallée de Courtineau, to grand Gothic-influenced cathedrals like Chartres, and Benedictine monasteries like the Abbey of Saint-Pierre de Solesmes, a leading centre for Gregorian chant. But for the gardening enthusiast, the Loire's most captivating space is undoubtedly the Romanesque Fontevraud Abbey.

Founded by the eccentric Breton monk Robert d'Arbrissel in 1101 as a religious community dedicated to the Virgin Mary, and largely built between 1105 and 1165, the sprawling collection of monastic buildings has always been unusual. From the outset, D'Arbrissel decreed that its mixed-gender inhabitants of monks, nuns and lay brothers should always be governed by an abbess, which it was right up to the Revolution, when the abbey was disestablished and, in 1792, the last abbess evicted. Shortly afterwards, Napoleon had it converted into a state prison, which it remained until 1963 – its most famous inmate reputedly being the writer Jean Genet. But even he is outdone in famous residents by Plantagenet royalty in the form of Henry II of England and his wife Eleanor of Aquitaine, who, along with her son Richard the Lionheart, were buried here. Both Henry and Eleanor were great supporters of Fontevraud, and under their patronage the foundation grew swiftly into one of the most important religious sites in the region.

While the heart of Fontevraud is undoubtedly its stunning church, the 13-hectare (32-acre) also site boasts a fabulous art gallery, which opened in 2021 in the former stables, a stunning Romanesque kitchen, the original chapterhouse, decorated with wall-

Left: The Renaissance-style cloister garden, one of the largest in Europe.

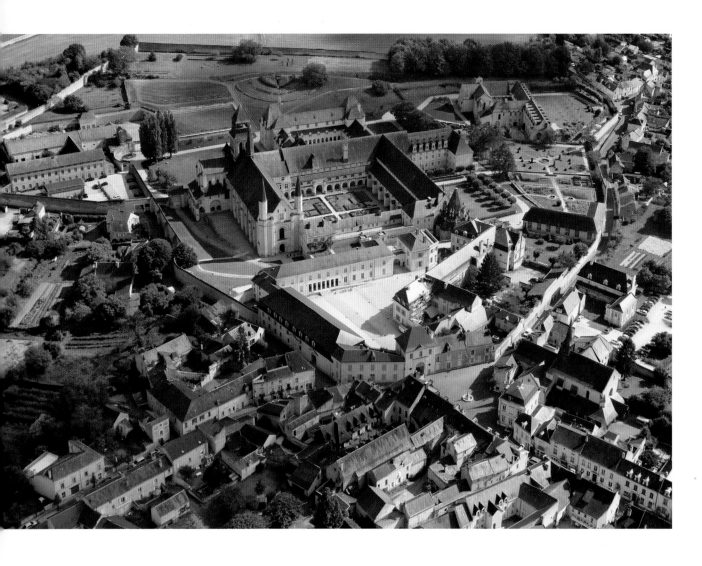

painted portraits of many of the abbesses who used it between the sixteenth and eighteenth centuries, and the impressive Renaissance-style cloister garden it opens onto – one of the largest in Europe. Dating from the sixteenth century, the symmetry and simplicity of the garden, planted with boxwood, lawn, herbs and perennials in a subtle palette of lavender, green and white, is like an earthly paradise, its design echoing the four rivers in the Garden of Eden and representing the linking of Heaven and Earth.

Beyond these lie the recreated monastic medieval herb and vegetable garden, filled with vegetables and aromatics from the prosaic to the elegant, and perfumed, as detailed in *Capitulare*

de villis, a series of rules and regulations issued by Charlemagne, written between 771 and 800. Regarded as one of the most important sources of information on medieval estates and their gardens, the ninety plants listed in the king's publication were selected to provide a huge variety of vegetables, herbs and medicinal plants to their estate residents. These days, those grown in Fontevraud's gardens mostly provide for the Michelin-starred meals offered to guests staying at the abbey's luxury hotel, located in the sympathetically restored priory. Overlooking the gardens in the old orangerie, the Terrasse Gourmande is a fine spot from which to enjoy the quiet sounds of nature.

Parkland, formal and botanical gardens, and even forty beehives – housing a total of 1.6 million bees capable of producing between 1,000 and 1,800 kilograms (2,400–4,000 pounds) of honey per year – add to the natural appeal of Fontevraud. The many art installations and exhibitions that draw on and interact with its rich history and architecture bring even more pleasure. It's a joy to wander, reflecting on its unique role as a medieval space ruled by women who were able to wield considerable economic, political and religious authority over centuries, not only managing the Order and abbey, but enhancing the reputation of both across Europe as those centuries unfolded.

Left and below:
Planting is both formal and informal, and ensures variety for the site's 1.6 million bees.

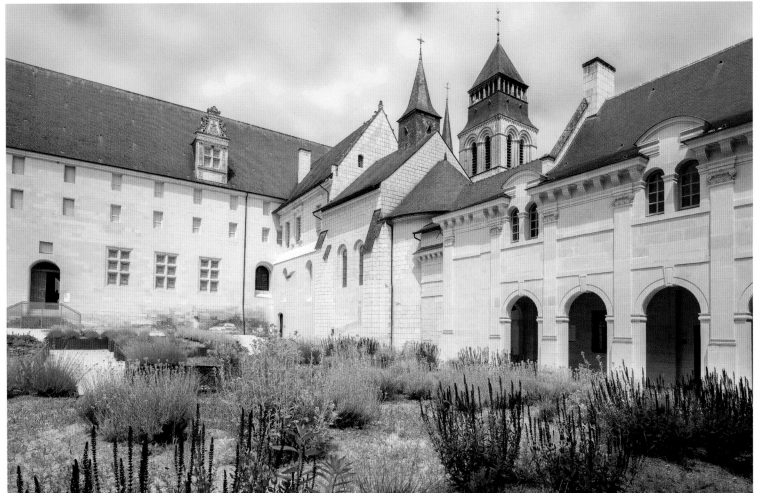

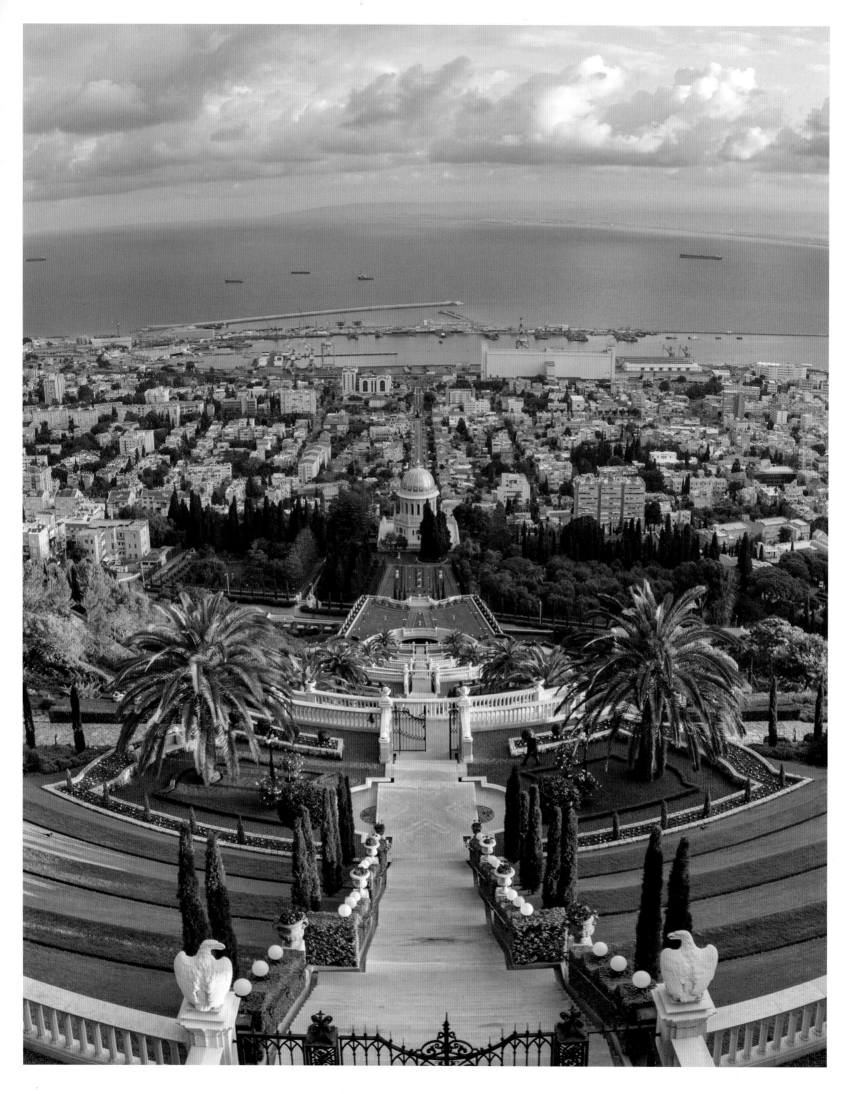

Bahá'í Terraces

Haifa District, Israel

You could be forgiven for never having heard of the Bahá'í faith, for while it's practised today by between five and seven million people, it does little to publicize its existence – perhaps due to a history of persecution stretching back to its foundation in the early nineteenth century. And yet, in its Bahá'í Terraces, also known as the Hanging Gardens of Haifa, it has a UNESCO site that's a stunning example of a sacred garden – one underpinned by that most crucial of contemporary concerns: the environment.

The Bahá'í faith was established by the Báb (meaning 'gate' in Arabic), who was born Siyyid 'Ali-Muhammad in Shiraz, Iran, in 1819. Aged just twenty-four, he announced himself as a prophet or messenger of God, founding, in 1844, the new monotheistic religion of Bahá'í, an offshoot of Shia Islam that forbade violence and holy war (jihad), recognized the equality of women, and encouraged science and education. By the mid-1840s he had enough followers to threaten the established order, and was declared a heretic before being arrested and, after three years of confinement, executed in Iran on 9 July 1850. He was aged just thirty-one. Many of his fellow Bahá'ís were tortured and murdered, but those that survived quietly continued practising their beliefs and hiding the remains of their murdered prophet until he could be brought to the Holy Land and buried under a simple stone structure on Mount Carmel, which was the beginning of what would, in 1953, become the golden-domed Shrine of the Báb that lies at the heart of the gardens.

The Bahá'í Gardens, located on the slopes of Mount Carmel overlooking the northern Israeli port city of Haifa and the Mediterranean Sea below, were constructed

in two periods, with nine initial terraces being built before more land could be acquired to complete the gardens. The full set of nineteen terraces, running from the top of the mountain to its base, represent the first eighteen disciples of the Báb (one of whom was, unusually, a woman), with an additional central terrace for the Báb's shrine.

By the mid-1980s, all the land was in place and one person had emerged as the obvious choice for the job of transforming the site into one fit for the Báb: Iranian architect and Bahá'í Fariborz Sahba, who had just completed New Delhi's Bahá'í Lotus Temple. Working with local structural engineers Karban and Co., Sahba began working on the gardens in 1987, and they opened to the public fourteen years later in June 2001.

It's hard to convey the scale of the project. Beginning at its base, the nineteen terraces extend almost a kilometre (⅔ mile) up the slope of Mount Carmel,

covering some 20 hectares (49 acres) of land climbed via more than 1,500 steps. Alongside the sheer feat of building on such a slope, one of its most impressive achievements has to be the environmental aspect of Sahba's design, specifically his use and conservation of that most precious of commodities – water.

Water is everywhere in the gardens. Its sound is ever-present and, married with the constant song and chirping of the birds attracted by the plants and water, creates a harmonious aural backdrop that's perfectly in tune with the sense of tranquillity and serenity needed to spiritually and emotionally detach oneself from the bustling city and industry below. A computer-controlled valve-based irrigation system informed by meteorological data adds water at night and in the early morning (to avoid wasting by evaporation), and the water in the fountains and running alongside the steps is recycled brown

Below: One of the many fountains in the gardens, which uses recycled brown water and a computer-controlled valve-based irrigation system.

Below right: Mulch, compost, ground cover and drought-tolerant plants minimize water use.

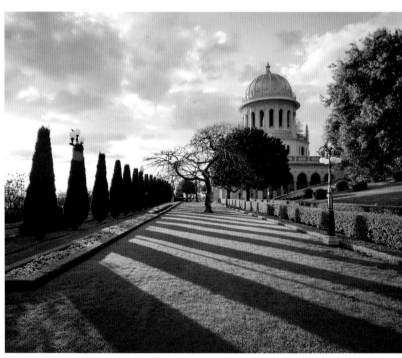

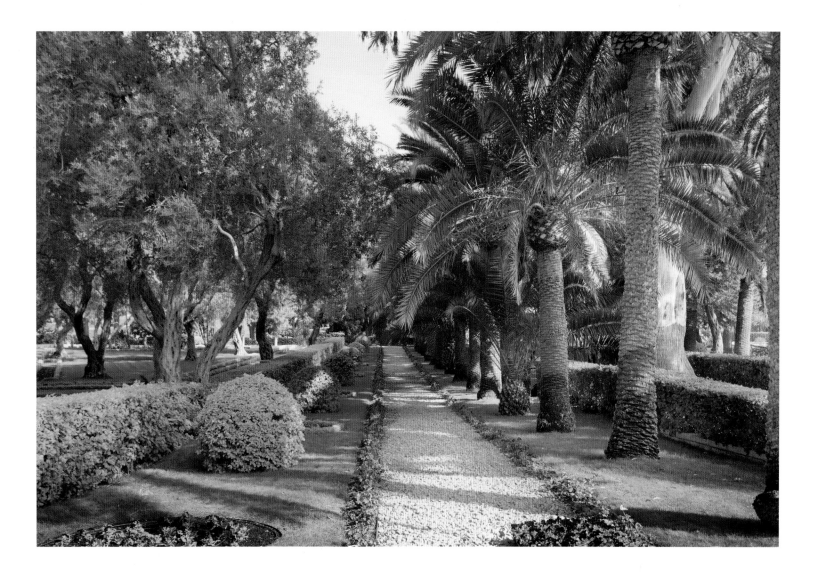

water. Mulch, compost, ground cover and drought-tolerant plants, together with beds of striking succulents and bold, colourful areas of strategically placed seasonal flowers, such as petunias, asters, geraniums and roses, ensure strong visual impact over small areas of ground, further minimizing water use. And erosion is avoided by the use of ryegrass, the roots of which keep the soil in place – essential for a garden set on these slopes.

Some 450 plant species work hard to create an effect that's part Persian, part Indian and part English garden. Here are flowers and hedges planted in circular and star-shaped beds that wouldn't look out of place in an English municipal park. There are symmetrical terraces dotted with lawns, shrubs, cypress trees, sculptures, palms, pools and fountains. An eye-catching bright-white cactus garden is filled with various types of agaves, night-blooming cactus, echeveria, prickly pear, barrel cactus, giant cactus, pincushion cactus and snake plant. Bougainvillea cascades down the terraces, roses provide fragrance and riotous colour, and other ornamental plants are carefully curated to enhance the beauty of the garden, including cotton lavender, geraniums, hibiscus, gladioli, iris, lupins, sacred bamboo from central and southern China and Japan, red hot pokers, bird of paradise and sago palms.

Above: Structure, form and shade are provided by trees including cypresses, pines, palms, carob, palmetto, casuarina, frangipani, eucalyptus, jacaranda and citrus.

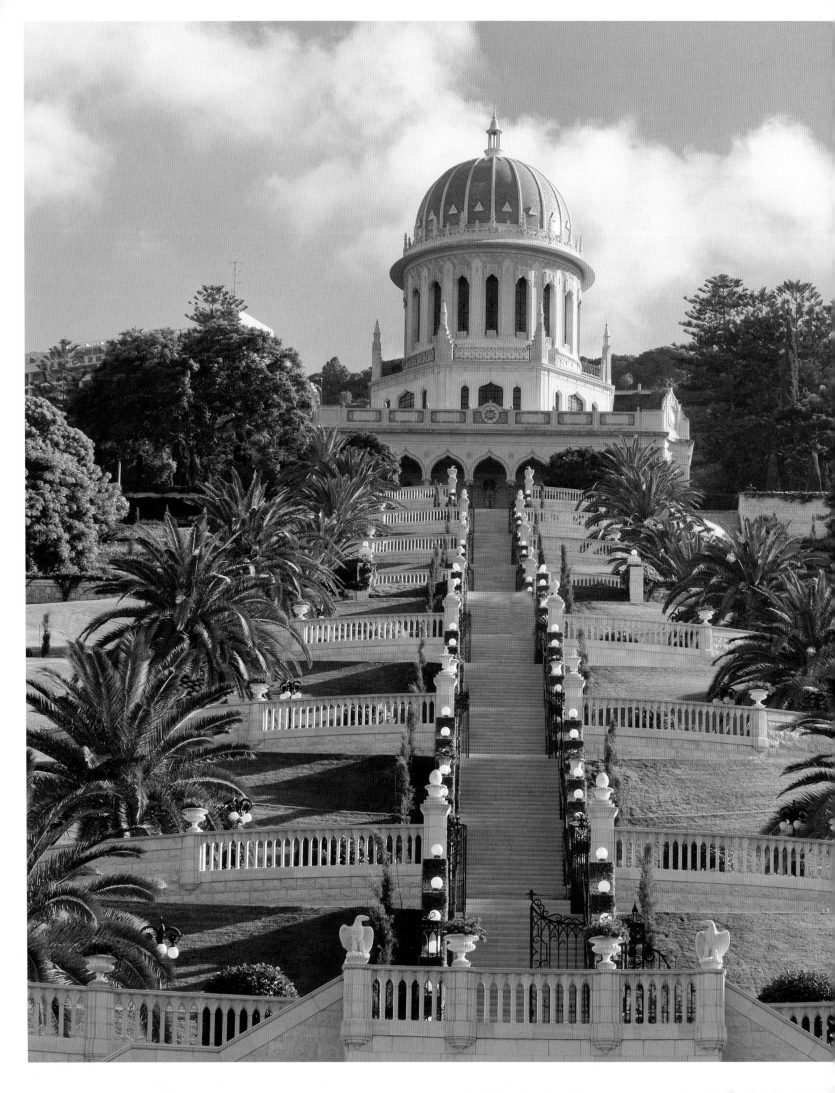

Structure, form, shade and more colour are provided by the trees. Cypresses stand like sentinels alongside the steps to draw the eye ever downward towards the sea, and pines, palms, carob, palmetto, casuarina, frangipani, eucalyptus, jacaranda and citrus all add to the colourful site. Contrasting the more formal planted areas are informal plantings featuring drought-tolerant species such as echium, lavender, rosemary and oleander, as well as yucca and olive trees. These give way to more natural areas filled with grasses from as far afield as the Jordan Valley, Turkey and Italy, all kept in a wilder, more natural state to provide a habitat for birds, insects and animals, thus helping to maintain the ecological balance of the site. Mimosa, honeysuckle, lilac and several varieties of jasmine create heady scents in the evenings. Nothing is coincidental, everything is considered, down to the clever drama of colour combinations, such as jacaranda trees flowering with a carpet of vibrant, blue-flowered convolvulus beneath them.

In twenty-first century religious beliefs, the Bahá'í is something of a conundrum. But as a faith centred around peace, harmony and equality for all, its gardens are the living embodiment of unity, tolerance and understanding of our world and all the living things in it. And, fittingly, entry and tours are free to all.

Left: Shrine of the Báb and lower terraces seen from below.

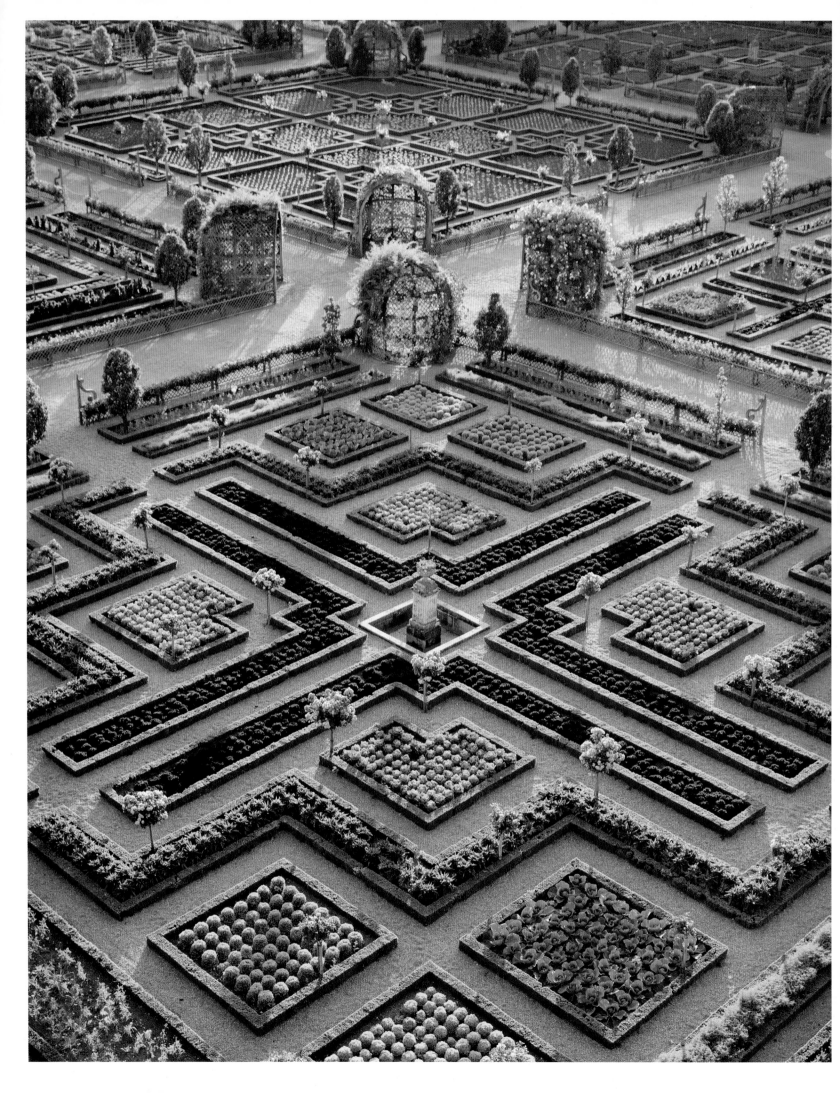

Villandry

Indre-et-Loire, France

The Loire Valley has no shortage of splendid estates wrapped around stunning châteaux, hence its designation as a UNESCO World Heritage Site, but Villandry is something special. This homage to the formal garden reaches back in history to give visitors the experience of nature tamed, in a myriad of beautiful and visually arresting ways. Put aside thoughts of the army of landscape architects, designers and hands-on gardeners it takes to produce such a spectacle, and enjoy the regimented beauty, harmony and tranquillity of this perfect example of a French Renaissance garden.

Villandry's loveliness is built on the historical tropes of many gardens through the ages, and elements from sacred gardens have clearly played a part in its shaping. Here are vegetable gardens that reflect centuries of monastic traditions; water features rooted in the symbolic representation of purity, life and spiritual renewal found in both Christian and Moorish gardens (informed by Persian and Mughal gardens); medieval knot gardens, whose geometrical precision and formal patterns can be associated with the idea of divine order and harmony, similar to some elements found in biblical garden symbolism; and, in its overall layout as the quintessential French Renaissance garden, the geometric design and emphasis on a space for reflection and meditation of the medieval cloister garden. Everywhere across its many varied spaces can be spied thematic elements and symbolism associated with biblical and spiritual references and the concept of creating an earthly paradise.

A fortress was built on the site in the eleventh century, and the Villandry name adopted in the seventeenth, but the château and estate that visitors see today took shape in the eighteenth century. By the time Joachim Carvallo (a Spanish doctor) and Ann

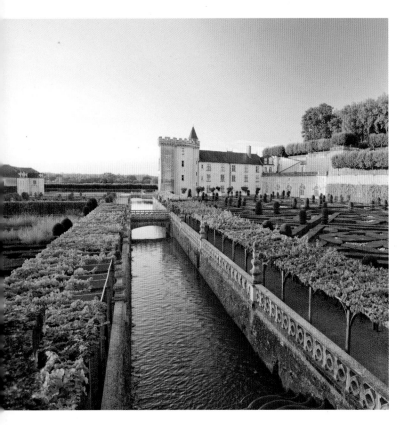 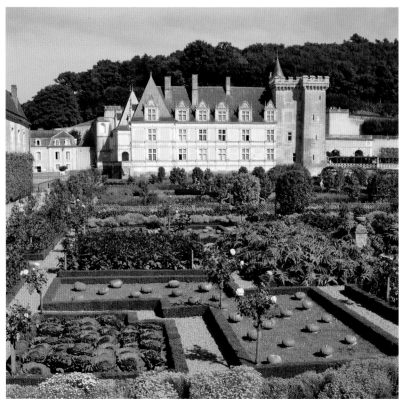

Coleman (an American heiress) bought the place in 1906, it was in a state of disrepair. The couple embarked on a grand restructuring project of both house and 9-hectare (22-acre) garden, which included an ambitious plan for a set of ornamental gardens featuring medieval, Renaissance and more modern French designs. The challenge was daunting, as by that time most of the grounds were given over to parkland.

A huge amount of research, covering everything from the layout to the flowers and shrubs, went into the project. Today, each one of the show gardens is intricately plotted and lovingly maintained; all the weeding is done by hand. The gardens are open year-round, with new delights in each season: in winter, frost highlights the geometric precision of the hedges; autumnal pumpkins bring pops of bright colour to the vegetable garden; spring offers pansies still in place while roses come into bloom; there are even a handful of summer nights – Nuits des Mille Feux – when the gardens are illuminated by more than 2,000 candles.

Most enchanting is the kitchen or vegetable garden (Le Potager), with its colour-coded vegetables planted in rigorous patterns over nine plots – the kind of garden to inspire (or alarm) any allotment owner. More than forty different types of fruit and vegetable are featured, installed over two plantings: the spring planting lasts from March to June, and is followed by the summer planting, which runs until November.

The ornamental garden (Le jardin d'Ornement) is ludicrously lovely, too. Andalusian in design, it consists of flower beds enclosed by neat hedges, and is divided into different parts, or 'salons'. One of these, Le jardin d'Amour, is dedicated to love, and the design cleverly symbolizes all manner of emotions,

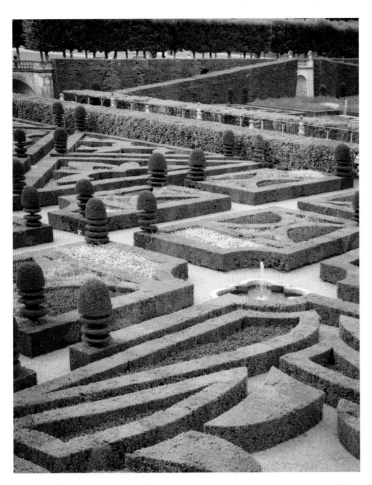

including broken hearts, flames of desire and horns for betrayal. A less passion-filled salon is the Garden of the Crosses (Le jardin des Croix), where hedges are laid out variously as the Maltese Cross, the Cross of Languedoc, the Basque Cross and a fleur-de-lys. The best overview of the mesmerizing geometry is from one of several raised terraces, the newest being a belvedere in the woods just above the gardens, with the woods themselves offering a charming contrast to the meticulous layout below.

A change of scene is offered by the sunken water garden (Le jardin d'Eau). Here, an elegant central pool, shaped

Left and below: Le jardin d'Amour and Le jardin des Croix form two of the ornamental gardens, created using boxwood and changing bulbs and annuals over the year.

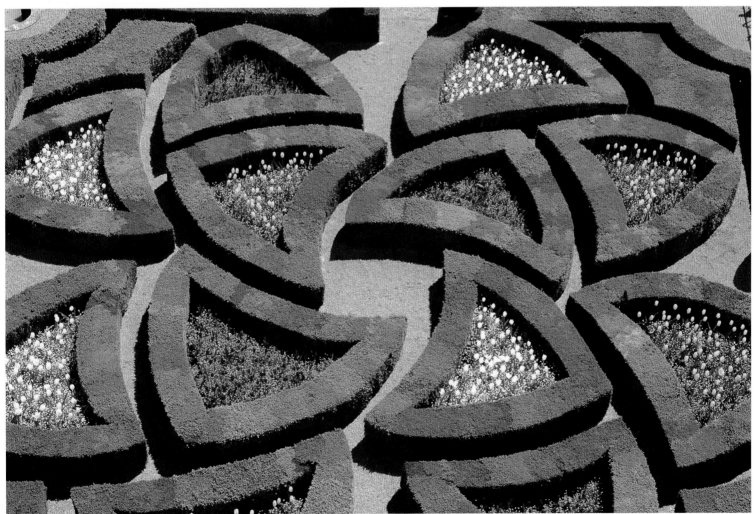

in the form of a Louis XV mirror, is surrounded by fountains and smaller ponds, amid immaculate lawns. Different again is the maze (Le Labyrinthe), formed of hornbeam hedges and based on Renaissance designs; there's a viewing platform at the centre so visitors can admire the trickery from above.

The current owners (heirs of Ann and Joachim) have continued to innovate: the estate has been organic since 2009, and is a haven for birds, with almost ninety species recorded here (in 2012 Villandry was the first château to join the French League for the Protection of Birds refuge scheme). New gardens have also been added. The herb garden (Le jardin des Simples) was created in the 1970s, from a design by Joachim Carvallo, and holds flowers, as well as culinary and medicinal herbs, arranged in circular beds neatly criss-crossed by footpaths. The sun garden (Le jardin du Soleil) was unveiled in 2008 to mark the centenary of the restoration. Built on what was previously a meadow, this showpiece is divided into three 'chambers': naturally, the sun-shaped area features a lot of yellow, with topiary and flowers arranged around a star-shaped pond (again from a design by Carvallo), but there is also a cloud chamber, with grass avenues and rose bushes, and a children's chamber with apple trees.

Of course, the château itself is charming, but here it plays a supporting role to the horticultural splendour. The sense of calm and order afforded by Villandry's precise designs is a timeless balm – these are gardens where not a bloom is out of place and everything is triumphantly perfect; an ideal world in which to spend some reassuring and reflective hours.

Right: The ornamental garden's second salon.

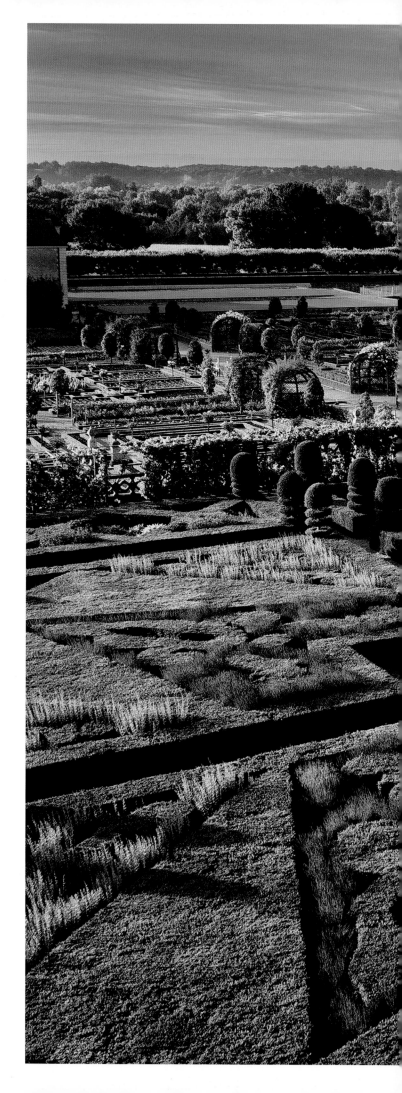

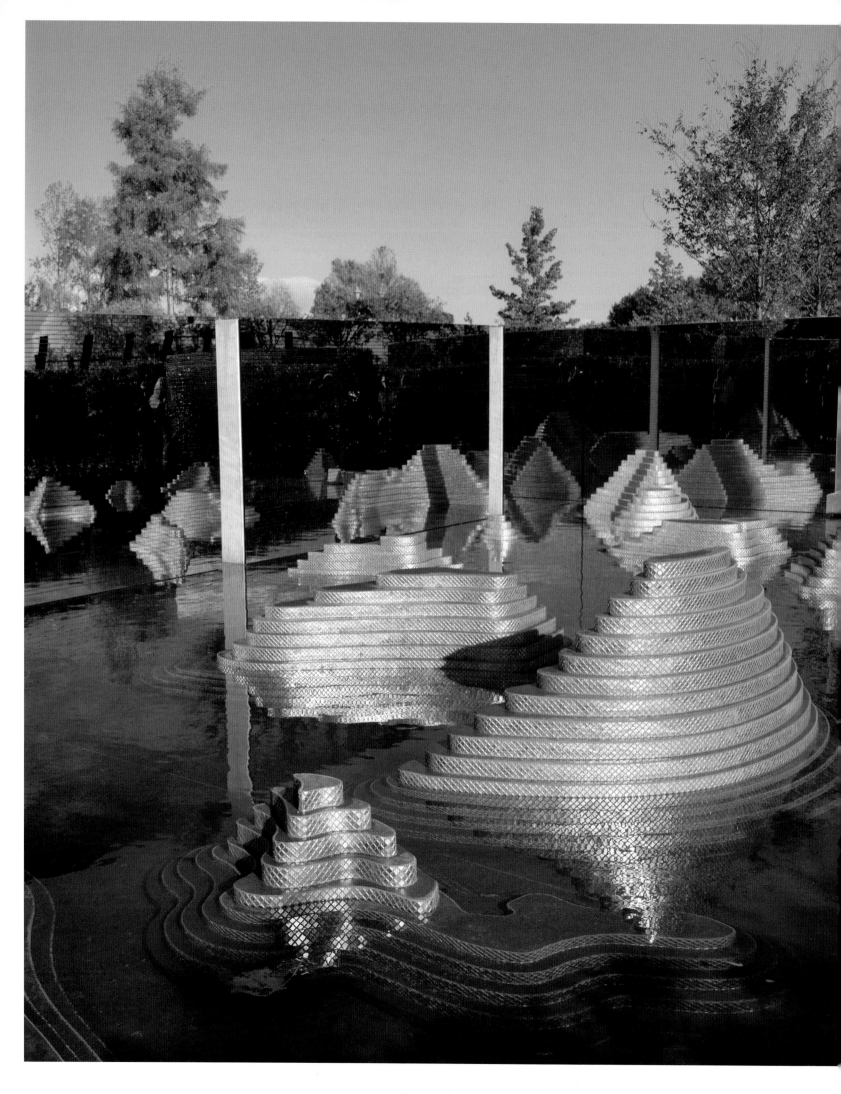

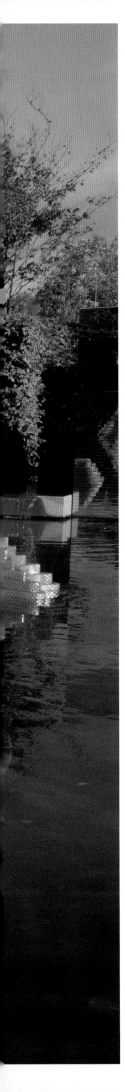

The Gardens of the World

Berlin, Germany

As everyone who visits Berlin's Gardens of the World seems to agree, this 16-hectare (40-acre) site established in the heart of what was East Berlin has created an international oasis that enables a connection with many different cultures and faiths. And their incongruous setting – amid the high-rises of Marzahn, home to the largest housing estate of the former GDR – simply adds to their appeal. While the eleven themed gardens, ranging from Chinese, Japanese and Balinese to Italian and Islamic, cannot hope to compete with their real-world geographical counterparts, they do offer great introductions to them, giving people an insight and understanding they would otherwise not be able to experience in one space.

The 2.7-hectare (6½-acre) Chinese Garden, the Garden of the Waxing Moon and the first of the gardens to be constructed here, marks the 1994 agreement of a city partnership between Berlin and Beijing. It was constructed as a classical Chinese garden complete with a tea house and 4,500-square-metre (48,400-square-foot) lake, the Mirror of the Sky, criss-crossed by various bridges and featuring traditional pavilions.

The Oriental-Islamic Garden, the Garden of the Four Rivers, bounded within a wall to shut out the noise of the everyday world, showcases the landscaping traditions of various Islamic cultures and the symbolism of gardens as paradise and spiritual places of rest. In accordance with Oriental-Islamic models, it has been designed geometrically around a central fountain bowl in the middle, and is filled with pomegranate, olive and palm trees set amid fragrant and vibrant shrubs and perennials such as lilac, jasmine, oleander, geranium and magnolia.

Left: The Gartenkabinett, or 'Garden of the Mind'.

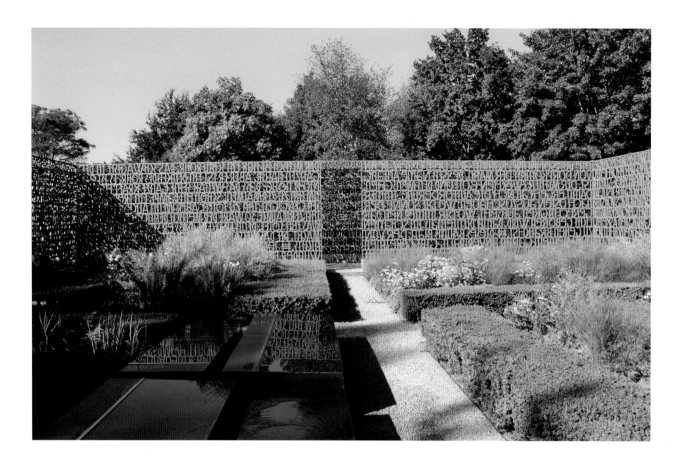

Above and opposite:
The Christian Garden.

While most of the gardens adhere to cultural origins, two, the Christian and Jewish gardens, are overtly religious in the stricter sense of the word. The highlight of the former is a unique colonnade of gold-lacquered rows of letters that make up sixty passages of text dealing with the theme of man in nature. Some are drawn from the Bible's Old and New Testaments, others from philosophy and culture, with all connecting the visitor with Christianity and humanity. But the colonnade's most powerful impact is a visual one, as the letters throw shadows across the plants that decorate the cloister garden, modelled on a typical monastery garden. The interplay of light and dark not only references dominant themes of medieval Christian beliefs, but the shadows literally fill the space with the words that monks would have been murmuring as they sat on benches around the edges of the garden. As a space of quiet contemplation, you almost feel you can hear the echoes of their voices from centuries ago.

The Jewish Garden was the last of the themed gardens to be built in 2021. Laid out as a network of paths crossing beds filled with plants anchored in the history of Berlin's Jews and referred to in Jewish scripture and literature – from novellas and poems to short stories, essays and letters by Jewish authors and writers close to Judaism – the 2,000-square-metre (21,500-square-foot) space, set next door to the Christian Garden and offering views over it, eschews symbolism in favour of straightforward horticultural history. It offers a workaday but still thoughtful space which continues the tradition of Jewish gardens as ones in which practical considerations are as dominant as aesthetic ones.

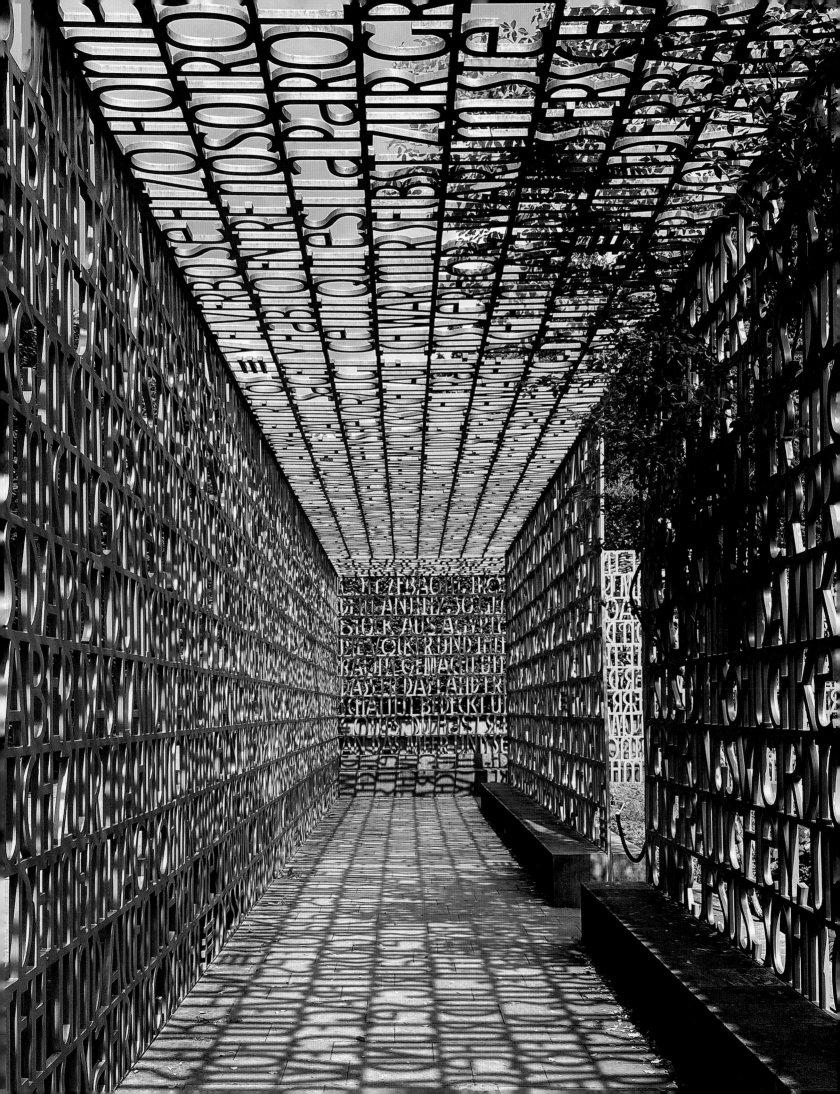

Above: Trees mentioned in the Torah as having healing powers, such as figs, are planted in the Jewish Garden.

The Jewish diaspora lacks a horticultural aesthetic or tradition that would make a garden instantly recognizable as a Jewish one (in the way that a formal Italian, Islamic or English cottage garden might) – perhaps because living across many different climatic conditions through centuries of legislation and persecution barring them from acquiring land and engaging in agricultural activity made connecting to their natural environment literally impossible. So the designers of the garden, Berlin-based Atelier le Balto (which in 2013 had designed the Diaspora Garden for the Berlin Jewish Museum) with artists Manfred Pernice and Wilfried Kuehn, 'understood our task to express the spirit of Jewish culture in our design', says le Balto's Véronique Faucheur. The result is a horticultural space centred around self-sufficiency and usefulness, filled with flowers and ornamental plants grown for ceremonial use, consumption and purpose. Here, these include trees mentioned in the Torah as having healing powers for

the mind, body and spirit – such as figs, almonds, cherries, pears and apples – as well as magnolias, chestnuts and elms, all plants found through the historical and artistic-literary types of research which accompanied the project. The Damask rose, for example, was brought to Europe by Jewish traders in the Middle Ages and used for rose oil extraction.

The garden's network of meandering cobbled paths is a more elliptical reference to the interconnections and international references of Jewish culture, and two sculptural pavilions offer spaces in which to rest or exchange ideas and thoughts, while also acting as a striking contrast to the planted areas. Where so many landscaped areas dedicated to the memory or people of the Jewish diaspora are harsh concrete spaces aimed at representing, remembering or evoking the horrors that history has inflicted on it, this garden, with its thoughtful planting, winding paths and elegant artworks, is a welcome contrast that eloquently reflects the spirit of an idealized Jewish garden.

Left and below:
The garden's
sculptural pavilions.

Tresco Abbey Gardens

Cornwall, UK

F orty-five kilometres (28 miles) south-west of Cornwall's Land's End, at the southernmost tip of England, lie the Scilly Isles, an incongruously tropical archipelago of five inhabited and 140 uninhabited islands where winters are as mild as those of the southern Mediterranean. Amid rolling downs dotted with heather, pretty dunes and powder-white sand beaches looking out across clear crystalline waters are to be found the kind of exotic plants you'd expect to see on a very different latitude. Nowhere is this more true than on Tresco, the second largest of the islands. For it's on this tiny spot, measuring just 4 kilometres (2½ miles) long by 1.6 kilometres (1 mile) at its widest point, that you'll find Tresco Abbey Gardens.

Centred around the remains of a Benedictine abbey founded in 964 CE and a garden established in 1114 by monks from the Priory of St Nicholas, who had come here from Devon's Tavistock Abbey, the current 7-hectare (17¼-acre) garden was first planted almost 200 years ago by the island's proprietor Augustus Smith. Having created it as a private garden within the grounds of the home he designed and built, he planned and planted carefully, beginning with a 3.6-metre (12-foot)-high granite wall, gorse and shelter belts formed of hundreds of sturdy trees to offer protection from the wild winds that batter the islands periodically, beginning with deciduous trees such as elm, sycamore, oak and poplar before introducing the Monterey cypress and pines that are still visible today. An enthusiast who keenly reflected the Victorians' interest in botany, he began to acquire plants from all over the world through connections with other plant collectors.

On Augustus's death in 1872, the garden's layout of terraces filled with Mediterranean climate zone plants from as far afield as North America, Brazil, Australia, New Zealand, Burma, South Africa and South America was well established. And today's garden is little changed from it. A top terrace protected by a hill is filled with dry-loving proteas

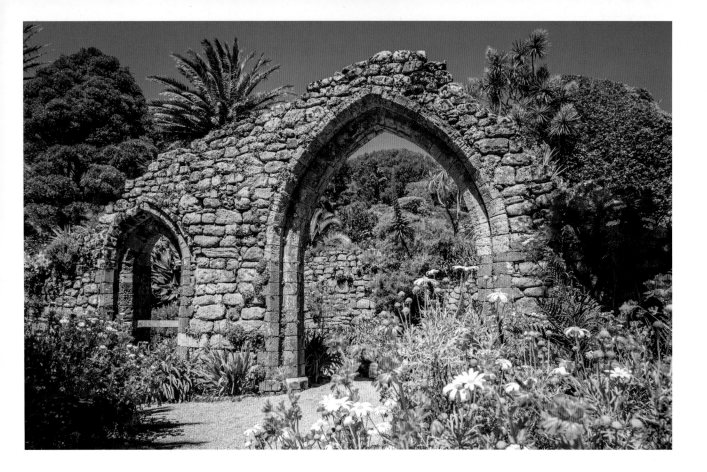

like *Protea longifolia*, the South African
sugarbush, African aloes, cistus and
succulents, and gives way to the more
formal and mannered Middle Terrace,
where ponds, a summerhouse and a stone
sculpture of Gaia, the Greek goddess
of Earth, are surrounded by a riot of
colourful plants. Below them thrive species
enjoying higher humidity, as is made
evident by the ferns and lush vegetation
lining the Long Walk, which spans the
garden, ending at the ruins of the old
abbey to its east and the Aloe Walk to its
west. South of it sits the Valhalla Museum,
a curiosity begun by Augustus and
containing thirty Victorian figureheads
and other decorative marine artefacts
salvaged from ships wrecked in the
Atlantic seas surrounding the archipelago.
And everywhere towering palms and
agave from Mexico and North America
and giant pillar box-red flame trees thrive
alongside riotous banks of colourful

sub-tropical plants – an estimated 20,000
of them, representing 6,000 species
from across the world. Many have self-
seeded across the island, so that gardens
filled with pride of Madeira, Madeiran
geranium and fire heath act as a charming
extension of the Abbey Gardens. And
it's not just the plants that proliferate
on Tresco – spectacular and rare golden
pheasants are a joy to see.

It's an astonishing garden, and with
its echoes of ancient religion in the shape
of the abbey ruins, one that gladdens the
heart and lifts the gloomiest of spirits. But
its existence is also something of a miracle,
for it's suffered some serious setbacks
since Thomas Algernon Dorrien Smith
inherited the estate from his uncle in 1872.

Thomas peacefully enjoyed the garden,
enthusiastically adding to its collection –
and extending it to include daffodils as part
of the 300 species of plants to be found in
bloom during the colder months – until

his death in 1918. It was his son Arthur who had to deal with the first of three killer blows the Atlantic dealt the garden. In 1929, it was virtually destroyed during five days of storms that saw hundreds of trees uprooted and plants crushed. Arthur, undeterred, valiantly spent the next six years rebuilding and replanting, so much so that by 1935 it numbered 3,500 species of plants. It's to be hoped that it offered spiritual healing to a man who lost three of his four sons to the Second World War, and it certainly must have been a joy to see that his remaining son, Thomas Mervyn, happily shared his enthusiasm for it, extending not only its plants but also its reputation as he turned it into a space to be enjoyed by likeminded enthusiasts. But in January 1987 tragedy was to strike again, with a winter freeze so severe that it transformed 80 per cent of the garden into sludge; or, as its curator Mike Nelhams evocatively describes it in his excellent *Tresco Abbey Gardens – A Personal and Pictorial History*, into something 'like stewed rhubarb that smelt like something a lot worse'. And three years later, as the process of replacing the plants was almost complete, another huge storm hit the island. Again undeterred, the family rebuilt.

More than forty years on, the garden is as glorious as it ever was, its mix of narrow and wide paths, varying elevations, natural and handmade features, and formal and more informal spaces creating not only a playful, delightfully diverse space, but also an intensely soulful experience. A statue of Neptune staring out to the Atlantic from the top of the Neptune Steps is an ever-present reminder of the sea's threat, but it has survived, thanks to the tenacity and love of its stewards, and hopefully will continue to do so for centuries to come.

Left (top, centre and bottom): Colourful Mediterranean climate zone and sub-tropical plants drawn from around the world.

Pages 130–1: Bright paths lined with colourful borders and towering palms.

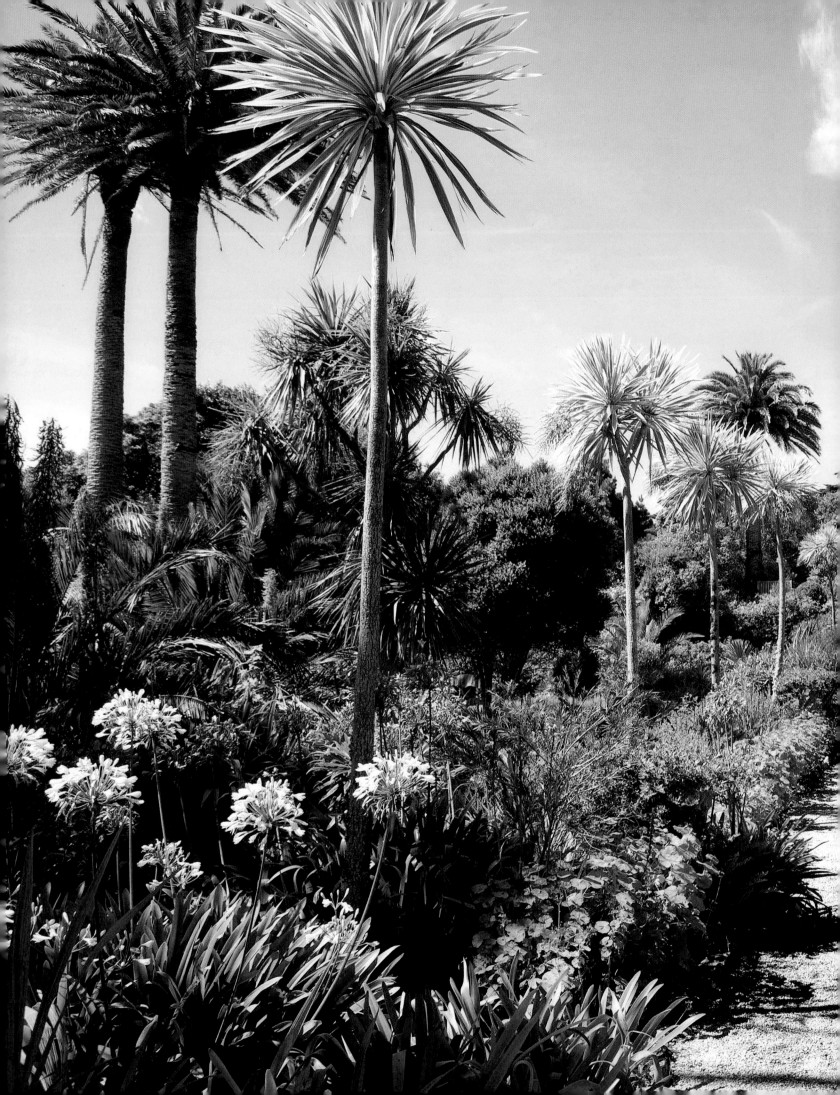

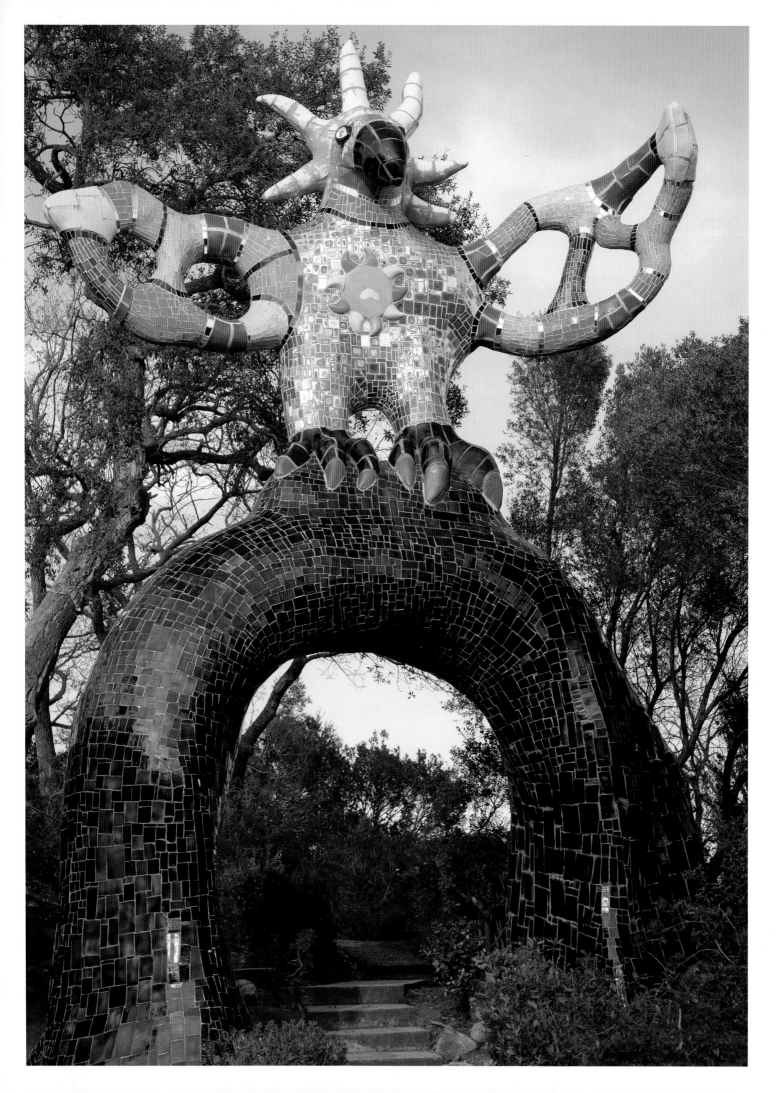

Pagan Tarot Garden

Tuscany, Italy

Near the small town of Capalbio in Tuscany, on the estate of Garavicchio, is surely one of the most surreal, fantastical gardens in the world, created over the last two decades of the twentieth century by the French-American artist Niki de Saint Phalle. If you know her work at all it is likely to be via her 'nanas', gaudy mother–goddess fertility figures that she first created in 1964, many of which appear in or influenced her Tuscan Tarot Garden, or the Giardino dei Tarocchi.

Conceived as a sculpture garden housing the twenty-two Major Arcana figures from the Tarot deck of cards, used for divination, Saint Phalle's jewel-like sculptures first catch the eye from afar, towering above a traditional Mediterranean landscape of olives, cypress and ancient oaks. With their glazed and mirrored surfaces catching the sunlight, they gleefully populate a garden that Saint Phalle envisaged as 'a sort of joyland, where you could have a new kind of life that would just be free'. She knew something about not being free; at the age of just twenty-two, she was incarcerated in a French insane asylum for six weeks. Here, she was subjected to shock therapy, but also began to discover the therapeutic, redemptive power of art, making collages from the natural elements found in the asylum's grounds. She emerged from the asylum to immerse herself in an unorthodox art practice and world, in which the Swiss sculptor Jean Tinguely would watch her shoot her paintings using real guns and bullets; he would go on to become first her collaborator, then lover, husband and lifelong friend.

Together the pair would collaborate on many pieces, but the overt sexuality of the works by Saint Phalle proved deeply controversial, enchanting and enraging audiences in equal measure. And her Tarot Garden was no exception. Constructed between 1978 and 1998, locals initially loathed its huge-breasted, gaudy occupants, such as The Empress

Opposite: The Sun Major Arcana Tarot card figure.

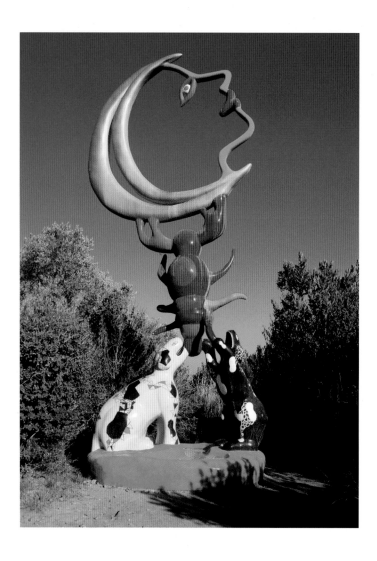

had a pagan force that she connected with, not just as expressions of her art, but as physical embodiments of the different aspects of human attributes and emotions that the Tarot cards represent. The Sun's primordial vitality, The Moon's melancholy, Justice's self-knowledge, The High Priestess's initiative and feminine power, The Hierophant's sacred knowledge, The Magician's intelligence, The Hermit's spiritual wanderings and Death's world of darkness are just some of the things Saint Phalle wanted to put in her world, their scale illustrating their importance to her and her world view.

Dominating the park is the figure of The Empress, her mirrored blue hair capped by a bright-red crown, and her two gaily decorated breasts bearing bright flowers and hearts on their exterior and hiding mirrored mosaics on their interior (spaces which acted as the home and studio of Saint Phalle for seven years). Other forms include the rainbow mosaic tower of The Castle, an unruly cobalt-blue legged Sun straddling neat and tidy box hedging and shrubs, a monochrome striped figure of Justice cradling scales in her breasts, the startling silver columns of The Hierophant, and the open-mouthed serpent-protected High Priestess. Central to it all, Tinguely's Wheel of Fortune represented the vicissitudes of life through a fountain reminiscent of Antonio Gaudí's Parc Güell in Barcelona, an influence Saint Phalle acknowledged in the formation of the garden, along with the sixteenth-century Park of the Monsters in nearby Bomarzo.

While Saint Phalle's focus was on her figures, she took care to ensure that their relationship with nature and the plants in the garden was a symbiotic, sympathetic

(a.k.a. The Sphinx) as they began to emerge from the Etruscan ruins of an estate owned by the family of an old friend and fellow model of Saint Phalle's, Marella Agnelli. But as those same locals began to be involved in its creation, their feelings towards this 'madwoman and her monsters' began to change. Young men brought in to construct the gigantic sculptures were enchanted by Saint Phalle, while women blossomed in confidence and strength as they were taught to make the mosaics that would cover the figures and forms in crackled glazes, coloured glass, mirror shards and hand-painted ceramic tiles.

For the locals, the figures of the Major Arcana may have initially appeared monstrous, but for Saint Phalle, they

one, and that nature and art would work together to offer a multisensory experience; according to Marella Caracciolo Chia, the daughter of the estate's co-owner Nicola Caracciolo, not a single one of Garavicchio's ancient oaks and olives was cut to make place for the sculptures, and Saint Phalle used the sound of water and the smells of aromatic plants, such as lavender, rosemary, pine and juniper trees, to create a sensual space in which plants and artworks work cohesively and harmoniously. The rainbow colours of the figures undoubtedly lead the way with visual interest, but our other senses are engaged too, thanks to Saint Phalle's thoughtful and holistic approach.

It would take almost twenty years for the garden to be formally constituted and opened to the public, on 15 May 1998, in which time Tinguely would die, Saint Phalle would relocate to California, and perhaps most poignantly, Ricardo Menon, a friend and assistant to Saint Phalle for ten years, would die of AIDS in 1989. She created a sculpture of a cat for his grave at Montparnasse Cemetery, and a smaller version for the garden, making the Giardino dei Tarocchi not only a wonderful interpretation of a sacred Pagan space, and a space of personal faith for Saint Phalle, but also an affecting memorial garden.

Below: The Empress (a.k.a. The Sphinx) rising over olive and cypress trees.

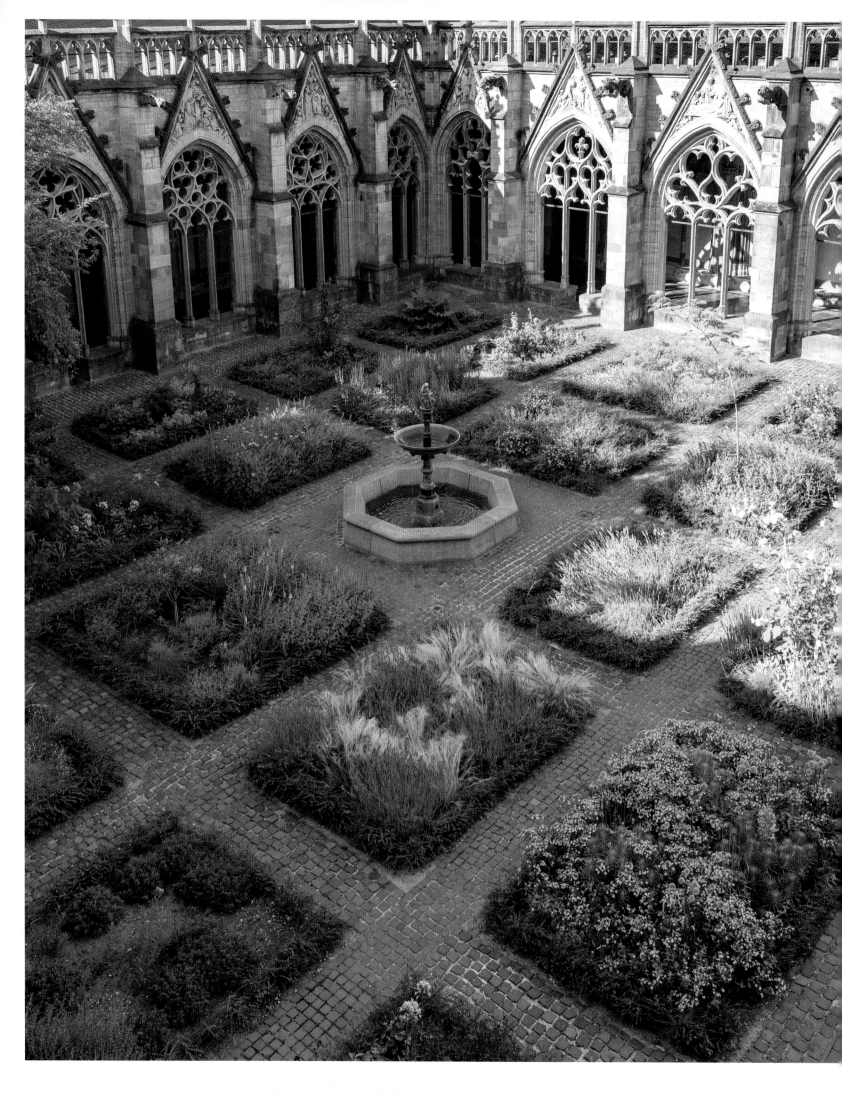

The Cloister Garden of Utrecht

Utrecht, Netherlands

What was once a retreat from the world for monks is now a sanctuary for the citizens and tourists of Utrecht from the hubbub of the city centre. An impressive Neo-Gothic door reveals beyond it the enchanted world of the Pandhof cloister garden, contained by the walls of the Dom Kerk and overshadowed by the Dom Tower, the tallest church tower in the Netherlands.

Monks were the herbalists of medieval times, tending and cultivating an array of medicinal plants and giving out healing remedies from their inner sanctum. Here, the monks were closeted away, tending their plants, using the daylight for reading and the fountains for washing clothes, all out of sight of the crowds. A cloister garden, however, is not merely a hideout for monks; there is inevitably symbolism woven in. The cross shape formed by the bisecting paths is a reminder of the crucifix; the division of the garden into four, a representation of the four gospels or the four evangelists; the central water feature – a pool or in this case a fountain – a reminder of paradise. The central green space of the cloisters is known as the garth, and its greenery symbolizes both rebirth and everlasting life.

The Dom Church has a chequered and turbulent history at odds with its current peaceable mien. The original church and monastery were built at some point between 1390 and 1440 and dedicated to St Martin. A somewhat contradictory saint, he is depicted as a dashing Roman centurion who shows mercy towards a beggar, using his sword to slash his cloak in half to share it, before going on to become a symbol of generosity to the poor.

Opposite:
A chequerboard of rectangles inside the square of the cloisters.

Pages 138–9: More than 140 different species of plants, including fennel and rosemary interlaced with cosmos and other decorative flowers, are contained within neat, clipped box hedges.

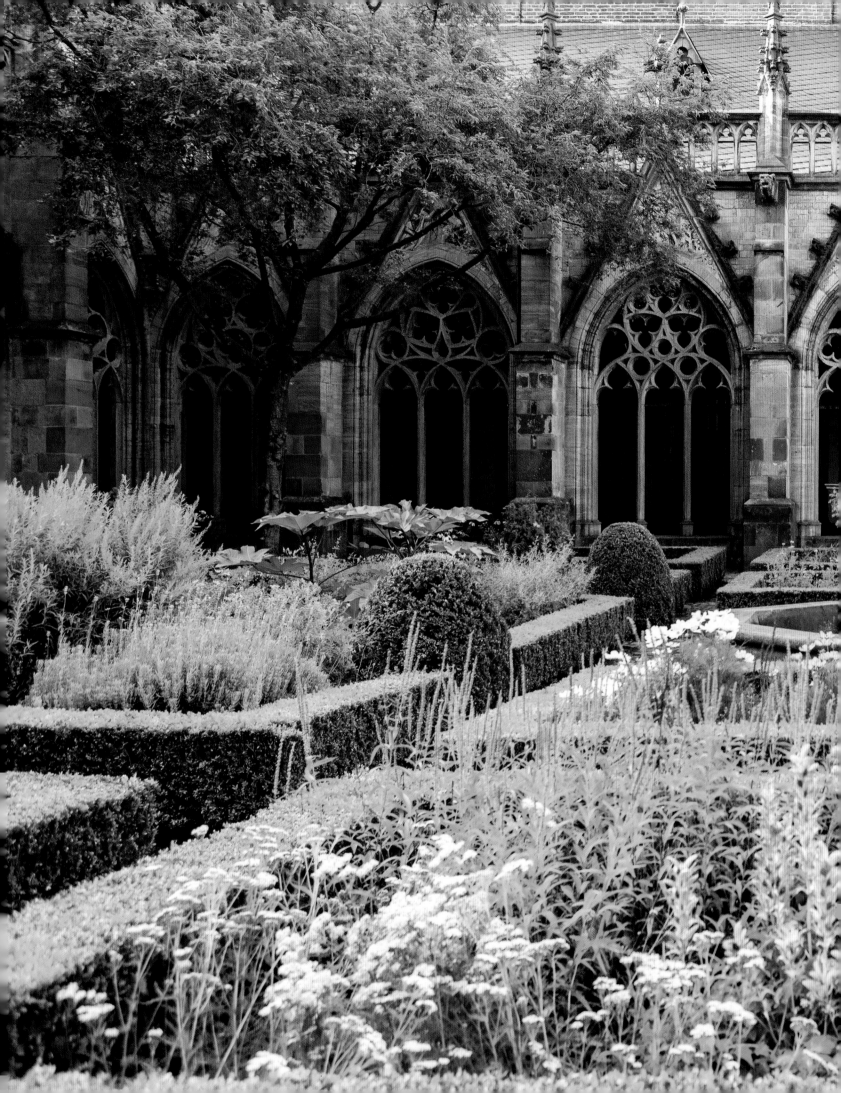

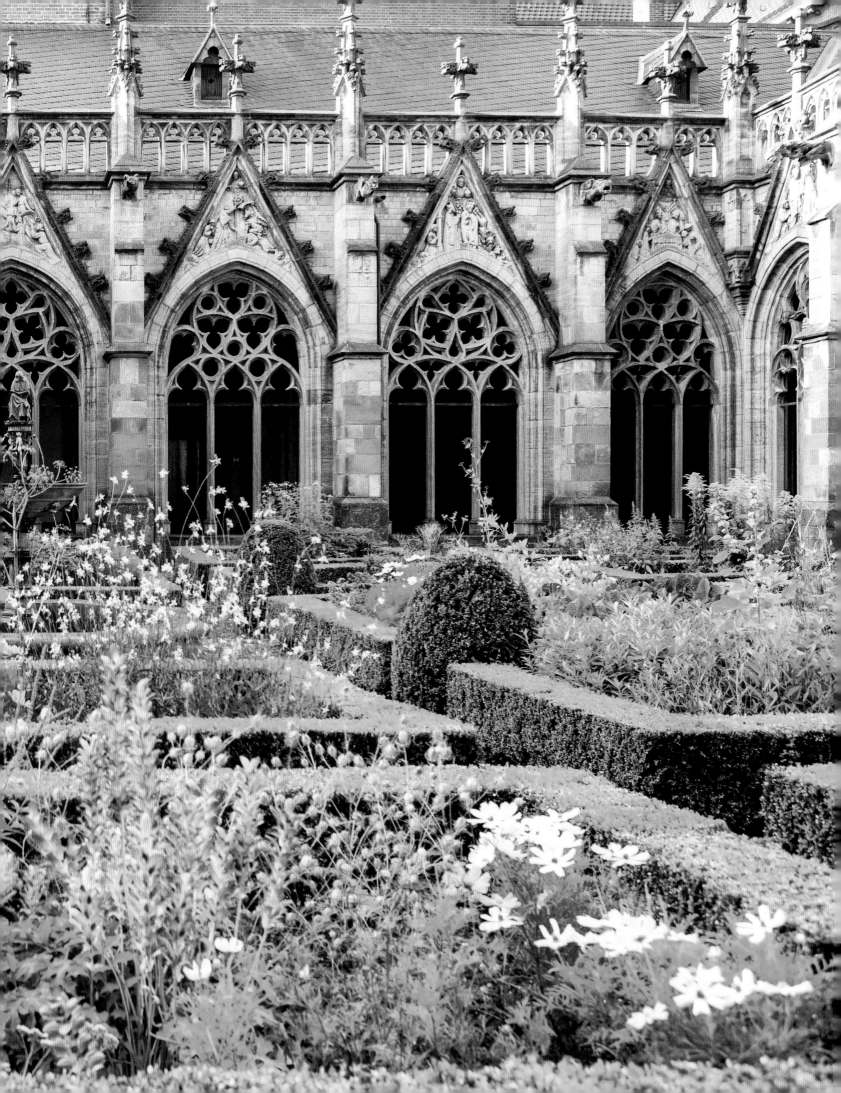

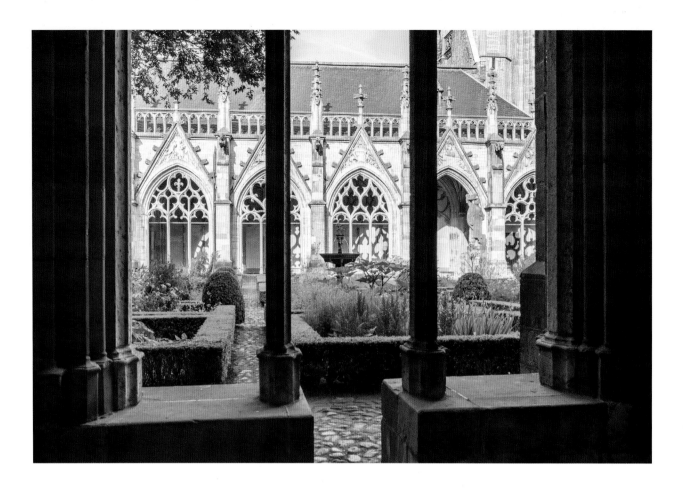

The original Roman Catholic church fell victim to the fervour of the iconoclasts, who in 1566 destroyed the carvings and buildings deemed to be idolatrous, smashing their way through churches in the wake of the Protestantism sweeping the country. What was left after this was further damaged by a catastrophic storm in 1674 which destroyed the nave, leaving a curiously truncated building behind with a choir, transept and the massive Dom Tower. The lost parts of the cathedral are marked out in different coloured stones on the adjacent Dom Plein, but the delicate glory of the cloisters remains. Gothic arches ripple their tracery around the cloister corridors, surmounted by a venerable comic strip of carved bas-relief scenes from St Martin's life. Ranks of uniquely fashioned gargoyles grin down on the visitors in the gardens below.

The cloisters and their gardens originally belonged to the cathedral, but over time the space was colonized by local residents, who apparently used the area to plant and harvest nut trees, drink beer and keep chickens. In 1634 the Protestant Illustrious School was founded nearby, and the cloister gardens were given into the charge of what later became Utrecht University. The gardens became a *wandelplaets van d'Academie*, a place for the scholars to wander and allow their thoughts to wander too. The cloister garden still belongs to the university but is accessible to all, except when there are university events. In one corner a slightly incongruous tea house squats, a 1980s addition in concrete and glass that may jar with the elegant surroundings but can give a welcome respite from the frequent Utrecht rain.

The cloister gardens, like the cathedral, have evolved over the centuries, but have generally remained faithful to their early incarnation as a place of peace and healing. The most recent renovations of the garden in the 1980s carefully reimagined the medieval herbal garden, harking back to the herbariums and knot gardens of earlier times. The courtyard is a geometric marvel, a chequerboard of neat, clipped rectangles of box inside the square of the cloisters. The crisp orderliness of the hedges now contrasts with a modern, looser planting style; amid the more than 140 different species of plants, fronds of fennel waft and spears of rosemary erupt from their confines, with decorative flowers interlaced. An ancient wild cherry tree, symbolic of the Garden of Eden, dominates the eastern corner, showering the ground with pale petals in spring and golden leaves in the autumn. At the centre stands a bronze statue poised above a gently trickling fountain. This is where the fourteenth-century Canon Hugo Wstinc sits writing, a modest figure and an invitation to while away the hours in learning, reading and thinking.

The cool quiet dimness of the cloister corridors is a gentle contrast with the lush green of the planting, the aromatic scent of herbs and the sounds of tinkling water and birdsong they enclose. Escape from the melee and while away a little time here capturing a 'green thought in a green shade'.

Below: One of the cloister corridors.

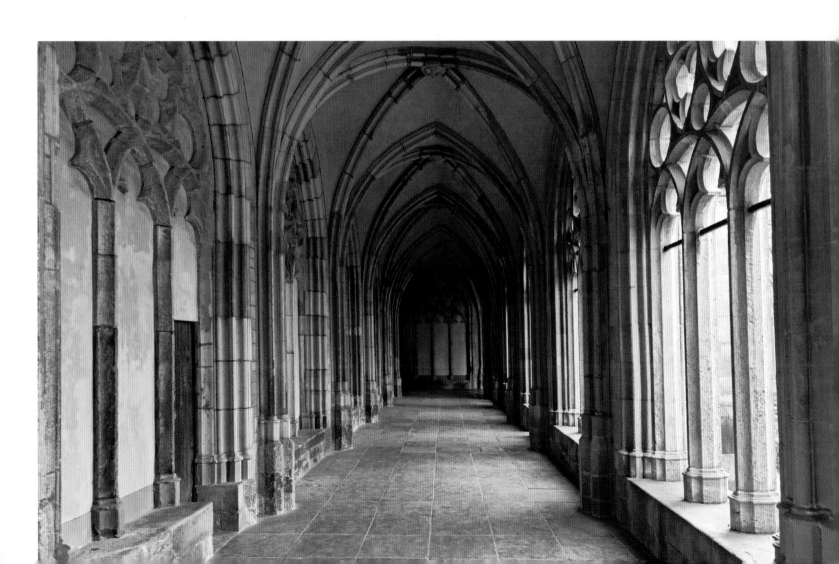

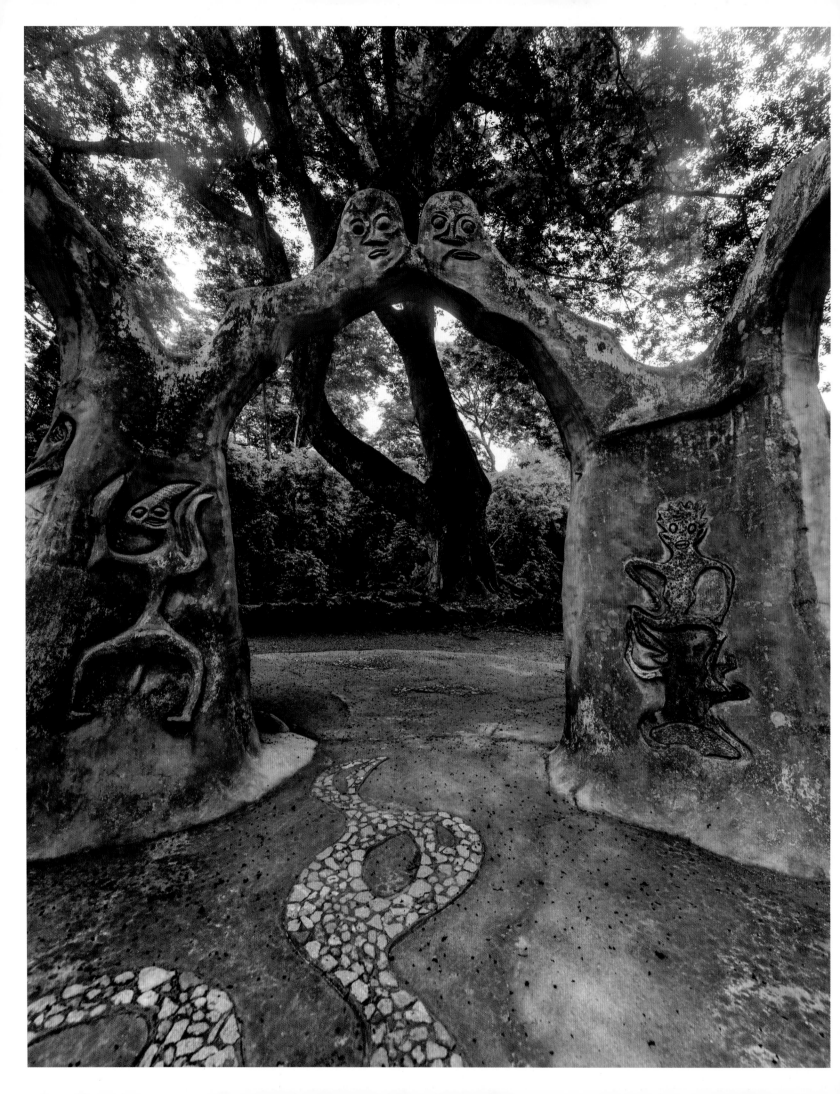

Osun-Osogbo Sacred Grove

Osun State, Nigeria

T hink of a forest – walking under a lofty canopy of trees, light sifting through majestic ancient tree trunks, the sounds of birdcalls and monkeys echoing across the path. Already this is a spine-tingling experience, a sense of awe and of being accompanied by mysterious invisible forces. Then, out of the forest rear figures, faces and bodies emerging from the earth; in clearings and among the trees appear gigantic statues, old and modern, abstract and human. The Yoruba goddess Osun and a pantheon of other Orisa (spirits or deities) inhabit the woods, protecting the surrounding trees and demanding respect. This is Osun-Osogbo, one of the last remaining sacred groves of South West Nigeria. It is both dense primeval forest and extraordinary sculpture garden, and now a renowned UNESCO World Heritage Site.

For centuries every Yoruba town would have a sacred grove established and cared for on its outskirts. Legend has it that a great hunter, Olutimehin, discovered the river here, and met the river deity Osun, who has powers of healing and fertility. He founded a city, Osogbo, which lies some 3 kilometres (1¾ miles) away from the sacred grove. The city people and many visitors from across the Yoruba diaspora come to the grove, washing themselves in the miraculous waters to bring luck, solve problems and honour the gods.

The history of the grove is a curious one. In the twentieth century it declined, as so many others did. Old observances were fading away, the land was being grabbed for farming and building, and ancient statues stolen for the antiques trade. In the 1950s the Austrian anthropologist and artist Susanne Wenger came to Osun-Osogbo and fell in love with the place and its religious significance. For the next half century, Wenger worked with local craftspeople to reignite the spirit of the grove, initiating the New

Opposite: Entrance to the Osun Shrine/Temple area leading to the Osun River.

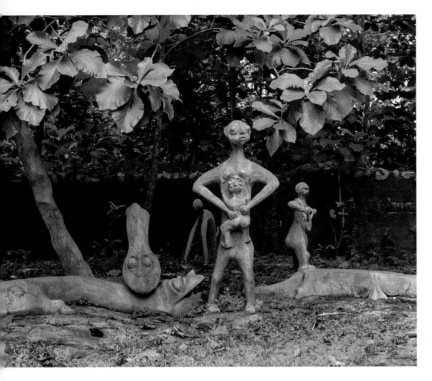
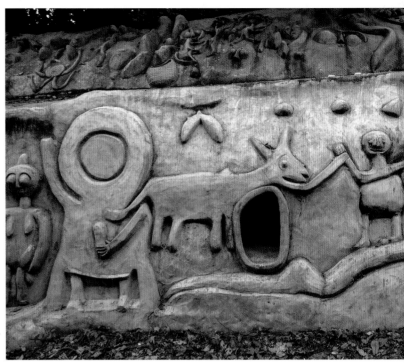

Above (left and right): Shrines, sculptures and artworks honouring Osun and other Yoruba deities.

Sacred Art movement. Together they created enormous works of art, towering deities of steel, concrete and mud, wall paintings and structures, all honouring the Yoruba pantheon. The ancient festivals and practices were revived, and Susanne acted as the 'Yeye' high priestess of the grove. She died in 2009 but her work continues, with the sacred grove valued both as a unique heritage site and as a living entity central to Yoruba identity.

Because the site is sacred, no felling of trees is allowed, and no hunting, so the grove is a sanctuary for flora and fauna as much as for the Yoruba people. The dense forest is rich in biodiversity, including some vulnerable species: African mahogany and ebony, zebrawood and karoi create a towering shelter, home to hornbills, flycatchers and a host of other birds. The grove is also a natural pharmacy, with more than half of the species growing there valued for their herbal properties. Pangolins and porcupines, tortoises and squirrels live within the

forest, though you may be lucky to see them. The ubiquitous white-throated mona monkeys you are unlikely to miss; they crouch like statues on the sculpted posts of the grove, scamper up the trees, and beg for food from the visitors.

Entering the grove is an otherworldly experience: two pathways intersect the woods, flanked by the characteristic red-toned walls and sculptures of the deities. Although well-informed guides can introduce the different deities, it is also worth exploring alone, as the serene yet powerful atmosphere of the grove takes time to seep into the mind. The ground is scattered with palaces, shrines, sacred places and worship points, with separate areas dedicated to different gods. The river goddess Osun is central, but many others of the pantheon appear: the great goddess Iya Moopo, with her three pairs of hands giving advice, blessing and regret; and Ese, the god of mischief, has his place. A devil sculpture sits at the junction of two paths and must be appeased with sacrifices of

palm oil or cassava flour to ward off bad spirits. The sculptures seem birthed from the earth, wearing the red tones of the mud – organic, skeletal and unsettling.

Through the core of the grove curves the wide muddy water of the River Osun. Yoruba people come to bathe here, to perform rituals, ask blessings and to bond with their Orisa or gods. A narrow suspension bridge spans the river, built without pillars interrupting the flow of the water, to avoid angering the goddess. Worshippers will be performing rituals and the sound of drumming and singing threads through the trees, alongside tourists wandering the paths.

Many people visit the Osun-Osogba Sacred Grove during the dry months from November to March, but the absolute highlight is the two-week festival that usually runs from July into August, when the people reunite with their gods. The culmination of many rituals is a procession winding carefully through the grove, led by the Arugba (votary maid) carrying a sacrificial calabash and other sacrificial objects, and protected on her journey by the Olose (whipping boys).

There are sacred groves remaining in Japan, Ethiopia, Siberia, the Himalayas and Australia, but nowhere else has quite the complexity of Osun-Osogba. This sanctuary of Yoruba culture and identity at once preserves the past, reveres the present and forges new art for the future.

Below: The grove's mature forest includes African mahogany and ebony, zebrawood and karoi.

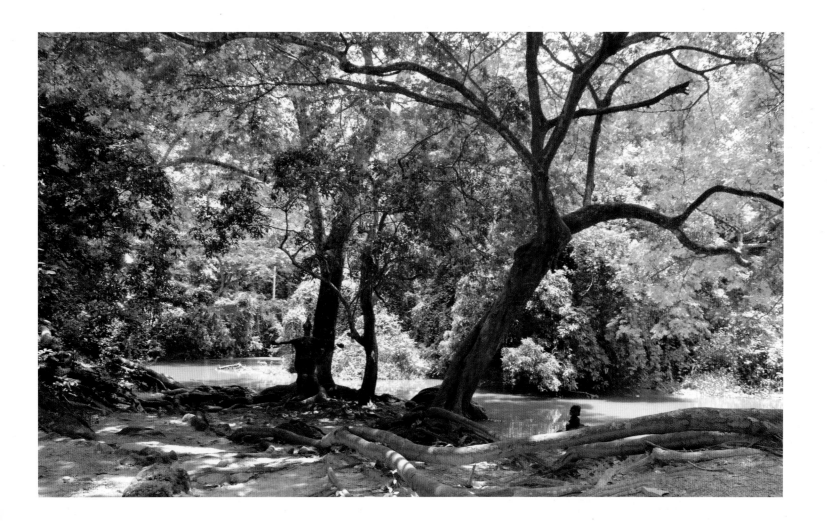

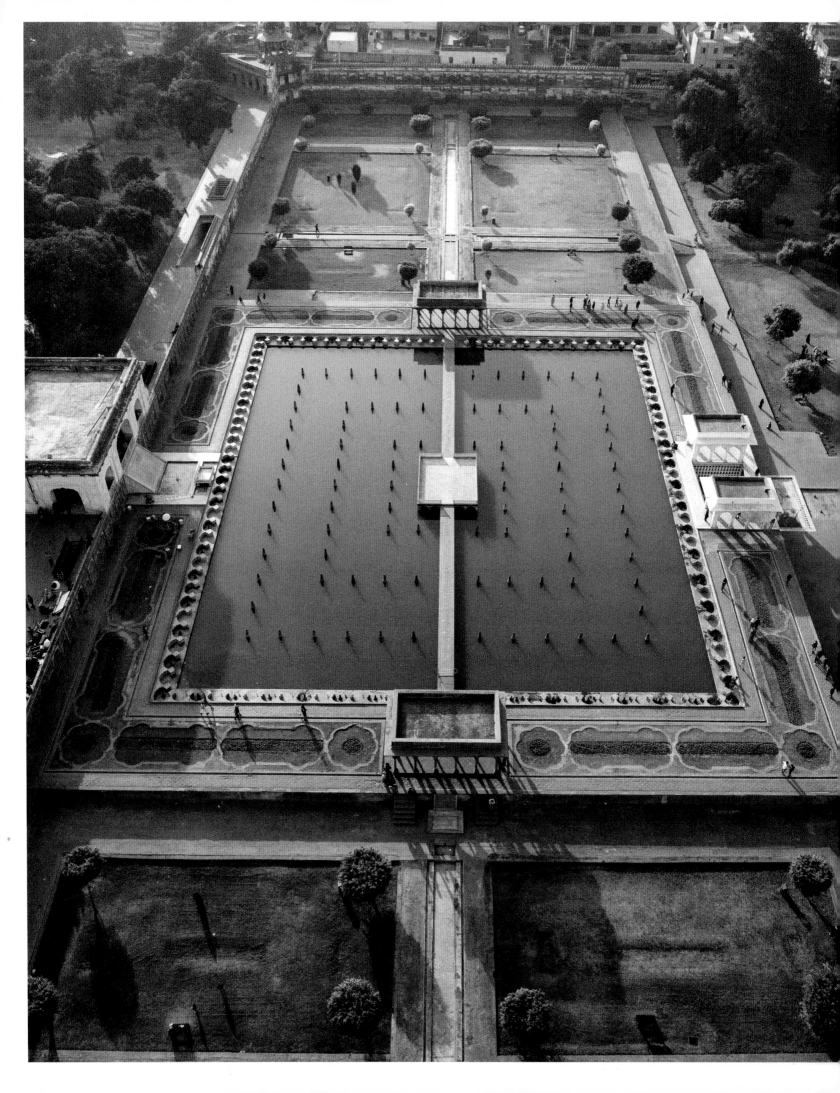

The Shalimar Gardens

Punjab, Pakistan

The design of eastern hemisphere gardens, including those of Persia and the Indian subcontinent, share many attributes rooted in the desire to create a representation of paradise on Earth that incorporates its beauty, harmony and spirituality. And for many garden enthusiasts, none achieve this more perfectly than Lahore's Shalimar Gardens, or Shalamar Bagh. As a typical Mughal garden, it reflects the fusion of Persian, Islamic and Indian architectural and horticultural traditions via a meticulously designed and symmetrical space that originated during the height of the Mughal Empire in the Indian subcontinent. It does so with extraordinary skill and elegance, and is often cited as one of the world's most perfect examples of the genre – no mean feat in a city which became known as the 'city of gardens' thanks to the number created by the Mughals from the sixteenth to the eighteenth centuries.

Mughal garden design is an extension of the style of Mughal architecture that reached the height of its fame during the thirty-year reign of the fifth Mughal emperor Shah Jahan between 1628 and 1658. Not for nothing was it known as the 'golden age', for Jahan (most famous for the creation of the Taj Mahal, page 173) undertook to develop and refine a style that already exhibited a strong character, emphasizing its symmetry and balance and paying meticulous attention to detail in every aspect of the architecture and landscape design.

This attention to detail is clearly evident in the gardens commissioned in 1637 by Jahan as a gift for his wife, Empress Nur Jahan, and conceived as a royal retreat and venue for imperial functions. Begun in 1641, construction of the gardens was completed in just one year, an extraordinary feat given its technical aspects, the intricate achievement of which still impresses engineers and historians almost 400 years later.

Left: The Shalimar Gardens' three descending terraces.

The water for the channels, pools and irrigation of the garden, for example, was brought from the Shāh Nahar (Royal Canal, later known as the Hansti or Laughing Canal) from present-day Madhpur in India, a distance of more than 161 kilometres (100 miles).

Symbolism plays a large part in Mughal garden design, not only in the infrastructure but in the planting too, with fruit trees symbolizing youth and life and cypress trees representing eternity planted along the main axis of the garden. That symbolism is seen to great effect at Shalimar Bagh in Srinagar, constructed in the seventeenth century by Emperor Jahangir; at the Pinjore Gardens (also known as the Yadavindra Gardens) near Chandigarh, influenced by both Mughal and Rajasthani architectural styles, and as such a unique blend of influences; and at Humayun's Tomb Complex in Delhi which, while primarily known for its magnificent tomb, also features beautiful Mughal gardens in the *charbagh* layout, creating a serene atmosphere that perfectly complements the grandeur of the tomb. The spaces were also meant to show off the Mughal rulers' connection to nature, but the greatest symbolism lies in the very existence of these splendid gardens, for more than anything they were constructed as status symbols – symbols of power, intelligence, refinement and knowledge. No one understood this better than Jahan.

Below: The water for the channels, pools and irrigation of the garden was brought more than 161 kilometres (100 miles).

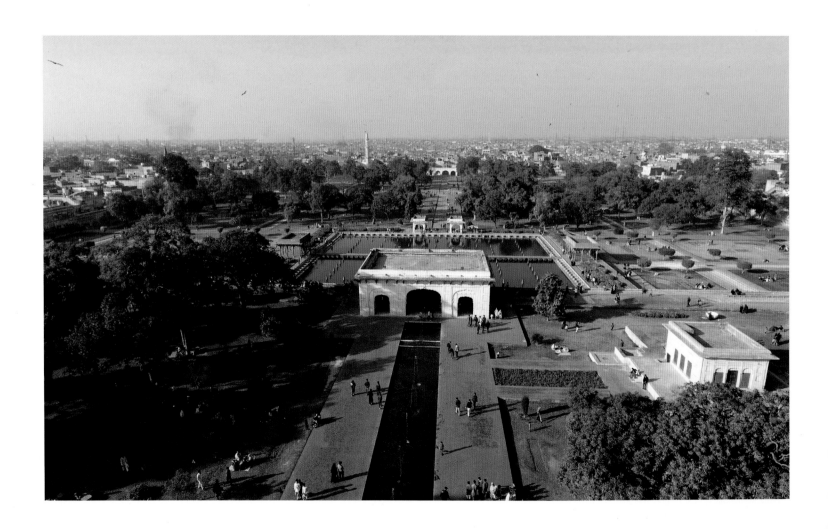

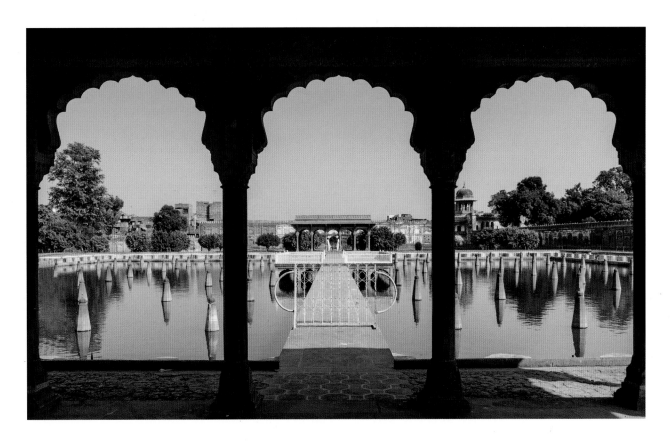

Modelled on the Royal Gardens in Kashmir, the Shalimar Gardens are about 228 metres (748 feet) wide and 548 metres (1,798 feet) long and comprise some 32 hectares (79 acres) of terraced, walled gardens, with three descending terraces elevated 4–5 metres (13–16½ feet) above one another. Water channels traverse and connect all three terraces, feeding 410 pools and fountains. As with all royal Mughal gardens, the Shalimar's are divided into the outer public part, the emperor's private area, and the *zenana* garden for the women of the household. Two of the terraces, the upper and lower, are designed as *charbaghs*, a form originating in Persian garden design and often used by the Mughals as a reflection of the Islamic concept of paradise. In the design, each of the square gardens is divided symmetrically into quarters by large water channels, with the lower terrace further sub-divided into four parterres by smaller channels.

All three of the garden's terraces feature intricately designed pavilions which, combined with the symmetrical design, the sound of the water flowing along the channels and bubbling or cascading in the fountains, and the vibrant colours of the meticulous planting, create a captivating and aesthetically pleasing space, heightened by the use of beautiful marble, fretwork and expansive views of the surrounding landscape. But while beauty was paramount in the creation and design of the garden, Jahan carefully considered practicality too, using strategically placed reflecting pools and pavilions to provide shade and viewpoints.

All three terraces would have been planted with a wide variety of flowers

Above: Vistas framed by arches and pavilions placed to provide shade.

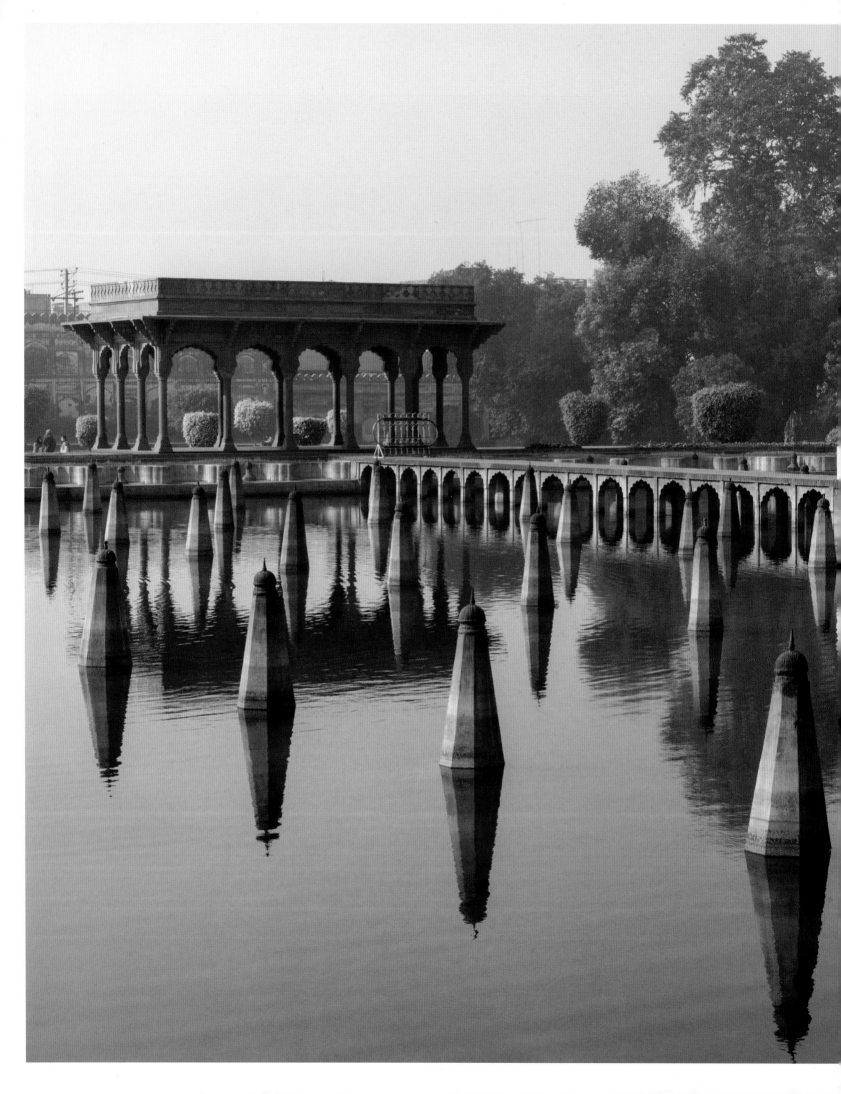

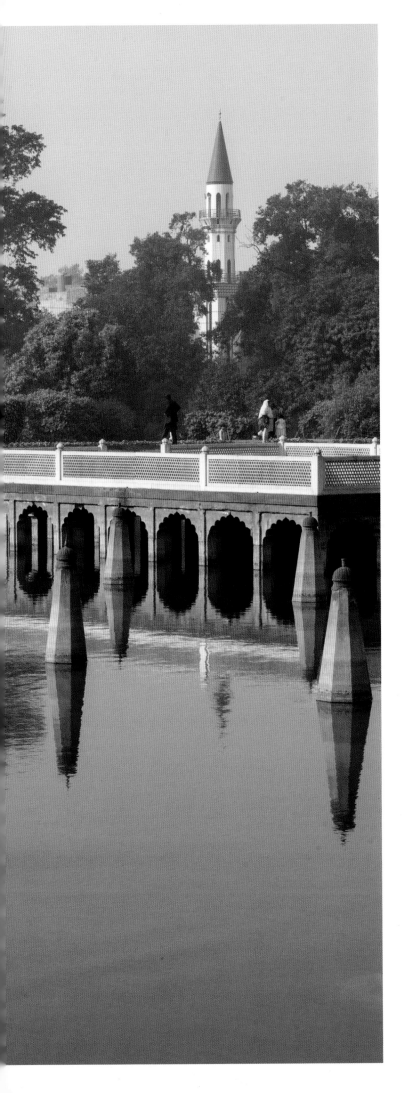

and trees, including cypress, poplars, evergreen pines, roses, jasmine and a huge range of fruit trees, including almond, apricot, cherry, mango, mulberry, quince, peach, plum, pomegranate, fig and citrus. Just as the design of the garden had its practical aspects, so too did the planting, with fragrant flowers such as roses, jasmine and lilies, shady havens and even the fountains all designed to offer a delightful sensory experience and an escape from the scorching heat of the summer months.

That the garden exists today, and appears to be in as splendid a state as it was when Jahan created it almost 400 years ago, is down to the kind of restoration work that you can't help thinking would have impressed even the mighty Mughal emperor. During the eighteenth century it was robbed of most of its decorative works in marble, red sandstone and *pietra dura*, and its subsequent fall into disrepair and neglect saw much of its planting destroyed too. But a century on, and with the help of historians, botanical experts and horticulturalists, original planting schemes have been identified and reintroduced, and traditional horticultural techniques that were prevalent during the Mughal period are used again.

It's thankfully all paid off; in 1981 the Shalimar Gardens were designated as a UNESCO World Heritage Site, ensuring their future and making them a vital visitor attraction to the thousands who come to appreciate the beauty, historical significance and harmonious blend of architecture and nature that the gardens offer.

Left: The middle of Shalimar's three terraces.

Jingshan Park

Beijing, China

The history of Taoist gardens dates back to a myth that began more than 2,000 years ago in 140 BCE. The fifth ruling monarch of the Western Han Dynasty, Emperor Wu Di, became obsessed with immortality and trying to tempt the Immortals away from their Mystic Isles so that he could learn the secrets of eternal life from them. In order to do so, he recreated the islands in gardens spanning, it's said, more than 129 square kilometres (49 square miles), simulating coastline, mountains and even the giant tortoises some of the mythical islands were built on out of rocks set across a vast lake representing the sea. Wu created the traditional Chinese lake-and-island garden, with its four indispensable elements of landscape, architecture, greenery and literature (represented by calligraphy and painting), that would become the basis for the Taoist garden.

At the heart of Taoism is the belief that everything in nature has its own spirit, and at the heart of a Taoist garden is the attempt to reflect those spirits and nature, creating spaces fit for the gods. Buildings and bridges are merely viewing points from which to admire and contemplate the garden's harmony between natural and artificial beauty. Jingshan Park, an imperial park covering 23 hectares (57 acres) immediately north of the Forbidden City in the Imperial City area of Beijing, is one of the best examples of this marriage of natural and artificial to create the perfect Taoist garden, one built on the possibility of adapting the natural landscape, as well as imitating it.

The park, which has also gone by the names Prospect Hill, Feng Shui Park, Wansui Hill (Long Live Hill), Zhen Hill and Meishan Hill (Coal Hill) was opened to the public in 1928, prior to which it actually formed part of the Forbidden City, dating back to the late twelfth century; indeed, it was created using the earth excavated from the moat around the palace and its nearby canals by the Yongle emperor Zhu Di in the belief that it would act as a feng shui shield for the palace. The park's five peaks,

Opposite: A mix of natural and handmade elements creates the perfect Taoist garden in Jingshan Park.

or 'mountains', are largely constructed from the mud dug out from the lakes, and are all topped by elaborate pavilions, each of which originally contained a copper Buddha statue representing one of the five tastes – sour, bitter, sweet, acrid and salt. Unfortunately, four of the statues were removed by the troops of the Allied Expeditionary Force in 1900. Replacement statues were installed in 1999, which are the ones visible today. Chief among the pavilions, the three-tiered Wan Chun Ting (Pavilion of Everlasting Spring) still contains the Buddha it is dedicated to, Vairocana, and gives the very best views of the Forbidden City, from which it's separated by the palace moat. Elsewhere, near the front gate of the park, the Qiwang Tower is framed by green cypresses and acts as a cultural exhibition site for calligraphy, paintings and porcelain, fittingly perhaps given that it was built to enshrine the memorial tablet of Confucius.

Linking Jingshan's 'mountains' are bridges, covered corridors and paths flanked by trees, plants, rocks and stones, each carefully and respectfully placed by humans fulfilling their role as the keepers of balance between the forces of yin and yang – a central part of Taoism being the concept of humanity having a role in the Tao, the way of nature. Rustic, naturalistic steps lined with large pock-marked rocks looking for all the world like rockfalls clamber up the hills, and stone tablets feature too, including one marking the spot at which the last emperor of the Ming Dynasty, Chongzhen, committed suicide by hanging himself from a tree in 1644 after Beijing fell to Li Zicheng's rebel forces. Set amid the numerous water features, including mirror-like lakes, streams, waterfalls and lily ponds, the elements combine to create a truly magical garden. And one that includes an unusual feature for a Taoist garden, for while formal planting isn't traditionally

Below left: The Wan Chun Ting pavilion, containing a copper Buddha statue.

Below right: A stone tablet marking the site where the last emperor of the Ming Dynasty, Chongzhen, hanged himself in 1644.

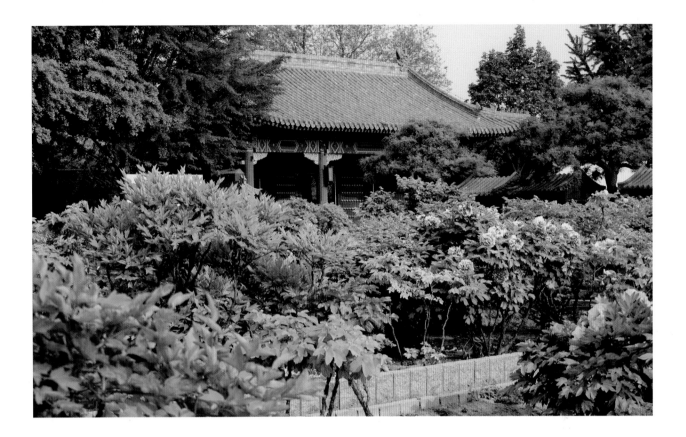

Above: Tree peonies
blooming in the park.

part of its make-up, Jingshan is notable for the biggest peony rose garden in Beijing, containing 200 varieties of the plant, as well as peach flowers, winter jasmine, tulips and roses that create a blaze of colour in spring; come autumn, it's the turn of the majestic trees to show off their hues.

The planting, views and beauty of the space make it a popular place for people to gather. You will often find people dancing, singing opera, practising Tai Chi, playing Chinese chess and performing *kuaiban* – a form of free rhyming oral storytelling performance. You can't help feeling that Emperor Wu, with his love of poetry, would have approved of these performances – particularly given *kuaiban*'s percussive use of bamboo, a natural element which in Chinese culture has long symbolized the elasticity, longevity, happiness and spiritual truth of life, and throughout the ages has had extremely profound symbolic meanings for Buddhist and Taoist poets, writers and painters.

Jingshan isn't the largest Taoist garden, but the views it affords, the harmonious balance of its natural and handmade elements, and its long history make it an essential part of Beijing's centre – a city which also offers at least three other very different Taoist treats at the Lodge of the Quiet Heart, the Palace Garden of Peaceful Longevity (in the Forbidden City) and the Garden of Harmonious Pleasures – part of the Garden of Ease and Harmony at the Summer Palace, where the exquisite eighteenth-century Jade Belt moon bridge (also known as the Camel's Back Bridge) is just one of the many pleasures to be found. That the palace, a World Heritage Site described by UNESCO as 'a masterpiece of Chinese landscape garden design' doesn't have its own entry in this book is purely because it would be impossible to do it justice in just a few pages.

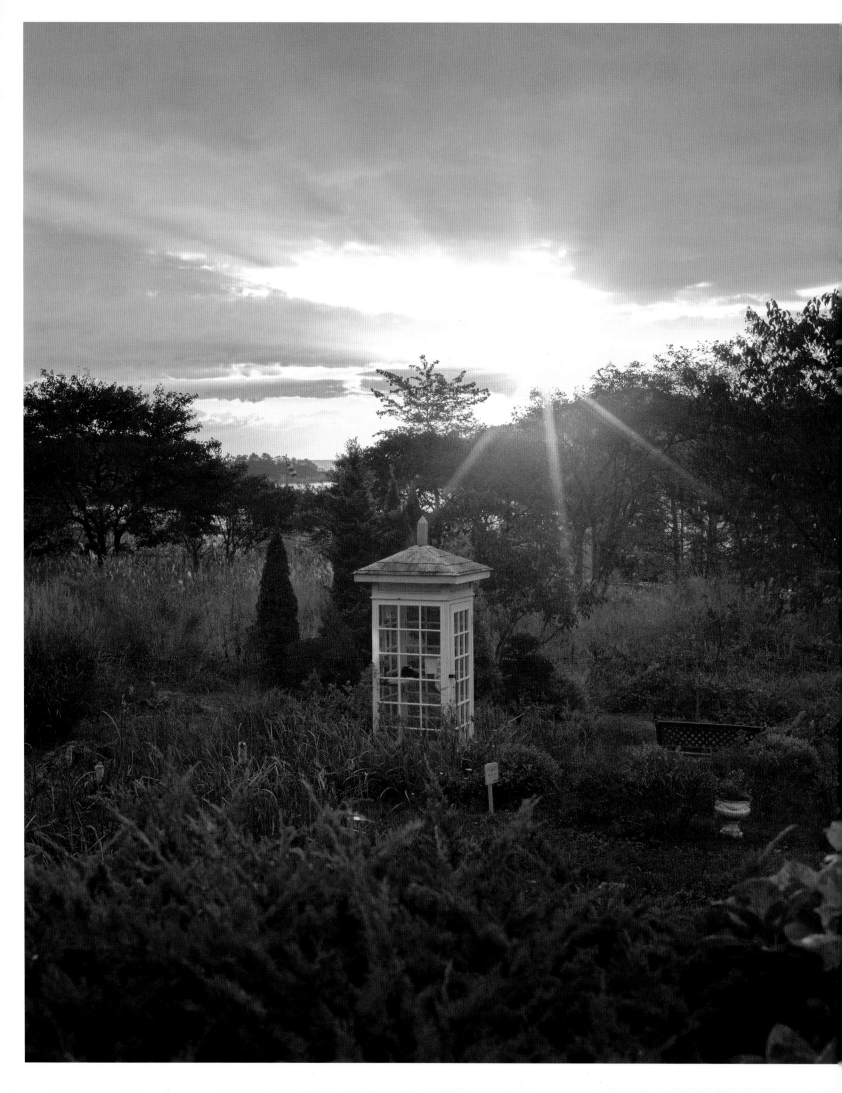

Bell Gardia

Iwate Prefecture, Japan

When garden designer Itaru Sasaki put a white phone booth containing an old-fashioned black rotary dial phone in his garden near Otsuchi, little did he realize the resonance it would have. Located on a beautiful hilltop setting overlooking the Pacific Ocean near Kujirayama in the Iwate Prefecture on northeast Japan's Tōhoku coast, within a decade of its installation, this phone booth has been visited by more than 35,000 people, had numerous articles written about it, and become the subject of not just international books and documentaries, but movies too.

Sasaki placed the phone box, now known as the Phone of the Wind, in the lush, beautiful Bell Gardia garden in 2010, following the death of a much-loved cousin he wanted to stay connected with. He would, he has said, go into the phone box and, lifting the receiver of the unconnected phone, dial the number of his cousin and speak to him, finding solace and comfort in the act of having his thoughts being 'carried on the wind'. A year later, the devastating Tōhoku tsunami caused by the Great East Japan Earthquake took the lives of more than 15,000 people in the region, among them more than 1,200 local residents, over 400 of whom are still unaccounted for. Sasaki opened the garden to mourning relatives and friends, and word quickly spread; from first near and then far they began to appear at Sasaki's home, wanting to use the wind phone, or *kaze no denwa*, to 'talk to' their lost loved ones.

But the phone is not an isolated connection to loved ones. The wider garden, and its location, play their part too in creating a very personal space of reflection and remembrance for the bereaved relatives and friends of those lost to them – increasingly, in more recent years, through suicide or sudden death. The very act of getting to and finding the garden are a kind of preparation, for it's not especially easy to get to, and

Left: Bell Gardia's white phone box and garden.

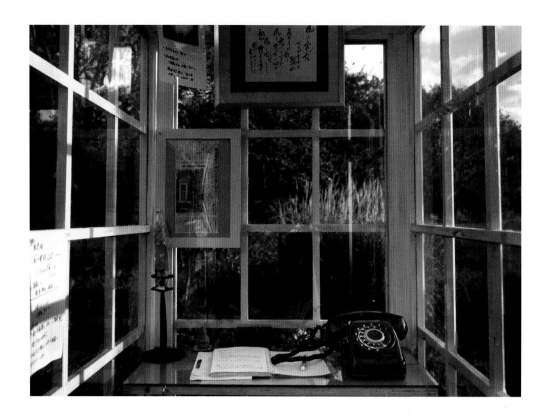

Above: The unconnected phone of Bell Gardia and notes visitors have left in the booth.

Opposite: Conifers, cherries, acers and maples are just some of the many trees set in the mature gardens.

signposts are understated and subtle. The winding route up to the hilltop provides plenty of time for meditation, with glimpses of the sea coming in and out of view as you travel up to the garden acting as a constant reminder of the ocean's ever-present beauty, but its ever-threatening power too.

On reaching the garden, different spaces within it create a gently unified whole that emphasizes connections to each of the senses. At the Library of the Woods, a lovely stone building set amid the shade of a forest, visitors can borrow from some 4,000 books to read on the nearby lawn, on a wooden bench under the shade of a tree, or even in a tree house. It's an environment, says Sasaki, where 'when you step outside, the world in the book is there', the reader's senses heightened by touching, hearing and seeing some of the things they may be reading about.

But it's the garden the phone box is set in that's the real delight of Bell Gardia. Ponds are home to frogs, spot-billed ducks and pheasants; dragonflies create darts of bright colour; arches and pergolas are wreathed in climbing roses or located in meadow-like areas filled with bursts of poppy red and cornflower blue; and everywhere beautifully tended shrubs and plants are protected and shaded by all manner of trees, among them conifers, cherries, acers and maples. Benches are everywhere, places of rest and contemplation for the people who have emerged from the phone booth, or are about to enter it, or just want to be in this intensely spiritual space.

Replicas are appearing around the world, but this original, described by Sasaki as a place for 'prayer' unconnected to any religion, and by its many thousands of visitors as a spiritual space in which to remember loved and lost ones, is clearly, for them, a sacred spaced detached from doctrine but with faith at its very heart.

Bagh-e Fin

Isfahan, Iran

Persian gardens are often markedly different from their Western counterparts. Where the latter are dominated and dictated by plants, sometimes lush and green, sometimes pruned and shaped, in a Persian garden planting is present, but it is just one element in the highly delineated rectilinear space in which paths, channels, fountains, springs and pavilions create a garden meant to be a reflection of the Islamic concept of paradise. It is a concept best seen in the *charbagh* (four gardens), in which water is by far the most dominant, and most symbolic, feature.

The use of water as a spiritual element in a Persian garden goes back much further than the Qur'an; all the way back to the Sasanian Empire and Zoroastrian religion prominent between the third and seventh centuries, when flowing water and fruit trees played an important role in the design of gardens, which, evidence shows, featured fountains and ponds. Always divided into four sectors, with water playing an important role for both irrigation and ornamentation, the Persian garden was conceived to symbolize Eden and the four Zoroastrian elements of sky, earth, water and plants. It was the Arab invasion of the seventh and eighth centuries that saw this style of landscaping deftly brought in as the *charbagh*, emphasizing Heaven, which the Qur'an describes as a location where two rivers converge and divide the garden into four quadrants.

One of the gardens that best exemplifies the desertscape Persian garden is the Bagh-e Fin (Fin Garden), some 9 kilometres (5½ miles) from the city of Kashan in the village of Fin, in Iran's central province of Isfahan. As the country's oldest surviving garden, and one of the nine gardens that form the UNESCO World Heritage Site known as the Persian Garden, it brings together all the features and elements mentioned above. The contrast begins with the arid, inhospitable desert landscape beyond its walls and

Opposite: Cedars and cypresses shade water canals and lower intense desert temperatures.

the abundance of life inside them, life nurtured by the constant flow of water which originates in the aquifers of the Karkas Mountains to the south and is carried by an underground aqueduct system, called a *qanat,* to a reservoir about 1.6 kilometres (1 mile) away from the garden. This is no mean feat for a project dating back more than 400 years to the late sixteenth-century Safavid period, though most of what is visible today was undertaken during its eighteenth- and nineteenth-century restoration, and repairs in the early twentieth century.

Following the traditional *charbagh* layout, Bagh-e Fin comprises a large quadrangle bounded by a high wall, with four towers at the corners and a monumental two-level entrance in its south façade. Water enters the garden via clay pipes at the main pool housed in the Howz Jushan (also known as the Hows Joosh, Hoz-e-Joosh or Soleymanieh) pavilion, from which twelve springs emerge to run through canals lined with eye-catching turquoise ceramic tiles. The colour is in striking contrast to the colour of the desert surrounding the garden, and is a 'trick' used in many Persian gardens to create an illusion of depth – in truth, the channels are generally just a few inches deep. But as with so many elements of the garden's design, the tiles are not just decorative; they also connect the garden creatively to its local community of Kashan, which has a long tradition of ceramic decoration.

A central pool is dotted with small fountains and bordered by large trees which shade the waterside parterres with towering cedars and cypresses (symbolizing both death and eternal life), some of which are thought to be

Right: The Qajar Kushk recreational pavilion.

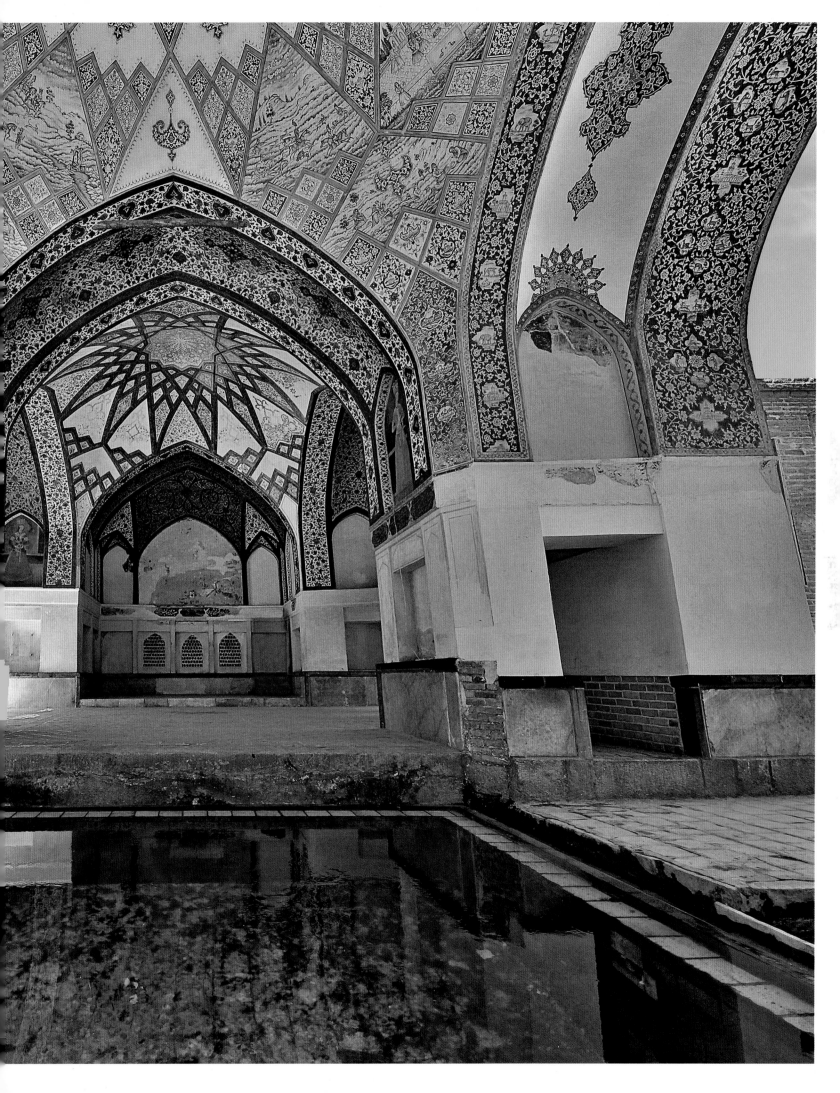

Above: Following the traditional *charbagh* layout, Bagh-e Fin comprises a large quadrangle bounded by a high wall, with four towers at the corners.

Right: Decorative glass windows have practical applications, cooling one space in summer and warming another in winter.

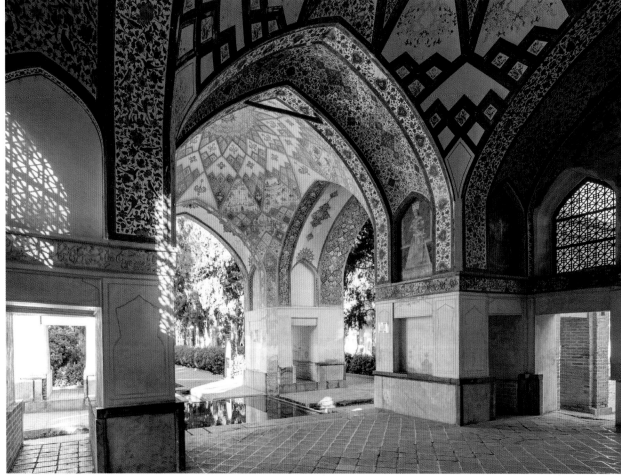

up to 500 years old, while numerous varieties of fruit trees – among them almond, apple, cherry and plum – feature alongside borders and beds filled with flowers such as lilies, iris, eglantine, rose bushes, jasmine, amaranth, gillyflower, narcissus, violets and tulips. Light stone pathways contrasting with the deep blue of the water rills and painted plaster and woodwork add to the vibrant palette, creating a bold contrast with the monotone landscape beyond the garden.

While the planting and water features are eye-catchingly lovely, a range of beautifully constructed and decorated pavilions and buildings built during the Safavid and Qajar periods add further to the appeal of the garden, among them the pavilion called Safavid Kushk (or Shotor Gelou), a two-storey pool house with water running through the middle of the ground floor. Set opposite the Emarat-e-Sardar entrance to the south, the effect created by looking down the length of the garden to the exquisitely tiled pavilion is nothing short of magical. But a domed recreational pavilion at the back of the garden, the Qajar Kushk, only increases the garden's enchantment, its rooms and ceilings decorated with beautiful paintings, tilework and coloured glass windows that again have a practical as well as decorative role: one room's blue, white and green glass cools and soothes visitors as well as making the room look bigger, while another's red, orange and yellow glass has the opposite effect, making the room seem warmer in winter.

Integral to Bagh-e Fin are its two bathhouses, or *hammams*, one of which gained notoriety when the modernizer, nationalist and prime minister Mirza Taqi Khan, more commonly known as Amir

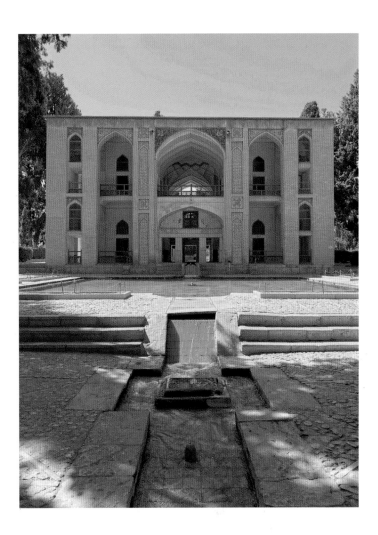

Kabir, was imprisoned in the garden and murdered (though some say he ended his own life) in the bathhouse in 1852, supposedly on the orders of Nasir al-Din Shah, who he was serving under. With its tranquil, shady setting and lovely tiles, it's a popular spot with Iranians, who come to pay homage to a national hero, and a good place to reflect on the mastery of the Safavid and Qajar periods that produced this beautiful garden. Though for that, enjoying a drink in the Fin Garden tea house near the source of the spring, watching the fish flit through the shadowy waters under the shade of the many trees, really does feel like paradise.

Above: The Safavid Kushk (or Shotor Gelou).

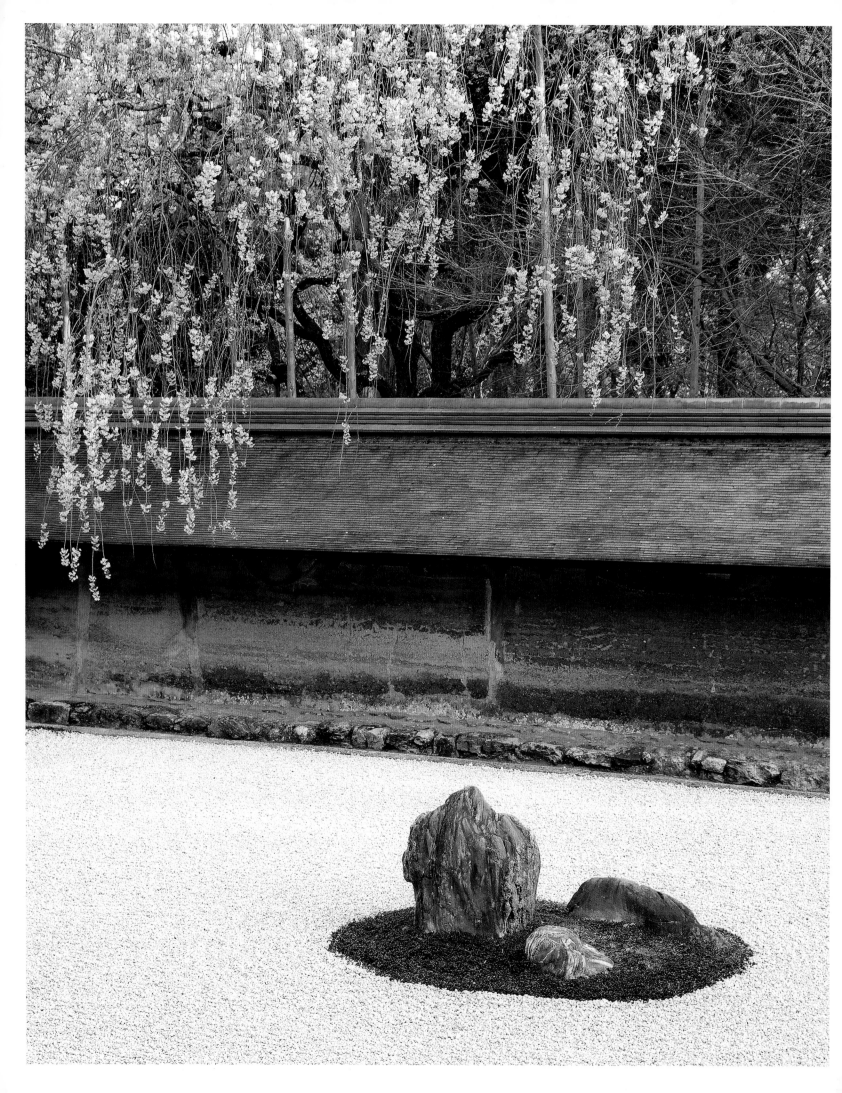

Ryōan-ji

Kyoto, Japan

'Zen' has become a by-word for calm, since some of the main principles of Zen Buddhism are to be present, mindful and fully experience each moment. The Zen Garden, by extension, is designed to provide a natural space for reflection and spiritual renewal. Given their historical heritage, there are many thousands of such gardens across Japan, and most are attached to shrines and temples, but one of the most revered is to be found at the Ryōan-ji (Dragon at Peace) temple in the cultural heart of Kyoto. Dating back to the late fifteenth century, it is considered to be one of the most important examples of *karesansui* (rock garden) in the world.

The use of stone in gardens goes back to the Heian period (794–1185), but formalized rock gardens began to be built in Japan in the fifteenth and sixteenth centuries. The original creator of Ryōan-ji is unknown, but it is believed that the temple and its garden were commissioned by the Hosokawa clan in the fifteenth century. The Hosokawa, an influential Samurai family, were prominent patrons of the arts, supporting many cultural activities, including the Japanese tea ceremony, Noh theatre and Zen Buddhism. The garden was most likely designed to be a meditative space for the monks to cultivate mindfulness and self-reflection. Over the years it has undergone restoration and maintenance, but its original essence and design principles have been preserved.

At first glance, the flat rectangular garden appears deceptively plain, empty and severe. It measures approximately 30 metres (100 feet) from east to west, and 10 metres (33 feet) from north to south, and is enclosed by an earthen wall. Fifteen carefully positioned rocks of various sizes have been placed in a sea of meticulously raked white gravel. But it is precisely the self-restraint of the design that has been captivating visitors for centuries and is thought to aid reflection and meditation.

Opposite: Cherry blossom hanging over three of Ryōan-ji's carefully positioned rocks.

Simplicity (*Kanso*) is one of the core principles of Zen beliefs, along with Austerity (*Koko*), Asymmetry (*Fukinsei*), Mystery or Subtlety (*Yugen*), Magical or Unconventional (*Datsuzoku*), Naturalness (*Shinzen*) and Stillness (*Seijaku*). The garden's profound symbolism and balance is created by capturing each of these elements. The austere design is asymmetrical, which serves as a visual reminder of the beauty of the irregularity that can be found within nature itself.

The rocks of varying sizes are placed in groups of two, three and five, so that, no matter where one stands, it is impossible to see all fifteen rocks at the same time, which is at once magical and mysterious. This deliberate arrangement invites viewers to engage in active contemplation.

The garden's aesthetics also embody the principles of *wabi-sabi*, a Japanese concept that embraces imperfection and transience. The rocks represent islands or mountains that appear to emerge from the sea or clouds, evoking a sense of eternal within the finite. The gravel, a symbol of purity, is raked in linear patterns to resemble the ripples in water, which is a symbol of the continuous flow of time and change.

The absence of plants allows one to focus solely on the minimalist arrangement and interplay of the rocks, but beyond the garden there is 'borrowed scenery' of cherry, maple and pine trees. Though outside the garden itself, these add colour and texture and are considered part of the overall design.

Aside from the trees, away from the rock garden, the temple grounds also feature serene ponds, lush greenery and carefully manicured landscapes that further enhance the harmonious environment. A stone water basin (*tsukubai*), with water flowing through a bamboo pipe (*kakei*), holds particular symbolic significance as it emphasizes the importance of purification of the mind and body before entering sacred spaces. The *tsukubai* also features four *kanji* that, when read alone, are meaningless, but when read together (including the middle square hole 口), become 吾 唯 足 知. Their literal meaning, 'I learn only to be satisfied', can also be paraphrased as meaning 'If you learn to be satisfied, you are spiritually rich'. And the complex also includes a Hojo (Abbot's quarters). Traditional Japanese architecture includes sliding doors, tatami mat flooring, and a raised wooden veranda that overlooks the garden. Visitors sit on the veranda, or find a space along the garden's perimeter, where they can quietly reflect or meditate.

Below: A *tsukubai* (stone water basin), with water flowing through a bamboo pipe (*kakei*).

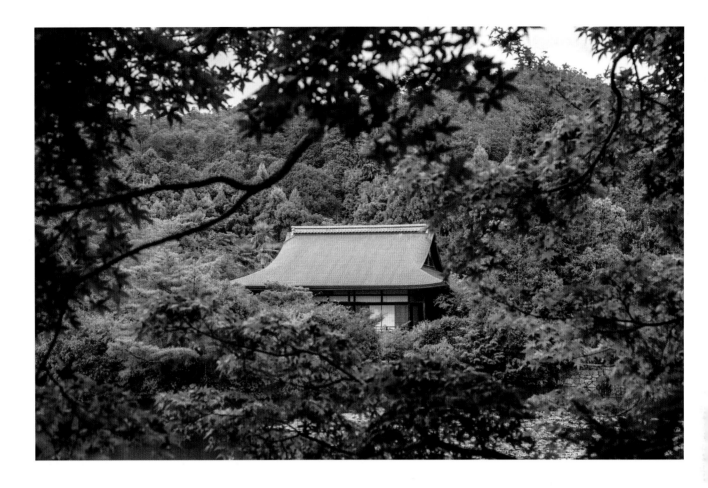

Unsurprisingly, many artists and architects have been inspired by the simplicity and harmony of the garden and complex, including Frank Lloyd Wright, renowned for his integration of the natural world within his work. What many people regard as his best work, the residential property Fallingwater, in Pennsylvania, USA, used cantilevered balconies and layered horizontal lines to reflect the harmony between architecture and nature.

The work of Japanese-American sculptor Isamu Noguchi, which often features clean lines and natural materials, is also reminiscent of the aesthetic qualities found in the Ryōan-ji rock garden. And when American composer and avant-garde innovator John Cage visited Japan in 1962, he was clearly inspired by Ryōan-ji; more than twenty years later he created a series of drawings, Where R = Ryoanji, and, between 1983 and 1985, a series of musical compositions for various instruments, including trombone, percussion and clarinet, also called *Ryoanji*.

Ryōan-ji is listed in the Historic Monuments of Ancient Kyoto and is a UNESCO World Heritage Site. Understanding the cultural context and significance of the rock garden enhances the overall experience and appreciation of the site, and visitors can learn more about the history, architecture and Zen Buddhist traditions associated with the temple through informational plaques and guided tours. But it's through wandering the complex independently, and spending time with the rocks in the garden, that you'll learn the most about it.

Above: Building beside the pond at Ryōan-ji Temple.

Pages 170–1: Ryōan-ji's *karesansui* (rock garden), with just fifteen rocks, is thought to be one of the best in the world.

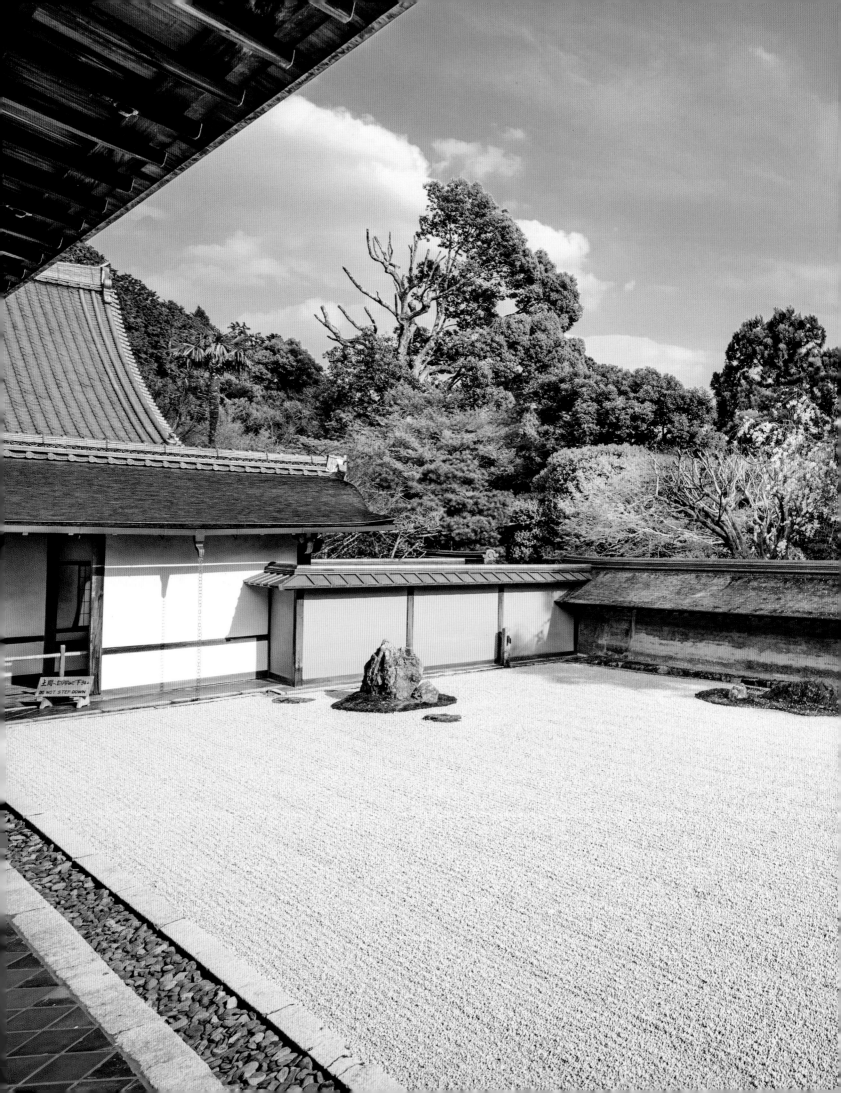

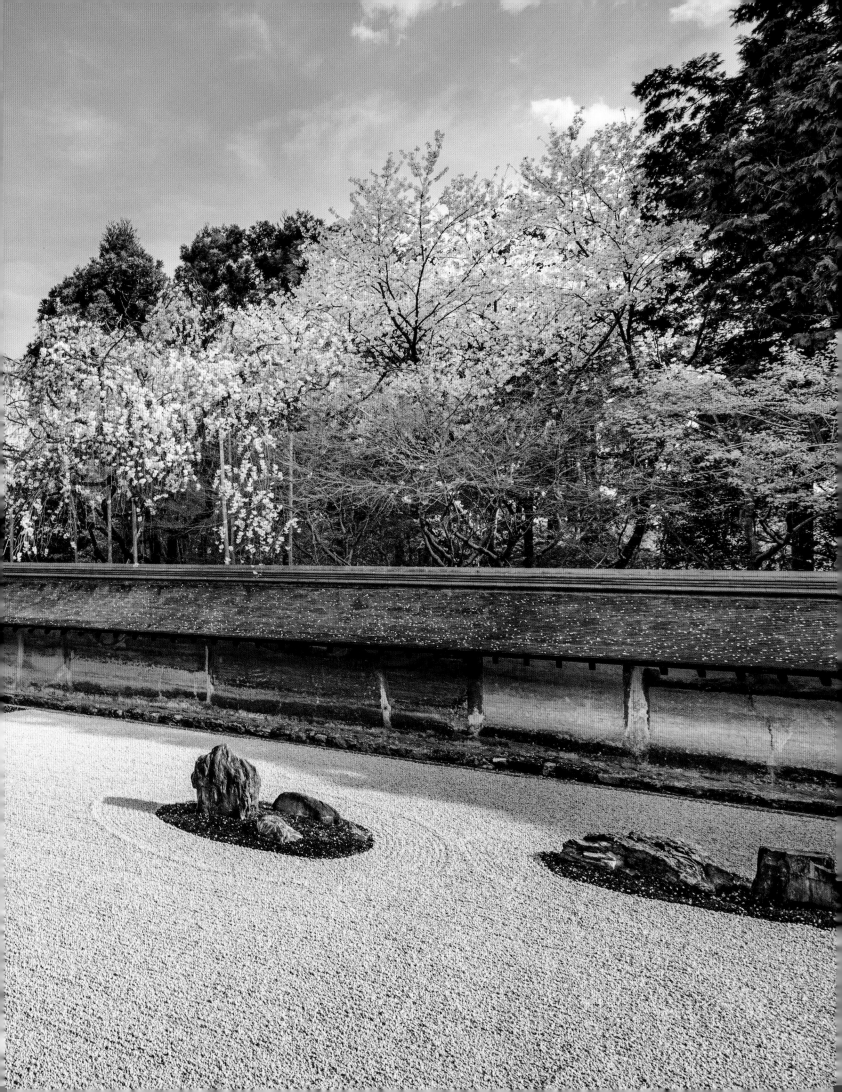

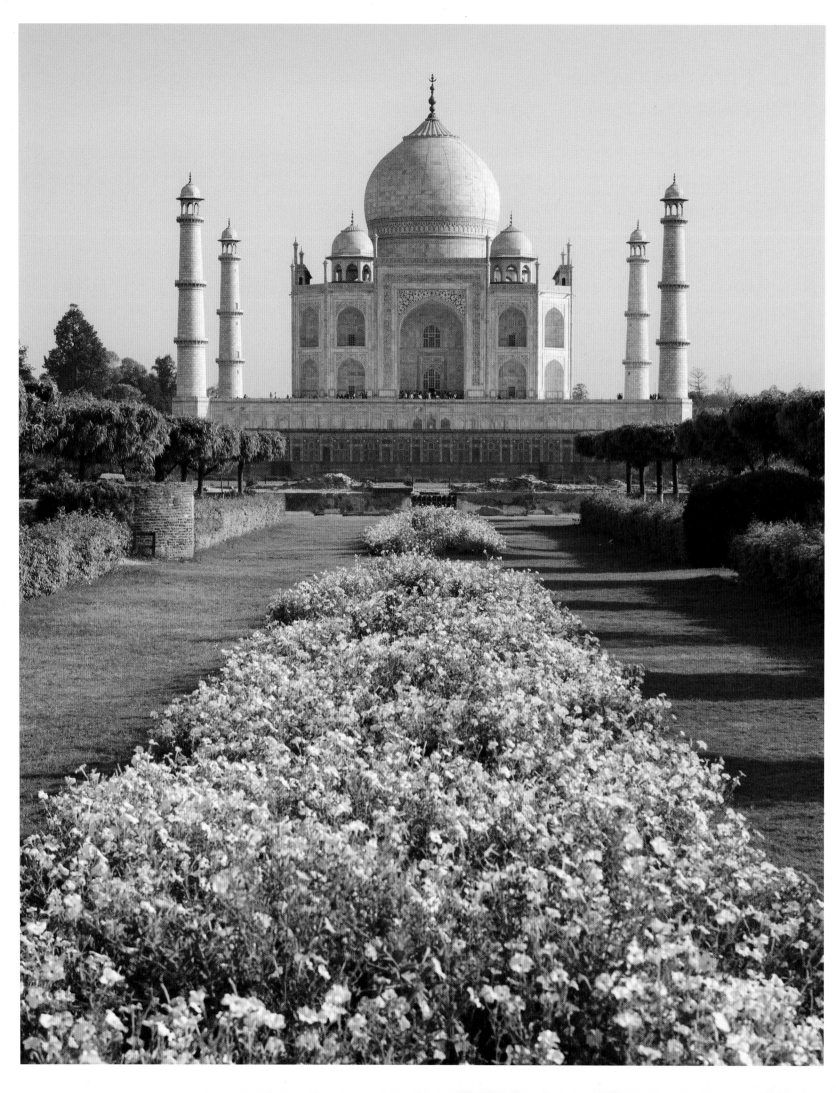

Mehtab Bagh

Uttar Pradesh, India

Take a straw poll among friends on the most romantic tourist attraction on the planet and the consensus will surely be the Taj Mahal, the mausoleum on the south bank of the River Yamuna in Agra, Uttar Pradesh. Commissioned in 1631 and finally completed in 1653 by the fifth Mughal emperor, Shah Jahan, to house the tomb of his favourite wife, Mumtaz Mahal, its gleaming white marble tomb, which also houses the remains of Shah Jahan, is the centrepiece of a 17-hectare (42-acre) complex tramped through every year by up to eight million visitors. All are keen to experience – and of course capture on their phones – the beauty of the timeless gardens, making it quite difficult to achieve the quiet contemplation one usually seeks in such a space. Luckily, there is a smaller garden just across the river from the Taj Mahal that's the perfect place for that. Standing in it, watching the hoards descending on the mausoleum at sunset, when the bright white marble is bathed in orange and red, and flocks of waterbirds rise over the river in front of it, you'd be forgiven for feeling a tad smug from your vantage point of the Mehtab Bagh, which as an added bonus offers the best view of the elaborately decorated riverfront terrace (*chabutra*) on which the tomb sits.

Some schools of thought say that the alignment of the Mehtab Bagh (Moonlight Gardens) with the Taj across the river means that Shah Jahan built it as an extension of – or even a part of – the main tomb complex. The mausoleum's placement, not in the heart of the Taj Mahal gardens, as one might expect, but at the end of a long courtyard that places it in the middle of the *two* gardens, certainly lends credence to this idea. Why would the Shah have done this? It's thought that, planted with fragrant flowers and shrubs whose heady scents would infuse the air, the Mehtab Bagh would be the perfect place from which to view the mausoleum at night. White pathways bounded by red sandstone walls, further heightening the luminescence of the site in moonlight,

Opposite: View towards the Taj Mahal; the Mehtab Bagh sits on the opposite bank of the River Yamuna in alignment with the mausoleum's garden.

Above: A misty view of the Mehtab Bagh.

to Shah Jahan, who rediscovered and repurposed the garden almost a century after its creation, retaining the *charbagh*'s quadrilateral layout, with its dividing channels symbolizing the four rivers of wine, honey, water and milk, and the other traditional elements of a Mughal garden – flowers, pools, fountains, pavilions, bridges and fruit trees. After his death, time and tides again put paid to the garden, only for it to be rediscovered in 1994, when the Archaeological Survey of India began the work of excavating and rebuilding the original.

These days, about eighty species of plants and trees, including cypress trees and a rose garden, help to frame the ivory complex of the Taj Mahal. In the high glare of dry season, sunlight all but obliterates the details of the building, but visit on a cloudier day and even from this distance it's easy to see the mausoleum's black and white inlaid pavement and even some of the larger decorative elements. For the smaller, delicately carved floral panels whose elements mirror the oblong flowerbeds of the mausoleum's parterres, you'll need to be a lot more close up. And it's close up that you'll best be able to appreciate the beauty of the mausoleum's own huge gardens, particularly in spring, when bluebells, daffodils, tulips, crown-imperials, lilies and irises fill some of the *charbagh*'s parterres with bright colour.

Raised walkways containing the central canal look down on these well-kept spaces, sub-divided again into sixteen large square gardens which are predominantly now given over to manicured lawns dotted with cypress trees perfectly placed to create a sense of order, but also to direct the visitor's eye to the riverside tomb. Above all, the

and the presence of a large octagonal lake perfectly placed to reflect the mausoleum at night from a nearby pavilion, bolster this idea further. There's a long-held belief too that Shah Jahan planned to construct a black marble mausoleum in the garden for himself, which would mirror that of his wife's, but was imprisoned by his son Aurangzeb before he could build it. But whatever the stories, the fact is that this garden was once as delightful as its counterpart across the river, and while its twenty-first-century iteration is a work in seemingly constant progress, with ongoing reconstruction work often undermining its design and planting, it is still a vital part of the Taj Mahal complex.

Dating first from the early sixteenth century, when it was supposedly built as the last of eleven *charbagh* gardens along the river's banks, the Mehtab Bagh has had such a turbulent history that it's amazing it's still there. This is in part due

symmetry and geometry that epitomized Mughal architecture during the Shah Jahan period create a harmony and balance that take one's breath away.

Viewed from either the red sandstone and marble inlaid gatehouse that sits at the entrance to the complex, or back from the mausoleum towards the gatehouse, the gardens are impressive, but it's the whole complex, including the Mehtab Bagh, that gives the site such a spiritual feel. Its combination of Indian, Persian and Islamic architectural styles so skilfully blended together – including elements such as Hindu umbrella-like *chhatris*, the hierarchical use of red sandstone and white marble, symbolic of ancient Indian traditions, the use of the *charbagh*'s central raised canal as a pathway to the tomb, the way that tomb is framed by the arched entrance of the gatehouse, and the view back onto it from the Mehtab Bagh – create a site whose overwhelming *raison d'être* of veneration and love is surely what lies at the heart of all sacred spaces. It is worth the effort to see the Taj Mahal as Shah Jahan supposedly intended it to be seen; it's a rickety 7-kilometre (4¼-mile) journey via the Ambedkar Bridge from the tomb complex to the Mehtab Bagh, but without making that journey, you're only seeing half the picture.

Below: The River Yamuna, which separates the Mehtab Bagh from the Taj Mahal gardens.

Milarri Garden

Victoria, Australia

The Aboriginal peoples of Australia have always had a deep relationship with the land, one that more developed societies could learn much from. Rather than a resource to be plundered, Aboriginal peoples revere the land as sacred, alive with spirits as well as flora and fauna, and are guardians of its treasures. Early European settlers were puzzled by the seeming lack of ownership or cultivation of the land, failing to see a deeper and more respectful co-existence.

Museums too have a troubled history with Indigenous Peoples, often marginalizing or dehumanizing them. The Melbourne Museum in Victoria has been on a journey to decolonize this imperialist past. The Bunjilaka Aboriginal Cultural Centre has been co-created within the museum with the Yulendj Knowledge Group, a group of elders drawn from many different communities and nations, to tell the stories of the First Peoples from their own perspective. The museum has been built on land on which Aboriginal people lived, dreamed, married, fought and died, over many generations, and now this precious space has been rededicated to telling their stories and preserving their knowledge. Integral to this endeavour is the creation of the Milarri Garden, showing how the Aboriginal ancestors lived lightly on the land yet cultivated and cared for it, knowing the potential of every plant.

Milarri means 'outdoors' in the languages of the Boon Wurrung and Woi Wurrung, the original inhabitants of the Melbourne area, and this connection to the outdoors is integral to an understanding of Aboriginal heritage. Filled with plants native to Southern Australia, the garden reflects the extraordinary storehouse of knowledge from First Peoples over 40,000 years of living intimately with the land. All the plants and trees here have been carefully nurtured to share the importance of this knowledge for medicine, food and tools.

Opposite: A soaring modern steel canopy at the museum contrasts with its more natural exhibits, one of which is the Milarri Garden.

The garden immediately evokes a wild indigenous landscape. A trail takes you through sheltered gullies and past rocky outcrops, a sculpture of the Rainbow Serpent, an open-air performance space and a cave with Indigenous paintings, winding through immense trees and across waterways. In this country of extreme heat and drought the importance of water is impossible to overstate, and the garden displays examples of the natural and managed watercourses used to irrigate the land. A creek cascades into a billabong which in turn fills a pool inhabited by eels. There is a daily feeding of the eels in Milarri pond, where a guide explains the significance of the fish to the Aboriginal people, their diet and their culture. A keen eye can spot the silver perch and Macquarie turtles that live alongside.

The garden teems with native species of Southern Australia. Here, you will find the drooping sheoak used to make boomerangs, the lilly pilly, whose tart juicy berries are used for food, and the messmate and austral mulberry, both important for creating fire. The cherry ballart, a multitasker of a tree, provides wood for spears, a succulent fruit stalk for food, the sap for snake bite and the leaves for smoking ceremonies. Even the smallest of plants have their place: the water ribbons for food and old man weed as a tonic to cure coughs and chest complaints. A guided trail helps the visitor to appreciate the knowledge hidden within, and to understand how Indigenous Peoples used fire and diverted water to manage the land and nurture the plants essential to their survival.

The aim of Milarri Garden is to acknowledge and preserve the amassed knowledge of many of the First Peoples, handed down over generations but in danger of being lost. The centre is named after Bunjil the creator spirit and tells

Below left: A cave with Indigenous paintings in the Milarri Garden.

Below right: Yellow gum (*Eucalyptus leucoxylon*) flowering in the garden.

the story … 'Bunjil sent the ancestor spirits to create the world … he sung the country … they made the mountains and valleys … he sung all the creatures … they made all the creeks and rivers … he sung … how to be in country.' For the First Peoples the tangible landscape and the intangible songlines that connect sacred areas and points are indistinguishable. This cultural heritage is imbued with meaning, and yet fragile in the face of the greed and ignorance of the industrialized world. The Milarri Garden teaches how to be 'in country'. The oneness of creation and interdependence of people and nature is here as a gentle reminder of what a precious inheritance the natural world is, and that we have long had models of better ways to respect and care for it.

Above: The garden is filled with plants native to Southern Australia.

Left: Indigenous trees in the garden include the messmate (*Eucalyptus obliqua*) and drooping sheoak (*Allocasuarina verticillata*).

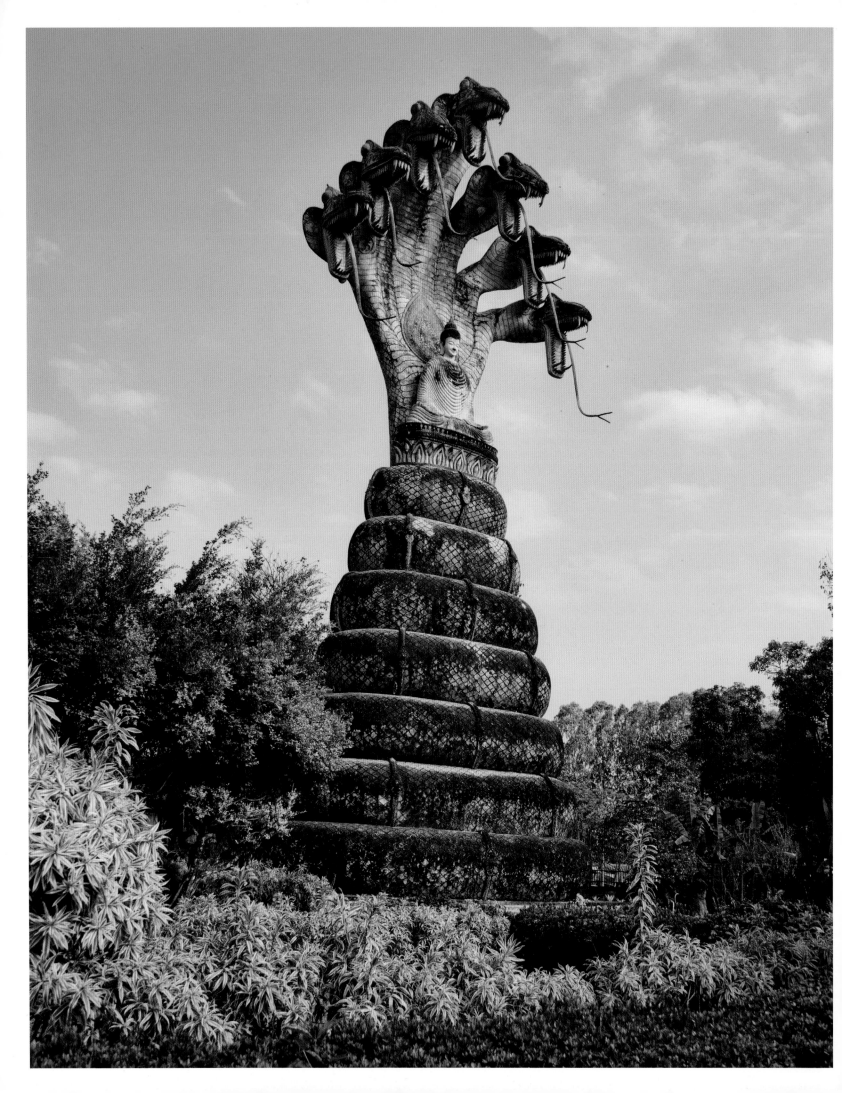

Sala Keoku

Nong Khai, Thailand

I s it a sacred garden or a sculpture park? Opinions differ, but what all agree on is the fact that Sala Keoku is a fascinating, and decidedly sacred, sculpture park, a huge site filled with a mix of natural and handmade beauty that venerates the Buddhist and Hinduist gods and beliefs followed by its creator, the visionary artist and mystic Luang Pu Bunleua Sulilat.

Born in 1932 on the Thailand side of the Mekong river, close to the site that would become Sala Keoku, Sulilat dedicated his life to the construction of the unique and spiritually inspired park. However, it wasn't the first of his projects to manifest his artistic and spiritual life – a life not only informed by Buddhism and Hinduism, but animist and mystical beliefs too. The artworks here and in his earlier, smaller sculpture park in Laos – Xieng Khuan, also known as the Buddha Park and similar in design and purpose – include not only religious deities and scenes from Buddhist and Hindu mythology but celestial beings and mythical creatures too.

It's hard to convey just how extraordinary the mix of all these sculptures is, particularly at Sala Keoku. With its intricately detailed and decorated concrete sculptures – more than a hundred of them, ranging in size and complexity and surrounded by beautiful planting – it looks like something created by a particularly artistic production designer on an Indiana Jones movie, and indeed clearly reflects not just the deeply spiritual side of their creator, but his artistic one too.

These dual interests first manifested themselves at Wat Pa Huak, a Buddhist temple in Laos in which Sulilat resided for several years. A charismatic and revered spiritual leader, he quickly attained a following due in no small part to the artistic inclinations and spiritual vision already evident during his time at the temple, where he created various sculptures and artworks intended to inspire and guide practitioners in their spiritual

Opposite: Buddha meditating under a seven-headed Naga – half-human, half-serpent.

journeys. The work led him to the creation of something bigger and Xieng Khuan was born, with construction taking place during the late 1950s and early 1960s. The Indo-China war sent him back across the border to his home, and in the mid-1970s, he and his followers began work on Sala Keoku.

Buddhism, with its emphasis on the cycle of birth, death and rebirth, is a central theme in many of the park's sculptures, and no more so than in the Wheel of Life, the Bhavachakra. This symbolic representation of the continuous cycle of existence, illustrating the various realms and causes and effects of karma, is visually manifested by Sulilat through a multilayered sculpture which one enters through an open mouth. Beyond it, a circular space features many representations of life, death and rebirth, some familiar, some fictional, some prosaic, some fantastical; here is a life-sized Communist soldier, complete with gun, there a young lovelorn couple holding hands in life then becoming a pair of skeletons in death, beyond them an elderly woman broken by life welcomes death, while a beautifully decorated nearby god carries fish.

Below: A diverse range of plants includes both ornamental and tropical varieties.

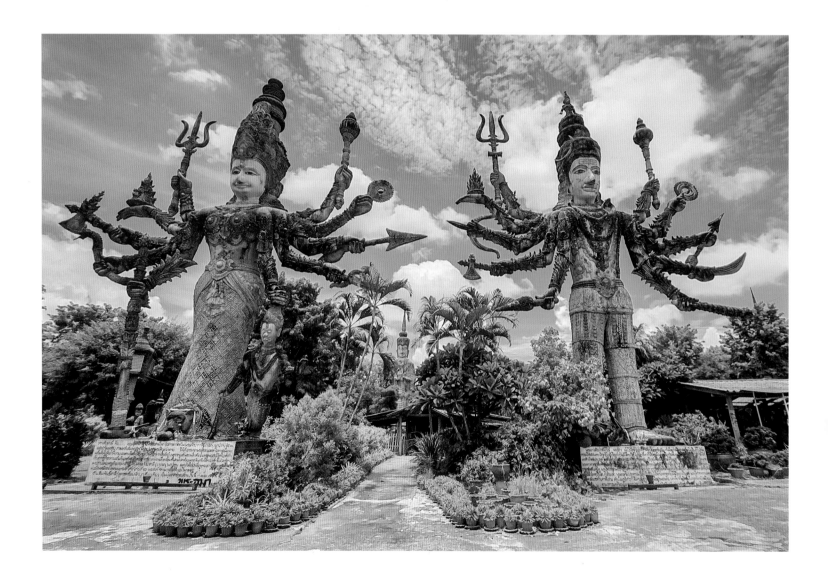

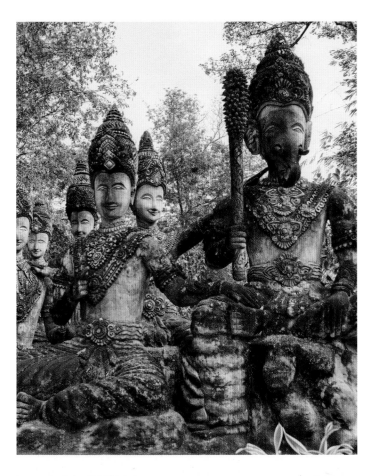

Everywhere Buddhas are present in many forms, including reclining and meditating, and Hinduism is also well-represented, with sculptures dedicated to Shiva, Vishnu and Brahma joined by other deities from Hindu mythology, such as Ganesh riding a rat, reflecting the artist's admiration for the diverse religious traditions of the region. Indeed, the tallest sculpture here is a towering depiction of the deity Indra, soaring up approximately 25 metres (82 feet). Often associated with storms and the heavens, the deity is here shown with multiple heads and arms, each representing a different aspect of their power and wisdom. It's far from being the only impressive large-scale sculpture, with tens of others similarly ornamented with their own unique symbolism and significance, but located as it is in the centre of the park, its towering presence commands attention and creates a sense of awe and admiration.

The sculptures in Sala Keoku are primarily made of reinforced concrete, used by Luang Pu Bunleua Sulilat for its durability and flexibility in sculpting, but they also utilize decorative elements like mosaic tiles, mirrored glass and ceramic fragments to give colour, light and a bold visual impact to the works, bringing them to life in a playful way that captivates visitors with their intricate details and larger-than-life presence.

But among the immobile, inert concrete giants, another element adds to and heightens the sense of spirituality: life. For the park teems with it. A large pool filled with hundreds of giant catfish, carp and other aquatic life and flora from the nearby Mekong river offers a pleasing shift in scale and makes the park feel very much alive – as do the thousands

Left (top and bottom):
Sculptures made of
reinforced concrete and
decorative elements.

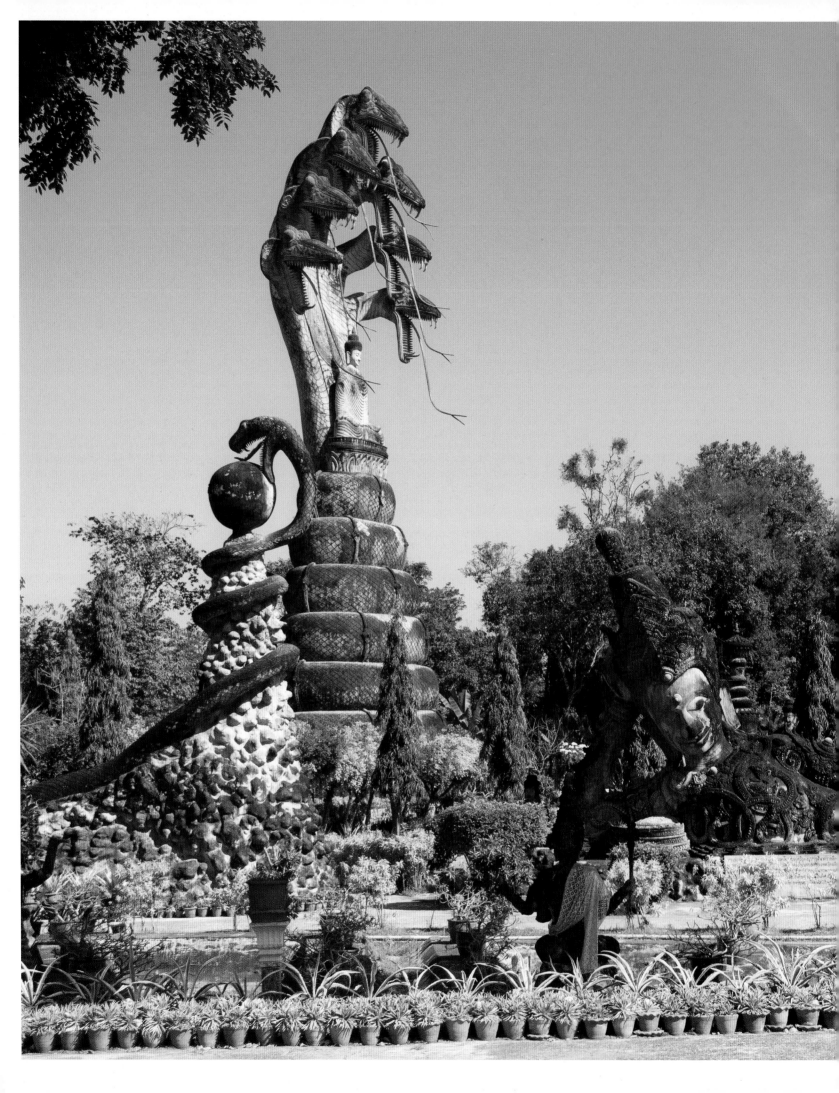

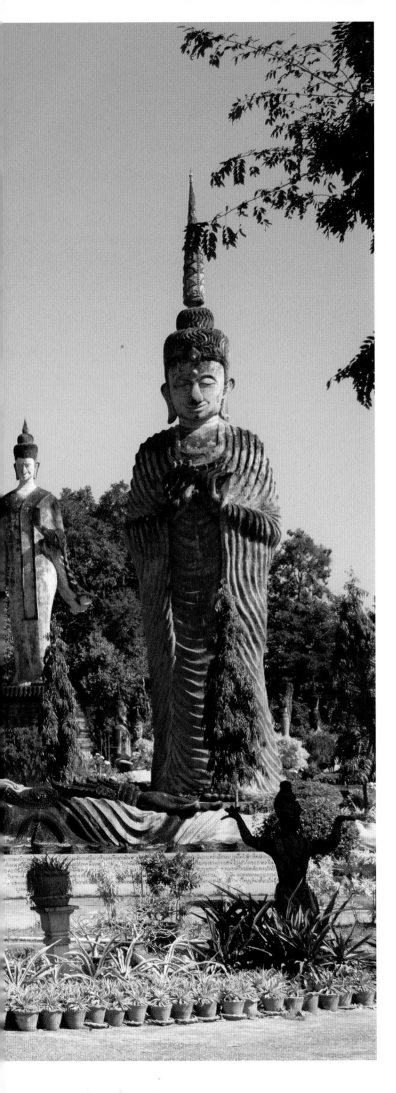

of tourists who visit each day. And everywhere, lush greenery and beautiful plants add to the overall ambiance and sense of peace, with a diverse range of plants, including both ornamental and tropical varieties, used to create a garden paradise.

Ashoka India trees, also known as Buddha trees, rise needle-like into the skies like a shaggy version of a Mediterranean cypress, drawing the visitors' eyes up to the faces of the deities and creatures that loom above them. Other trees such as palms, banyans and fig, provide shade and shelter to the flowering plants and foliage beneath them, including vibrant orchids, hibiscus, frangipani, bougainvillea, ferns, elephant ears, crotons, calatheas, and other leafy plants. And whispering bamboo creates natural partitions, paths and decorative elements. A planted area dedicated to medicinal and aromatic herbs gives visitors the chance to learn about their healing properties and significance in traditional medicine. The combination of all these living things creates a truly harmonious blend of nature and art, allowing visitors to immerse themselves in a tranquil and serene environment while appreciating the sculptures and spiritual ambiance of Sala Keoku.

Tragically, Luang Pu Bunleua Sulilat died in 1996 after falling from one of his own sculptures, and the mummified remains of his body can be found on the third floor of the park's temple, known as Wat Sala Keoku or Wat Pa Non Kum. This level within the temple also happens to be the best vantage point from which to take in the views of Sulilat's creation. There could surely not be a more fitting resting place for its creator.

Left: Buddhas and Hindu gods soar into the sky alongside trees including Ashoka India and palms.

The Lion Grove Garden

Jiangsu, China

The Classical Gardens of Suzhou in China's Jiangsu province are almost as famous as Japan's Kyoto gardens, and certainly *as* famous to garden lovers and designers. The nine UNESCO-listed gardens, including the Lion Grove Garden, span almost a millennia of temple garden design. Shaped predominantly by the principles of Taoism – notably simplicity and living happily in tune with nature – all adhere to the traditional tropes of classical Chinese garden design, which include bounding walls, one or more ponds, rock works, trees, flowers and shrubs, and various halls and pavilions connected by myriad paths. Minutely detailed consideration is given to all these elements, which are set so as to surprise the visitor while also framing vistas and scenes as though they were exquisite, idealized landscape paintings.

The Master of the Nets Garden, created almost a thousand years ago in 1140, is lauded the world over for the harmony created by elements such as the Barrier of Cloud grotto (a rock wall which metaphorically stands for a bank of clouds or layer of mist), a cypress tree dating from the Ming Dynasty, a centuries-old pine, and plants and rocks used in such a way as to create views representing different seasons.

The Humble Administrators Garden is generally regarded as one of the most spectacular gardens in southern China, the interplay between the yin of its water features and the yang of its rocks creating a stunning setting for a space noted for the hundreds of pots on pedestals filled with miniature tree and stone landscapes, or *penjing*.

However, it is the Lion Grove Garden – also known as the Stone Lion Grove of Shi Zi Lin – that stands out not just as a superlative example of a classical scholar's temple garden, but one that exhibits creative and imaginative interpretations of faith and harmony at every turn. All this while clearly referencing the famous and

Left: The Lion Grove Garden and its famous rocks, from nearby Lake Taihu.

utterly surreal and fantastical elements that make up Huangshan or Yellow Mountain, which are an integral part of China's classical gardens, having been for centuries depicted in the paintings that would go on to inspire them.

Built in 1342 during the Mongol-led Yuan Dynasty, the Lion Grove Garden continued the style of classical scholars' gardens inspired by the Valley of the Jante garden, designed almost six centuries earlier by poet, painter and Buddhist monk Wang Wei.

The garden was originally that of Puti Zhengzong Temple, having been created there by the Monk Tianru and other disciples of the Abbot Zhongfeng, and named for the Lion Rock on Tianmu Mountain in eastern China where Zhongfeng attained nirvana, while also honouring a myth that had him riding a lion to the site of the garden and witnessing the creation of numerous lion cubs when the beast shook its mane. The result is a 1-hectare (2½-acre) site that's filled with all manner of rock lions, many barely recognizable from erosion, which makes it a unique experience among sacred gardens. Unsurprisingly, it became famous throughout the country within decades of its creation.

Centuries later, the Lion Garden still bears many of the elements it did then, despite periods of decline and damage. Restored in the early twentieth century by an ancestor of the starchitect I. M. Pei and later donated to the country, it's comprised of twenty-two pavilions, connected to one another by long galleries, seventy-one stele (inscribed stone slabs), and numerous works of art. The western part is largely taken up by water, while the eastern area features a dizzying range of sculptural forms and rockeries carved organically from limestone into the shapes of lifelike lions (*shizi*) and miniature mountain ranges and peaks.

Dominated by grotesque, gnarly, bone-like rocks that look like the most extreme excesses of Rococo architecture, the effect is surreal and organic, giving a sense of being in an alien landscape that in fact is influenced very much by China's actual landscapes, and the rural way of life that is still to be found in so much of it. Indeed, the rocks come from the nearby Lake Taihu, whose chemical composition erodes them in such a way

Below: Ponds filled with carp, lily pads and other water plants.

Left: Traditional Chinese building.

Below: Rockeries and surreal sculptural forms carved organically from limestone.

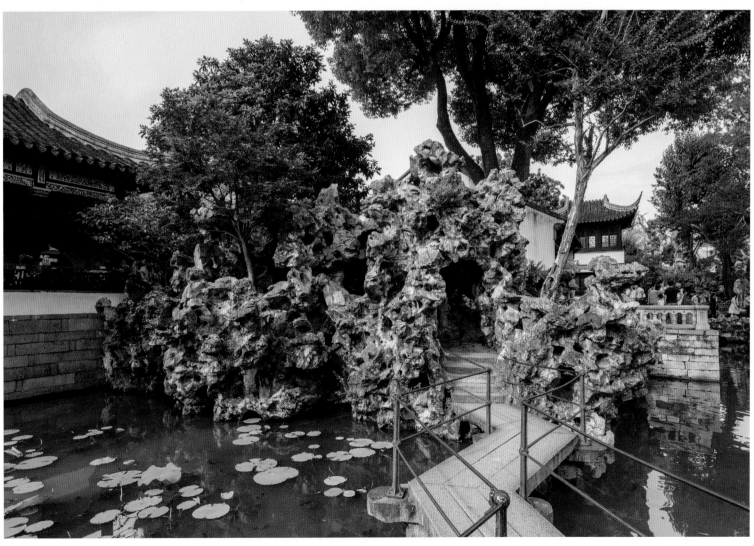

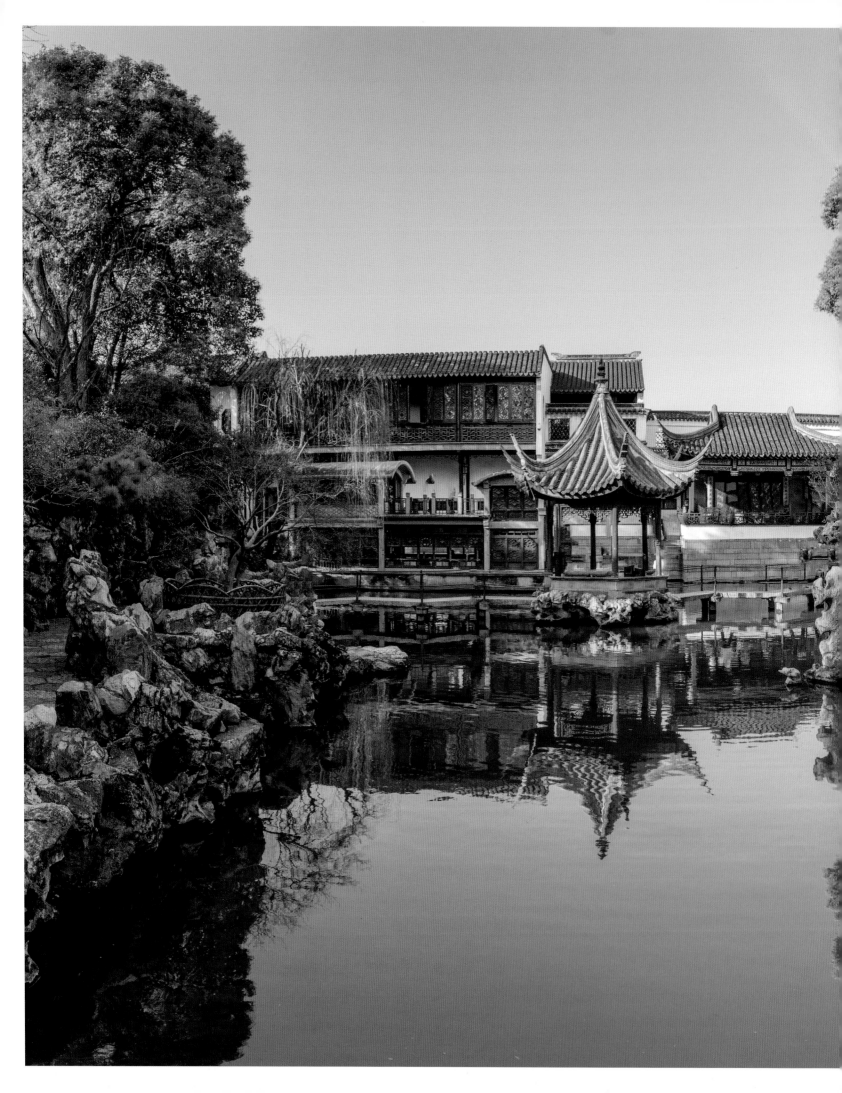

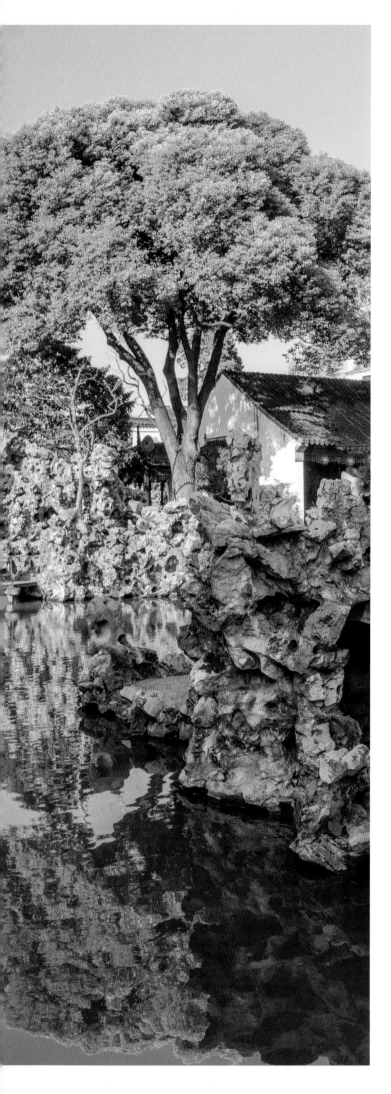

as to create fantastical forms and fissures, while retaining a uniform grey colour.

The most arresting of these 'landscapes', a 1,154-square-metre (12,420-square-foot) grotto containing a maze of nine paths winding through twenty-one caves across three levels, lies to the north of the plum blossom gate and in front of the Pointing to Cypress Pavilion. It features a series of formations whose intricacy is breathtaking, with separate peaks displaying their own characters and stone paths connecting grottoes and caves to form a labyrinth which might bring you to a watery dead end, or a bridge, or a small courtyard.

While this famed central grotto is the Lion Garden's most dramatic feature, the rest of the site is equally captivating, thanks to the delicacy and understated elegance created through a mix of planting with ancient cypresses, fragrant blossoms, ponds crowded with lily pads and whispering cathedrals of bamboo. The built elements, such as the stele, bridges, water features, pavilions and halls containing displays of paintings and calligraphy, connect the relationship between nature and man just as surely as the garden outside does.

But it's the other-worldly grey rock formations that are the star of the show here, and when they're draped in delicate wisteria, or glimpsed through hundreds of bamboos, or framed by dense clusters of magnolia, or viewed through boughs laden with cherry blossom, the effect is nothing short of astonishing. It's as though the beauty and wonders of the natural world in all its diversity have been brought together into a unified whole to create the atmosphere of harmony and peace that lies at the heart of Buddhism.

Left: Twenty-two pavilions are connected to one another by long galleries, seventy-one stele and numerous works of art.

Nishat Bagh

Kashmir, India

Kashmir's Dal Lake, set against the backdrop of the Zabarwan Mountains, is a spectacular site, so it's no wonder it boasts not one but two equally spectacular Mughal gardens on its banks. The largest in terms of size is the royal Shalimar Bagh (not to be confused with Lahore's garden of the same name in Pakistan, page 146), but it is the smaller Nishat Bagh that has been dubbed the Garden of Joy or Bliss, the Garden of Gladness and the Garden of Delight. For the seventeenth-century garden, designed and built by the prime minister Asif Khan, truly is a delight, and while encompassing many of the traditional tropes of a Mughal or Persian garden, contains some unique features that make it unforgettable.

To begin with, there's its setting between the Zabarwan Mountains and the lake, itself backdropped dramatically by the snow-capped Pir Panjal mountain range glimpsed in the distance beyond it. Then there's the design. Instead of the more typical square layout associated with Mughal gardens, Nishat consists of a rectangular layout, a diversion from the norm forced by the topography of the site and the location of the water source. As an adaptation of the traditional Persian *charbagh* (four gardens), which takes its inspiration from the Quranic description of Heaven as having four rivers of wine, honey, milk and water, the latter plays a vital role in not just the design and layout of Nishat but in the planting too. Chutes, water channels – the central one is 4 metres (13 feet) wide – pools and fountains bisect and nourish twelve terraces, one for each sign of the zodiac, creating beguiling spaces filled with bright colour in beds bustling with annuals and perennials such as poppies, pansies, marigolds, roses and lilies.

In autumn, bordering trees burst into fiery reds and oranges, contrasting dramatically with the vivid green of the grass, cypress trees and other evergreen shrubbery and hedges that call to mind English country estate gardens as much as Persian ones,

Opposite: Terraces of the Nishat Bagh with their central water channel.

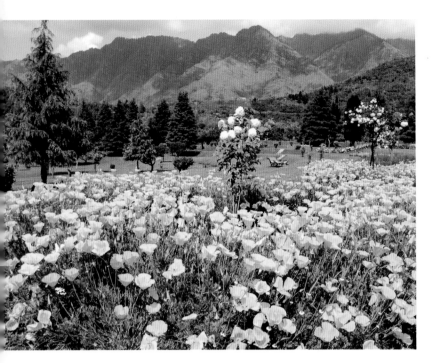

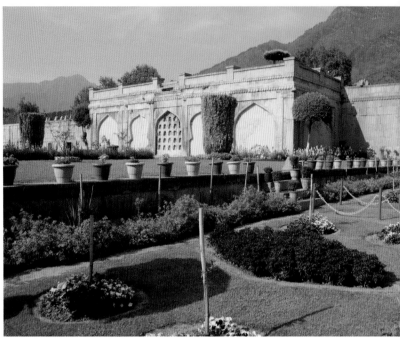

Above (left and right):
Beds and borders
filled with annuals
and perennials such
as poppies, pansies,
marigolds, roses
and lilies provide
bright colour

particularly when the bright hollyhocks
are in full flower. But in its details – like
the cascading water tumbling over the
5.5-metre (18-foot) wall of the top
terrace into the pool below, the numerous
fountains sending up their elegant jets
of water, the engraved stone ramps
(*chadars*) that carry the water between
the various terraces, and the stone and
marble benches near and over the *chadars*
that allow visitors to sit and listen to the
harmonious movement of the water as
it cascades gently onto a lower terrace
– Nishat bears all the hallmarks of a
Persian garden, without the constraints
and hierarchies inherent in royal Persian
garden design.

Despite being a fairly compact
548 metres (1,798 feet) long and 338
metres (1,108 feet) wide, Nishat's twelve
terraces ensure lots of variety in the
planting, but the design is quite simple.
The terraces are set across just two

sections, a public pleasure garden and
the private *zenana* (harem, or women's)
garden. Built in an east–west direction,
the top terrace has the *zenana* garden
while the lowest terrace is connected
to the Dal Lake. It's from the lake that
the garden is meant to be approached,
and stepping from a water taxi onto the
first terrace to see the full length of the
gardens laid out before you is magical. As
you make your way gently uphill across
the first pool to go through a wooden
gate leading to the second terrace, a pool
with five fountains and a waterfall directly
ahead of you set the scene perfectly for
the rest of the site. Twenty-three niches in
the arched recess just behind the cascade,
each originally filled with a lighted lamp,
make this terrace the most elegant of
the twelve terraces, especially when the
Persian lilacs and pansies are in bloom.

Arched wall niches and another water
chute feature in the third terrace too,

as do more delicately engraved *chadars*, ornamental stairs, pools, fountains and waterfalls that greet the visitor as they progress up through the terraces towards the mountains behind the *zenana*. At the eleventh terrace, reached via another engraved *chadar*, the space opens out to reveal a pool containing twenty-five fountains, fed by the chadar leading to the twelfth terrace, hidden behind its retaining wall punctuated with blind arches. A staircase in one of the arches gives access to the densely planted *zenana*, where a two-storey pavilion (*baradari*) and two small octagonal towers flanking the wall add pleasing architectural closing notes to the experience of the garden.

Persian gardens were derived from Islamic gardens, which were designed as an earthly utopia in which humans co-exist in perfect harmony with all elements of nature. In that sense, Nishat Bagh succeeds on every level. There is a story that on seeing the completed garden in 1633, Emperor Shah Jahan wanted Asif Khan, his father-in-law, to gift it to him. When he didn't, Shah Jahan ordered the water supply to the garden be cut off, resulting in desolation for both the garden and Asif Khan. A bold servant turned the water supply back on and the Shah, supposedly in appreciation of his loyalty to his master but perhaps also in recognition of the garden's resemblance to paradise with the water back in place, ordered its supply be permanently restored. Centuries on, that servant's name is unknown, but we, and surely the many visitors to what is now a public park, are very grateful that he existed.

Below: A 5.5-metre (18-foot)-high wall punctuated with blind arches and two small octagonal towers contains the twelfth terrace.

Pages 196–7: Dal Lake, from which the Nishat Bagh is designed to be approached.

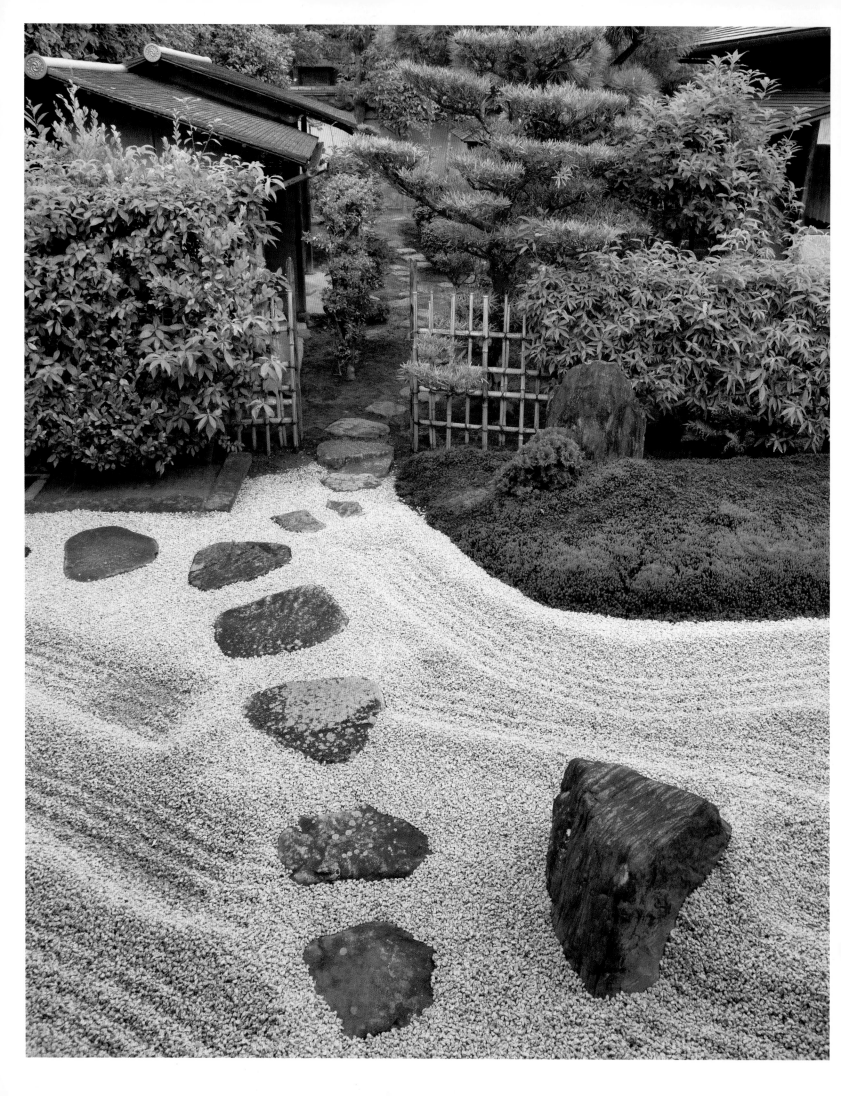

Daitoku-ji Compound

Kyoto, Japan

The abundance of Zen gardens in Kyoto makes it a magnet for garden lovers the world over, but that abundance can make it very difficult to decide which to visit. One unmissable site, in the city's north, is the Buddhist temple complex of Daitoku-ji. Across its vast area lie twenty-four sub-temples, the earliest dating back to the complex's founding by Daitō Kokushi in 1319, and nearly all have a garden, with four regularly open to the public – Ryōgen-in, Daisen-in, Zuihō-in and Kōtō-in. Each has its own character and focus, with three – Ryōgen-in, Daisen-in and Zuihō-in – being stone gardens, and the fourth, Kōtō-in, eschewing stone and gravel for moss, bamboo and, famously, the many maple trees that blaze with autumn colour.

Ryōgen-in, built in 1502, lays claim to being the country's smallest rock garden and is actually comprised of five even tinier gardens, all with deeply symbolic meanings and representations that encompass the inhalation and exhalation of breath (in the whirling patterns of the Kodatei Garden), a depiction of Mount Horai-Zan, the blessed island of immortality from Taoist mythology (in the rock 'islands' of the Isshidan Garden), and the power of cause and effect (in the ripples and swirls of Tōtekiko, the smallest garden in Japan). The latter is remarkable for the power it holds in a tiny space set between two buildings bordered by two wooden platforms whose boards are exactly the same width as the lines of raked gravel that form the garden they overlook. This space, with its ripples of gravel spreading out from its five rocks, is breathtaking, but so too is Ryōgen-in's diminutive Ryugintei Garden, which, with its undulating moss bed surrounding a central rock representing Mount Sumeru, the core of the Buddhist universe, consisting of eight seas and nine mountains, offers a deeply affecting contrast to its stone-hearted neighbours.

Opposite: Zuihō-in, in which the stones represent islands and mountains surrounded by water.

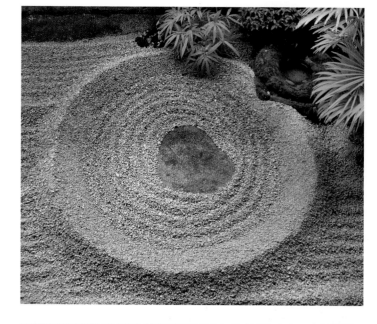

The large stone garden of Zuihō-in also represents islands and mountains, again including Horai-Zan, but also features an intriguing element in the form of a series of rocks which, viewed from its south-east corner, form a diagonal cross, referencing the Christian conversion and burial site of the owner of the temple, Ōtomo Sōrin, and placed here by the creator of the garden, Shigemori Mirei, in 1961. His powerful waves rippling out from the rocks are utter perfection, and make a fitting resting place for the sixteenth-century warlord and his wife, both of whom are buried here.

Kōtō-in stands out among the gardens for the tree- and bamboo-lined pathway and three gates visitors must pass through before emerging into an apple-green moss lawn and maples overlooked by a viewing platform and another path, this time in the form of a winding route of stones through more moss, leading to the beautiful stone lantern grave of the temple's founder, Hosokawa Tadaoki, another sixteenth-century warlord and the famous tea master who founded the temple in 1601. In the autumn, when the moss carpet is covered in rich red leaves from the maples, the contrast is spectacular.

The final temple garden regularly open at Daitoku-ji, Daisen-in, is one of the most famous dry gardens (*karesansui*) of stone and sand in Japan, its elaborate elements detailed in an English guide that outlines the meaning and symbolism of each stone and tree to create a story of the journey of the human spirit towards peace and tranquillity.

Dating from the end of the Muromachi period (1336–1576), when the creation of dry gardens was at its

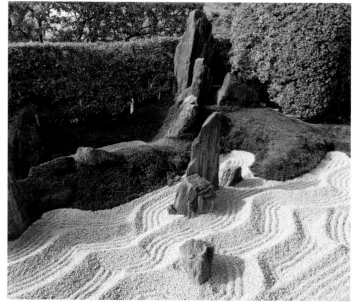

Top right: Ryōgen-in, built in 1502, lays claim to being the country's smallest rock garden.

Centre right: Zuihō-in.

Bottom right: The path leading to the Kōtō-in entrance.

Opposite: Kōtō-in houses the grave of the temple's founder, Hosokawa Tadaoki.

peak, the garden is divided into four parts that surround the main hall on all sides, and was built by the Zen priest and poet Kogaku Soko, who founded the temple in 1509 – though it is also attributed to the painter monk Sōami, whose *fusuma* landscape paintings are displayed inside the temple. What is undisputed is the beauty of a design not primarily related to religious Zen, but instead to an abstract painting; indeed, it was conceived as a three-dimensional copy of a Sung monochrome painting, achieved using stones, gravel and sand. Its main feature, a boat-shaped stone, sits in a gravel river, waterfalls from Mount Horai and rivers streaming toward the seas represented by gravel and raked sand, and animals such as turtle (*kame*) and crane (*tsuru*), symbols of longevity, represented by arrangements of stones. All the stones have rested in their exact positions for more than 500 years, but interpretations of the symbolism of the garden and its zones have differed over the centuries, the most common being that each zone illustrates a theme: the waterfall represents the beginning of life, the river illustrates the stages and trials of human existence, then the intermediate sea, and finally the ocean, mark the serenity of old age.

While Daisen-in's design and materials express the philosophy of Zen in the more abstract manner of a painting rather than the direct symbolism of a traditional Zen garden, in its careful, considered use of rocks, gravel and sand to represent the simplicity, balance, harmony and austerity that are at the heart of Zen Buddhism, it is undoubtedly a masterful example of a Zen garden, and hugely deserving of its classification as a National Treasure of Japan.

Right: The early sixteenth-century Daisen-in garden.

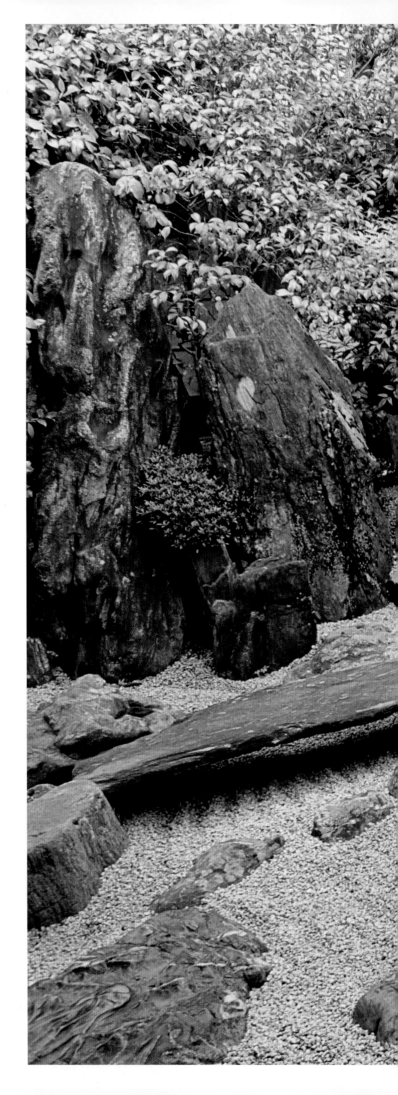

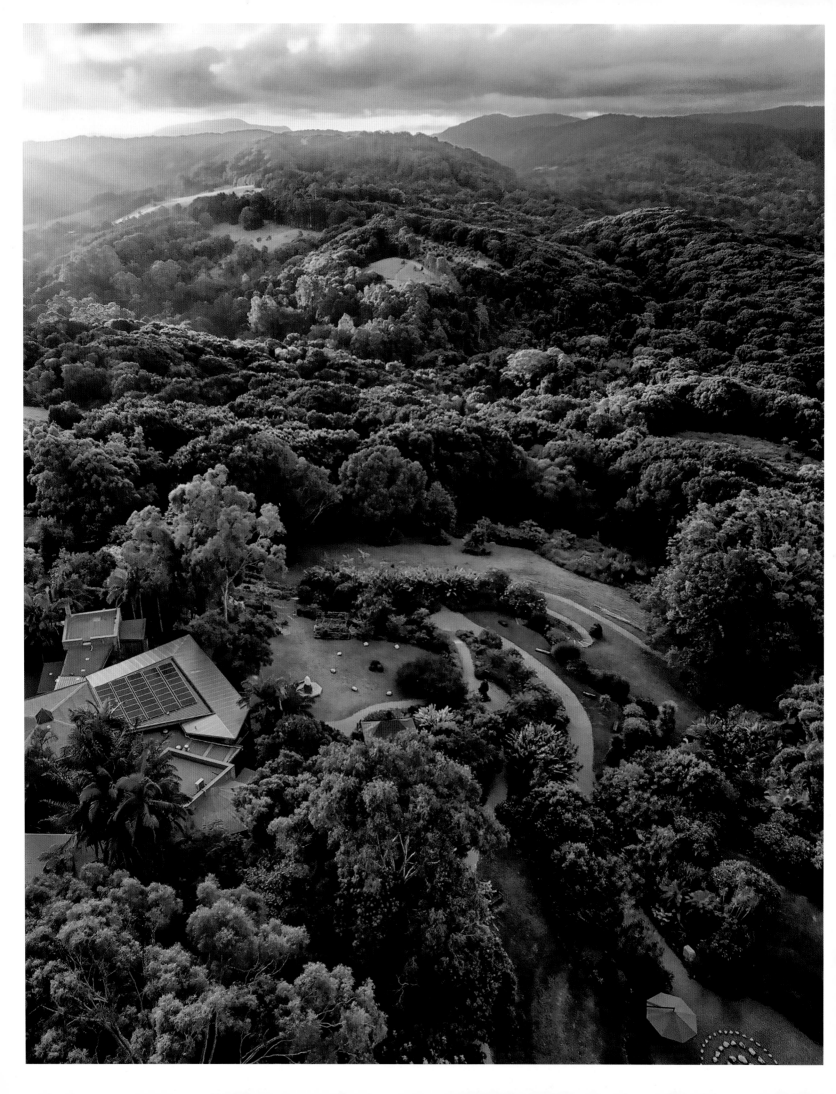

Shambhala Gardens

New South Wales, Australia

Humans have been enchanted by the natural beauty of crystals for millennia. And belief in their powers dates back just as long: ancient Sumerians used them in healing and spiritual rituals; in *Critias*, Plato wrote that Atlanteans used them to read minds and transmit thoughts; Roman historian Pliny the Elder claimed that certain crystals had medicinal properties; and Ancient Egyptians used them for both beauty and health, believing that they warded off evil and protected the wearer both in this world and the next. They feature in Christian contexts too, symbolizing spiritual purity and perfection, and appearing in Christian churches, where during medieval times they were used to decorate Gospel books and other important religious items. It was an association that went beyond the Church into everyday life during the Middle Ages, when people craving a physical embodiment of their faith and spirituality used them. They also feature in Chinese medicine (needles were even made of gemstones in ancient Chinese acupuncture), Buddhism and many forms of meditation and contemplation, and it's with these latter ideas in mind that Naren King co-founded the Crystal Castle and Shambhala Gardens in the mid-1980s.

King, at the time an enthusiastic young global traveller and hunter of crystals, which he would sell to fund further travels, first came across the former farming site and its abandoned futuristic mansion at a party in New South Wales's bucolic Byron Bay, and knew he'd found a fitting home from which to wholesale his crystals. But as word of their beauty and size spread, requests for visits poured in, and he realized the site could become a meditative, healing space of calm beauty, in which the crystals – including some of the oldest and largest in the world – would definitely be the stars of the show, but supported by a cast of wonderful extras.

Opposite: An aerial view of the gardens with the Rose crystal circle in the lower right-hand corner.

Extraordinary crystals like the 10-tonne deep-purple Dragon Egg amethyst cave, 5.5-metre (18-foot)-high smoky quartz Giant Guardians, and the 5.5-metre (18-foot)-wide and 20-tonne Enchanted make the space unique, but over the ensuing years and with the help of his wife Sono and daughters Ayla and Manya, King added additional features. There are paths lined with rose quartz crystal, a stone spiral with an expansive smoky quartz throne at its heart, a labyrinth, a bamboo path, an amethyst rock wall, fossils, a giant Buddha from Java, and various Hindu statues, all of them set across 10 hectares (24½ acres) of lush, subtropical gardens filled with meditative walks and calm spaces for contemplation, and which have attracted visitors in their thousands. And thirty-seven years on, they still come, drawn by the crystals, but enchanted too by the planting and design.

In a muddy area with a non-working dam, King and his team spent a year creating an amphitheatre in which people could enjoy the 4-metre (13-foot)-high, 13-tonne Buddha he'd acquired in Java, along with volcanic rock Hindu statues of Ganesha, Nandi, Lakshmi, Garuda and Vishnu, and the Avalokiteshvara. The Blessing Buddha, named for its raised outward-palm stance and gazing serenely across the Buddha Pond encircling him, is a real highlight of the garden, its avenue of bamboo trees creating a harmonious aural backdrop to the serene centre.

The lush settings of the garden are almost entirely thanks to King and his team. The property was near barren when he bought it, and through a partnership with Rainforest Rescue they have created the Rainforest Walk within the gardens to

Top right: The Blessing Buddha, overlooking the Lotus Mosaic by Turiya Bruce.

Centre right: A volcanic rock statue of the Hindu god Ganesha.

Bottom right: A bamboo path.

show how regenerating scrub land can be achieved. The project has seen more than 10,000 trees planted during community days, in which locals come together to learn about traditional indigenous plants of the area. Abundant bird life, water-sculpted feature rocks and rare species of wildlife add to the appeal.

Another centre of spirituality in the garden is the 9-metre (30-foot)-high Kalachakra Stupa, knowns as the World Peace Stupa, its fifty-four solid brass prayer wheels individually filled with 170,000 prayers and crafted over eighteen months in a workshop that's been building them for 350 years. The stupa, the only one in the southern hemisphere, also contains items brought by the local community, 'things of value to them, things sacred to them, things that represent their future hope and dreams of humanity', says King. The crystals themselves provide resonant focal

points as well; Rosie, a 4-tonne, 2-metre (6½-foot)-high block of rose quartz is at the peaceful heart of a reflexology walk.

While Shambhala is clearly a business venture, the sense of serenity and tranquillity it's imbued with lend it an authentically spiritual feel, informed by King and his team of some fifty gardeners and workers, delivering a space of harmony and beauty that does work. This is a space filled with nature at its most abundant, from the lush foliage through to the glittering crystals that have taken millennia to be forged. In essence, everything has been curated by the Shambhala estate, but it is done so with a sensitivity to the land as well as to the spiritual. As Marisa Galvez, an associate professor at Stanford University, says, 'Crystals, in a way, fulfil a spiritual need for some people. Some people go to church, some do yoga, and others collect and meditate with crystals.'

Above: A Bodhi tree and, in the distance, Kalachakra World Peace Stupa.

Pages 208–9: The Giant Amethyst Guardians, at 5.5 metres (18 feet), are thought to be the largest pair of crystal geodes in the world.

Soswaewon Garden
Damyang County, South Korea

Just under 10,000 square metres (107,640 square feet) isn't particularly big for a garden – a soccer pitch is around 7,000 square metres (75,350 square feet) – but the Soswaewon Garden, located close to Mount Mudeung near Gwangju, an hour to the west of Gwangju in south-east Korea, packs a lot into its footprint, and was deservedly designated a National Historic Site in 1983. As a relatively youthful garden – Korean gardens such as those at Changdeokgung Palace and Byeongsan Seowon can be traced back more than 2,000 years – built in the sixteenth century, it's typical of the Joseon period it represents, making extensive use of its sumptuous natural features and the thick bamboo grove it sits in. Approached through that grove, it's a study in harmony between the natural and handmade worlds, and wandering this intimate, peaceful space, it's easy to believe it's never been touched by the turbulence of Korea's troubled past. But Soswaewon, derived from the Korean word *soswae*, meaning 'clean and cool', actually came into being because of one such period of political turmoil, when its creator, a Confucian scholar called Yang San-Bo, constructed it as an exile and haven first for himself, and then for other disillusioned scholars, following the murder of his teacher and mentor Jo Gwang-jo in a political purge in 1519. He spent the rest of his life living off the land here, studying and teaching Neo-Confucianism.

Bounded within a stone and mud wall is a garden filled with woodlands of pine, peach, maple, zelkova and maple, interspersed with flower beds, a pond fed by a stream and boulders strewn along a path flanked by different handmade structures, all accompanied by the sound of gurgling water being carried along open bamboo aqueducts delivering water into the meandering stream and pond. It feels slightly ramshackle and untended, but this is deliberate; the gardens are aligned to the idea of *anbinnakdo*, which loosely translates as 'being comfortable amid poverty and taking

pleasure in an honest lifestyle'. All elements have been carefully considered, despite their seemingly natural appearance and position, and all are rooted in symbolism and ancient beliefs that date back to the prehistoric gardens of Korea – the boulders, for example, are an essential element of traditional Korean gardens, reflecting the prehistoric Koreans' belief that rocks had more power than water and other elements in nature.

It all combines to create a layout that is as harmonious as the planting, with a small artificial waterfall acting as the linchpin for both natural and handmade features. The Gwangpunggak Pavilion, a beautifully constructed viewing pavilion in wood, bamboo and stone capped with an intricately tiled roof, flanks the fall, while an aqueduct and simple stone bridge span the clear waters. Behind it on a terraced hill, another small structure, the Jewoldang, is believed to have been the home of Yang San-Bo and his descendants, the stark simplicity of their living made clear by a humble verandah for the summer months, one closed room for the cold winter months, a small exterior kitchen and nearby kitchen vegetable garden. A thatched pavilion (*daebongdae*) adds a sympathetic and pleasing nuance to the rustic appeal of this very special garden.

Below: Soswaewon's Wi-gyo bridge with views of the thick bamboo grove the garden sits in.

The decorated boundary walls feature a wood-block print made in 1755 showing the original plan of the garden and buildings, and, on the entrance wall, a poem written in 1542 by Kim Inhu, a close friend of Yang San-Bo, in praise of Soswaewon. Realized in swirling calligraphy, such decorations draw the eyes upward to the swaying bamboos above, and a log bridge over the valley adds to the charm of a scene which appears timeless – indeed, it's almost certainly very similar to how it would have appeared 500 years ago, despite having been partially destroyed during the Japanese invasions of Korea (1592–98) and reconstructed by Yang San-Bo's descendants.

Kim Inhu's collection of poems on the garden includes one called 'Relaxing with Visitors Next to a Brook Shrouded in Willow Trees':

Visitors come knocking on the gate in
 the bamboo grove
Their rowdy singing wakes Yang San-
 Bo from his afternoon slumber
Having given up public service, he is
 enjoying a life of bliss.
They tie up their horses and stand by
 the edge of the brook

It is undoubtedly a garden to escape from the woes and worries of the world, a sanctuary offering peace and tranquillity, but it's also a space worth seeking out to see how man and nature can work in harmony to realize *anbinnakdo* in a very real sense.

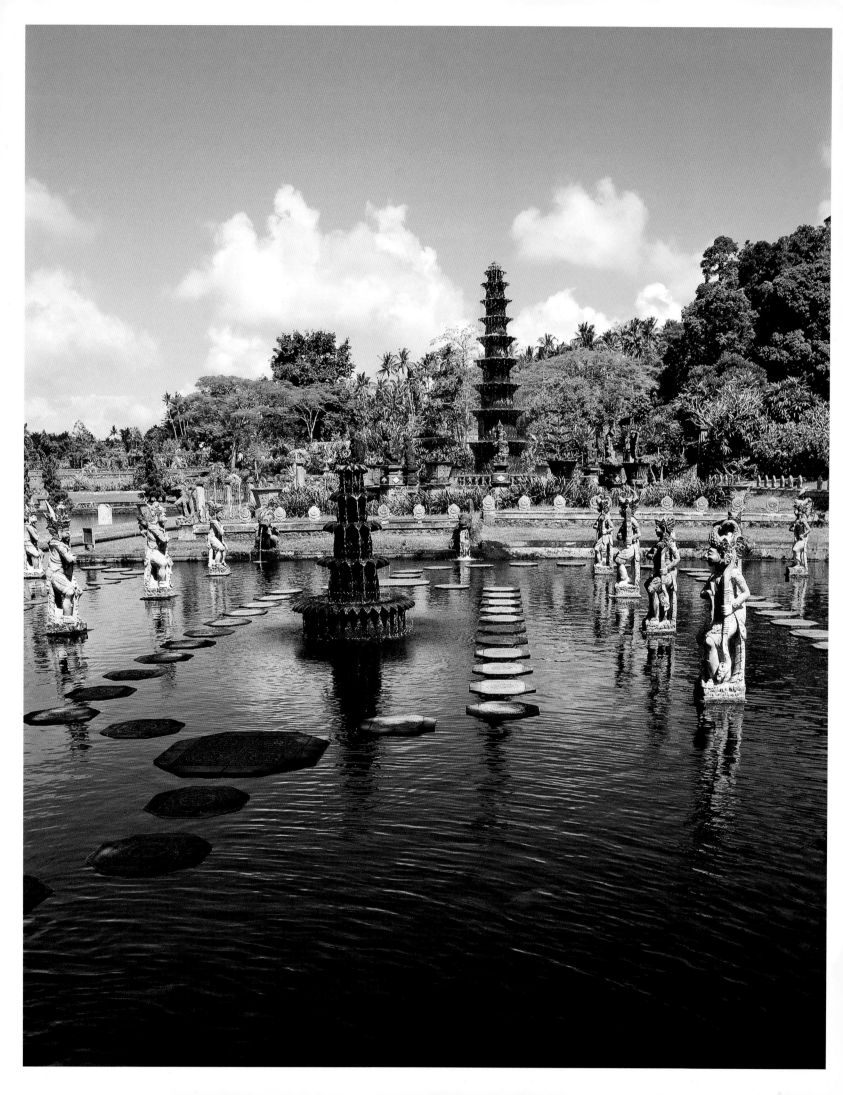

Tirta Gangga

Bali, Indonesia

Harmonious beauty is a feature of many of the gardens contained in this book, but it's possible that Tirta Gangga, located in the village of Ababi, some 75 kilometres (46½ miles) east of Denpasar in Karangasem, East Bali, is the most beautiful of them all. Designed and built as a series of royal water gardens in 1946 by the last raja of Karangasem, Anak Agung Anglurah Ketut Karangasem, and inspired by a visit the raja made to the Palace of Versailles in France, the gardens are based closely on the principles and philosophy of the Balinese Hindu Buddhist religion.

The courtyards of Tirta Gangga (named for *tirta*, the 'blessed water' of the holy springs the complex is fed by, and Gangga, or the River Ganges) are laid out on three levels, representing the Hindu concept of *triloka*: the divine world (*swah*) at the highest level; the mortal plane (*bwah*) on the middle level; and the lower realm of demons (*bhur*). Each has its own range of pools, two of which are swimming pools, an upper and lower on the *swah* and *bwah* levels, and one of which, South Pond, on the lowest *bhur* level, has Demon Island at its heart.

For Anak Agung Anglurah Ketut Karangasem, the gardens were a labour of love that the raja literally worked on himself, helping craftsmen and gardeners with the digging and foundations on which his vision would be built. Tragically, it was a vision he would see realized and then, just two decades on, virtually destroyed by a volcanic eruption in the early 1960s. For more than a decade, the gardens lay in a sad state until the raja's son and famous physician Dr Anak Agung Made Djelantik was able to raise enough funds to begin overseeing its repair, a project continued and completed with the help of his son, Widoere Djelantik, and two Americans who had fallen in love with the gardens, Emerald Starr and Michael Honack.

Opposite: Pools and fountains with stone carvings and stepping stones.

Widoere Djelantik designed many of the buildings, bridges and sculptures that make Tirta Gangga what it is today, creating elements that would reflect more strongly Bali's Hindu Buddhist religious philosophy than his grandfather had envisaged. But in many ways the story of the gardens begins not with their design, but their setting. Located some two hours east of Ubud in the eastern highlands, perched on the south-eastern slope of the island's highest mountain, Mount Agung (whose eruption in 1963 played a large part in the gardens' destruction, with hot ash and lava destroying the vegetation, and tremors reducing the structures to rubble),

the 1.2-hectare (3-acre) site is surrounded by paddy fields and fed by the holy natural spring called Rejasa, a crucial element in the siting of the gardens. So powerful is the spring that it feeds all the garden's bathing and ornamental pools, with enough left over to provide piped water to the people of Amlapura and irrigation for farmers in the surrounding area.

It's hard to take in just how much water that means until you see the breadth and scale of the bathing pools, ponds and fountains that make up Tirta Gangga, their crystal clear waters crossed by elegant bridges or stepping stones to pagoda shrines, and filled with the movement of glistening golden koi carp and the vibrant green lily pads of the Amazonian giant water lilies (*Victoria amazonica*), their edges neatly folded up as though by machine. Delicate statues of gods and demons are set in and around the water, while animals act as gurgling waterspouts. Pagodas, bridges, pavilions and gardens are guarded by more beasts and deities.

The sound and constant awareness of water is ever present, making the pools and interplay of light and movement utterly mesmerizing. But equally pleasurable are the manicured gardens criss-crossed with stepping stones and pathways, the bridges topped with fearsome dragons and demons, the tropical planting ranging from vast banyan trees to small ornamental palms and, rising above it all, the delicate features of the eleven-tiered Nawa Sanga Fountain. This, together with the lower swimming pool and Mahabharata Pond, filled with koi carp, stepping stones and statues of the warring Pandavas and Kauravas that feature in the epic tale of

Opposite: Stone statues stand out against the garden's tropical plants and soaring trees.

Below: The Mahabharata Pond, filled with koi carp.

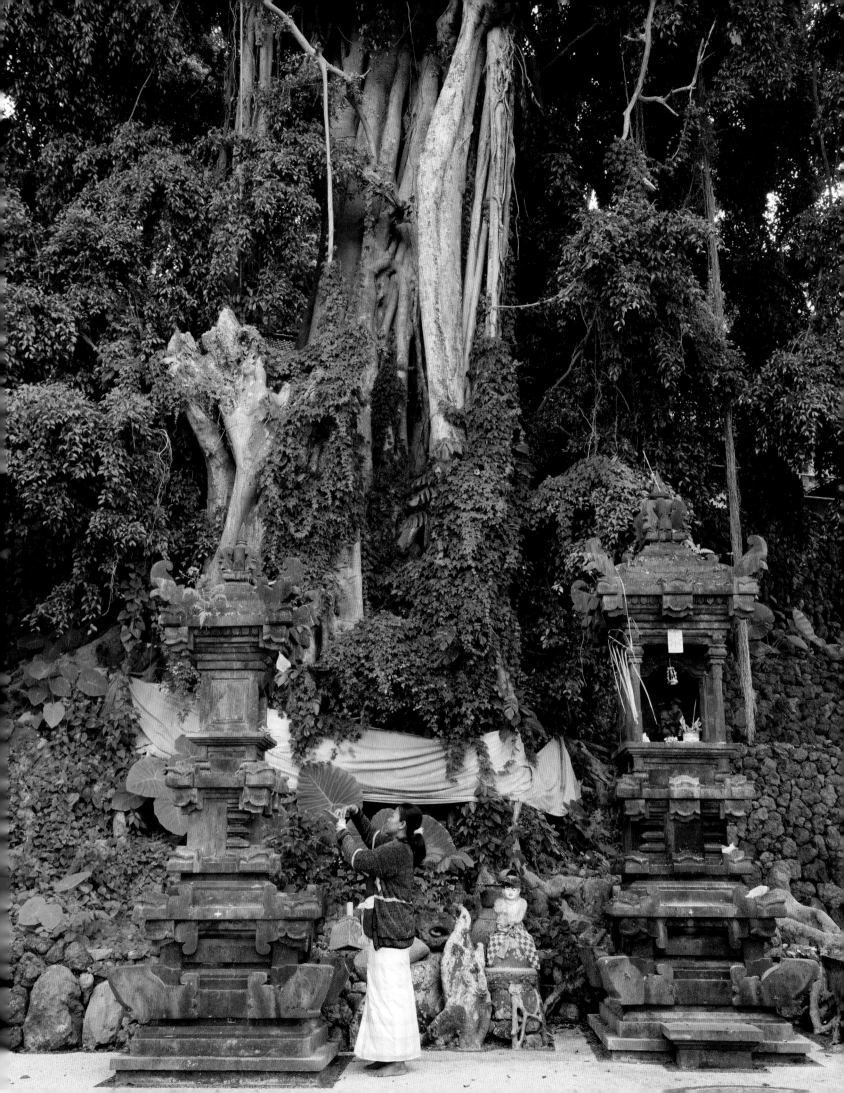

conflict the pond is named after, form the mortal *bwah* level of Tirta Gangga.

Tirta Gangga's largest water feature, the South Pond, is found in *bhur*, the lower realm, where Demon Island can be reached via a pair of bridges featuring ornately sculpted Balinese dragons. The island itself is a study in understated elegance, its lovely quatrefoil-shaped ponds each bearing a small fountain and surrounded by palms and pathways.

But it isn't just the water features that make Tirta Gangga as special as it is. The planted gardens are integral to what Widoere Djelantik was trying to do with the complex, namely to draw *taksu* – defined as the energy needed for a creation to be good – into it. Nowhere is this felt more keenly than in the meditation circle. Set under banyan trees, it contains eight statues which encourage us to meditate on free will, choice and the balance between good and evil.

In 2018 Widoere Djelantik gave up stewardship of Tirta Gangga, but he leaves behind a garden that is as joyful and thoughtful a representation of Bali's faith and spiritual beliefs as one could wish for. With its hordes of Instagrammers and children splashing around in the bathing pools, it may not feel particularly sacred, but at its heart lie many of the tenets of Bali's Buddhist beliefs. In its quieter moments, exploring the physical representations of those beliefs, stories and characters remains a poignant experience.

Right: Ornately sculpted Balinese dragons on one of the garden's bridges.

Te Parapara and Hamilton Gardens

Waikato, New Zealand

'Why travel the world to see its gardens when Hamilton has them all?' could well be the slogan for Hamilton Gardens, the award-winning public garden park running alongside the banks of the Waikato River in the Waikato region of New Zealand's North Island. Established in the 1960s, the 58-hectare (143-acre) park is built on a site whose recent chequered history takes in a British military post, Victorian rifle range, city rubbish dump and netball courts. The park contains almost thirty different types of garden, created with the idea of exploring the history of gardens and their styles through the years and around the world, taking in their context and meaning while also offering an insight into different cultures. The result is a kind of model village with scaled-down examples of diverse horticultural spaces, including an Italian Renaissance garden, an Indian *charbagh* garden, a Sung Dynasty Chinese scholar's garden, a Japanese garden, an Ancient Egyptian garden and an English garden. It doesn't stop at historical gardens, but also includes 'fantasy' gardens, such as chinoiserie, tropical and surrealist. There is also an area dedicated to a 'productive' collection, which includes a herb garden, kitchen garden, sustainable backyard and, arguably most interesting of all Hamilton's gardens, Te Parapara, a pre-European Māori garden and New Zealand's only traditional Māori productive garden.

Rooted in Māori culture, Te Parapara is named for the *pā*, or fenced fortified village, of the famous Ngāti Wairere chief Haanui and his Ngāti Wairere descendants, who once lived on a site known for sacred rituals associated with the harvesting of food crops, centred around a sacred altar or shrine (*tuahu*) called Te Ikamauroa. It's a space designed as a living garden museum which preserves the traditional horticultural practices, materials and ceremonies relating to food production and storage of a pre-European Māori settlement, drawn from the knowledge of local Māori passed down the generations.

Opposite: Carved Māori totems at the entrance to Te Parapara.

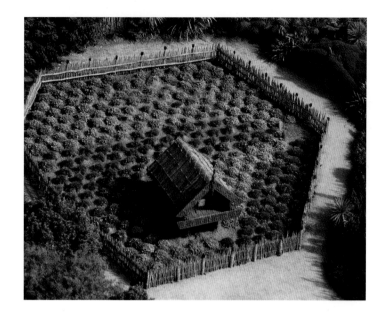

Opened in 2011 as a collaboration between Hamilton City Council and local *iwi* (Māori tribes), particularly Ngāti Wairere and Ngāti Hauā, Te Parapara's aim was, and remains, to showcase the historical and cultural significance of Māori gardening, and the importance of traditional crops in its society. To that end it's filled with crops such as sweet potatoes (*kūmara*), taro, gourds (*hue*) and indigenous herbs and plants, but also with the intricately worked structures and carvings that would have been an integral part of the *pā* – such as the *pou*, ancestral Māori posts adorned with carvings which play a crucial role in connecting the garden to Māori heritage. Other structures of cultural and ancestral significance include palisade fencing (*taepa*) and three forms of traditional Māori houses whose designs depict the genealogy of the Ngāti Wairere, including an elevated storehouse (*pataka*), a ceremonial gateway (*waharoa*) and a scaled-down representation of a meeting house (*wharenui*).

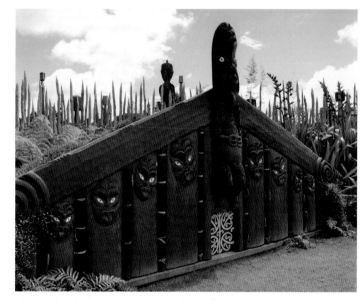

All these combine to provide insights into traditional Māori architecture, food production and preservation methods, but the gardens do not stop at architecture to reflect their Māori heritage. Traditional planting techniques and farming methods are illustrated by the use of small *puke*, or mounds, which help to provide the drainage needed to ensure crops in the ground don't rot; the *tākupu* raised garden beds and cultivation areas, framed with logs and arranged so as to maximize sunlight and drainage; and the *kūmara* storage pits.

The garden's layout, and its positioning in the wider Hamilton Gardens, offers insights into the centuries-old beliefs and rituals of the Māori, being divided

Top right: An aerial view of the garden.

Centre and bottom right: Carved posts and fencing adorned with intricate carvings play a crucial role in connecting the garden to Māori cultural heritage.

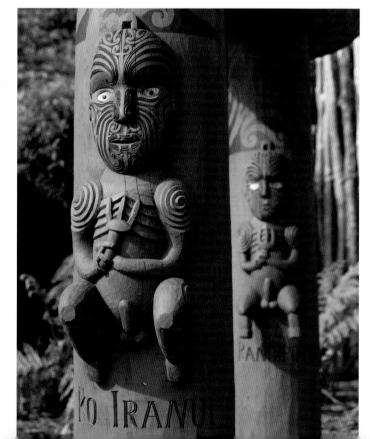

into two realms: Te Ara Whakatauki (the path of proverbs), lying between Hamilton's Piazza and Te Parapara's *waharoa*, is the realm of the uncultivated food from the forest and grassland, ruled by a deity of wild food plants, Haumia-tiketike; while Te Taupa, beyond the *waharoa*, is the realm of cultivated food, ruled by Rongomatane, deity of the *kūmara* and all cultivated food plants.

Through these various elements and interpretive panels, workshops, ceremonies, records and tours, the garden tells the story of the establishment of cultivated food crops in the Waikato, from the landing of the Tainui waka – in Māori tradition, the great ocean-going canoes in which Polynesians migrated to New Zealand approximately 800 years ago – to the era of the expansive plantations described in the 1840s by European visitors. It shows how the first Polynesian arrivals used the plants they found growing wild and demonstrates the techniques they developed for growing tropical crops in a sub-tropical climate.

As such, it's a rich record of the region's pre-European history, which, before Europeans arrived, contained many Māori gardens. But in its creation, it also has something to say about modern history, and the understanding and connections that exist between New Zealand's different cultures and peoples in the twenty-first century. In 2020, ten years after Te Parapara's completion, the Ngāti Wairere historian Wiremu Puke told New Zealand's news website Stuff: 'It's the equivalent of an ancient school of learning, a *whare wānanga*. The garden is a *taonga*, a treasure.' Te Parapara Garden Trust worked for eight years to bring the project to completion in 2010, and

Puke told Stuff he will always remember with gratitude the experience of working with the Trust. 'When I reflect upon the garden, it brought many people together. For me, it brought compassion and empathy. It's about the willingness of people to come together regardless of their background.' Once a year, each February, those people literally come together for the Hamilton Gardens Arts Festival, a celebration of music, theatre and nature, while much of the produce grown in Te Parapara is donated to causes such as the Women's Refuge, and gifted to elders or visiting dignitaries.

Below: Three forms of traditional Māori storehouses (*pataka*) at Te Parapara include an elevated *whatarangi*.

Saihō-ji

Kyoto, Japan

O ften in fables and fairytales, the pilgrim needs to complete certain tasks in order to enter a mythical land. The same is true for those aspiring to enter Saihō-ji – although the archaic challenge of a handwritten application with stamped addressed envelope has thankfully been replaced with an online reservation system. Once you arrive at the temple, shoes off and kneeling on a tatami mat, you will write your own prayer, using Japanese calligraphy brushes, attend a Buddhist ceremony with prayers, chanting and drumming, and only then will the monks allow you to enter the enchanted garden.

One of the oldest and most keenly protected of Kyoto's temple gardens, Saihō-ji's lure came about by accident. It has been a garden since the eighth century, but only a Zen garden since the thirteenth century. It was designed as a Zen Buddhist garden by Muso Sōseki, monk, poet and garden designer. The two-level garden was planned as both *karesansui* (rock garden) and *chisen kaiyu* (strolling garden), one a stripped back essence of nature, the other a more lavish cornucopia, combining elements intrinsic to Japanese gardens: streams, bridges, lanterns, rocks, viewing points and tea houses. Over time the garden fell into disrepair, and this is when the magic happened, for gradually, what had been a manicured garden of white sand and green pines became covered in moss.

Saihō-ji has been a sacred site for Buddhists for many centuries, but a World Heritage Site since the 1990s. Surrounded by mountains and located in a valley with abundant spring water, the mild humid weather and dappled light from cedar trees create the perfect growing conditions for mosses to flourish. Saihō-ji became better known as Koke-dera (the moss garden), and it is this extraordinary landscape that draws people from around the world.

Opposite: Rock paths wind through gardens shaded by cedars, cypresses and maples.

The upper garden still retains the dry landscape style and is thought to be the first of its kind, influencing many later ones. The imposing rocks are arranged down a slope to portray carp climbing up a waterfall to become dragons, a transformation based on an old Chinese myth, but symbolizing the novice monk labouring to reach enlightenment. Today, the upper rock and gravel garden is not open to visitors, and applicants to see the moss garden are carefully restricted to protect its delicate ecosystem.

You enter the garden through the weathered Shumyo Gate, meaning 'mystery of mysteries, the gate of all wonders', under a gabled, cypress bark roof. Instantly you are submerged in a mesmerizing kingdom of shades of green. Moss ripples away into the distance, carpets the ground, surrounds the rocks like islands in a sea, climbs trees and drips from branches. Rock paths wind through the gardens, under shaded

cedars, cypresses and maples. More than 120 different mosses abound, dense and lush green, feathery and silver, subtly shaded and softly rounded, blanketing the mounds and hollows.

The lower garden follows the *chisen kaiyu* – 'strolling garden surrounding a pond' – style. The Golden Pond at Saihō-ji is shaped like the Chinese character for 'heart' and lies at the heart of the garden, just as water lies at the heart of all living things. There are now two large islands in the pond, the Island of the Rising Sun and the Island of the Setting Sun; the deity Inari Myojin is enshrined in a chapel built on the Island of the Setting Sun. A flat-bottomed boat floats on the pond as a reminder of the days when the emperor would make night-time visits to the islands lit by ten tall candles.

The garden of Saihō-ji is known as a place of origins and journeys; a place to rediscover your original self, to reflect on the past and commence your journey in

Bottom left: Tea House near the entrance to the garden.

Bottom right: A flat-bottomed boat on the Golden Pond acts as a reminder of the days when the emperor would make night-time visits to the islands lit by ten tall candles.

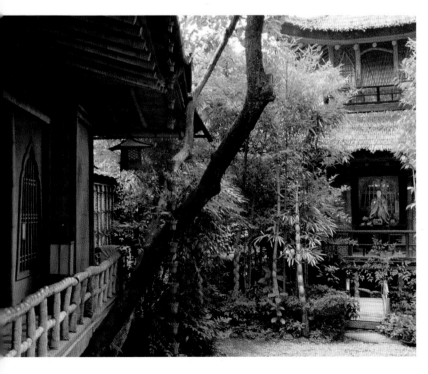

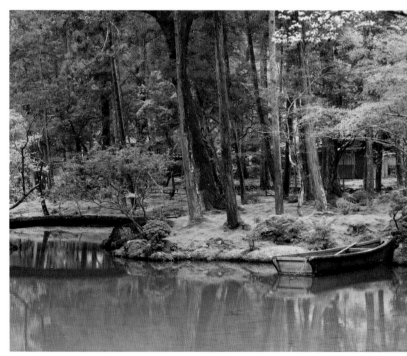

to the future refreshed and in harmony. Muso believed that Zen nirvana could not be achieved by reading, but must be physically experienced, and that creating the garden would enable this. A cluster of large flat rocks provide a space for Zazen (sitting meditation), in which you must empty your body and mind of any thoughts, feelings, desires or expectations, becoming an empty vessel. Steve Jobs, originator of Apple products and exponent of Zen meditation, attributed his inspiration to the Zen gardens of Kyoto, and to Saihō-ji in particular, his aesthetic of stripped back simplicity and precision coming directly from Zen principles of subtraction.

Every aspect, from the far views of the mountains to the tiniest detail of the mosses, is thoughtfully considered. Mount Torigatake appears as one with the garden, an almost touchable backdrop, following a classic design principle that everything within sight of the garden is the garden. Every plant and every tree is minutely considered and cared for: a giant bonsai is clipped to look like a boat in sail; and look closely at the moss, as each tiny piece is like a miniature world – a variety called *sugi-goke* is the most abundant, and prized for its long, velvety growth. Gardeners tend the plants as an honourable duty, taking pride in removing any debris and ensuring every leaf or frond is in place.

Three beautiful tea houses are placed along the garden paths, of differing design and intent. The first, Shonan-tei,

Above: The upper garden's dry waterfall (*kare-taki*) is thought to be the earliest in Japan.

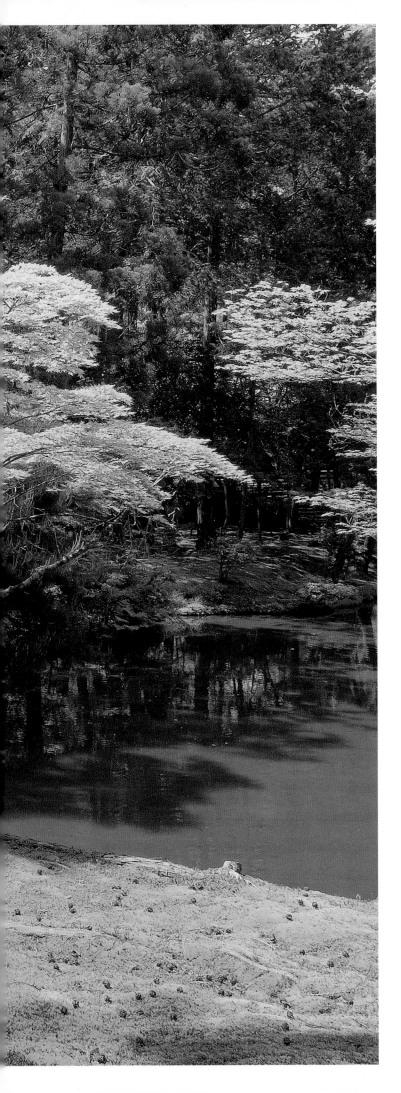

originated in the fourteenth century and is designated as an important cultural property, while Shoan-do tea house and Tanhokutei pavilion were both rebuilt in the 1920s. The pavilion has a unique viewing point, where the moon can be seen reflected in the golden pond.

The green of the moss is punctuated throughout the year, every season clothing the garden in different ways. Spring brings showers of cherry blossom, followed by a blaze of azaleas, a paeon of colour and scent. Next, lotus flowers unfurl on the tranquil pond, then summer taxes the mosses with intense heat, but their humidity and resilience keeps them stalwart. Autumn layers the garden with the reds and golds of the maple trees, creating multicoloured rivers of fallen leaves, and only in winter is the bare evergreen structure of the garden revealed in its total simplicity.

Although Saihō-ji can seem to be an epitome of perfection, it is at the same time emblematic of the Japanese wabi-sabi culture, a Zen aesthetic of beauty in imperfection. The ageing and weathering of plants, stones and handmade objects by nature is seen and appreciated, so the creep of the moss on ancient carvings, the weathering of rain and the gnarled bark of the cedar trees are all part of the garden's essence. Nature has its own way with the world of the garden and the Zen way is to embrace this and work in harmony with it. A lesson for our times.

Left: Moss in the garden blankets its mounds and hollows.

Pages 230–1: Autumn fills the garden with the red, orange and gold of maple trees.

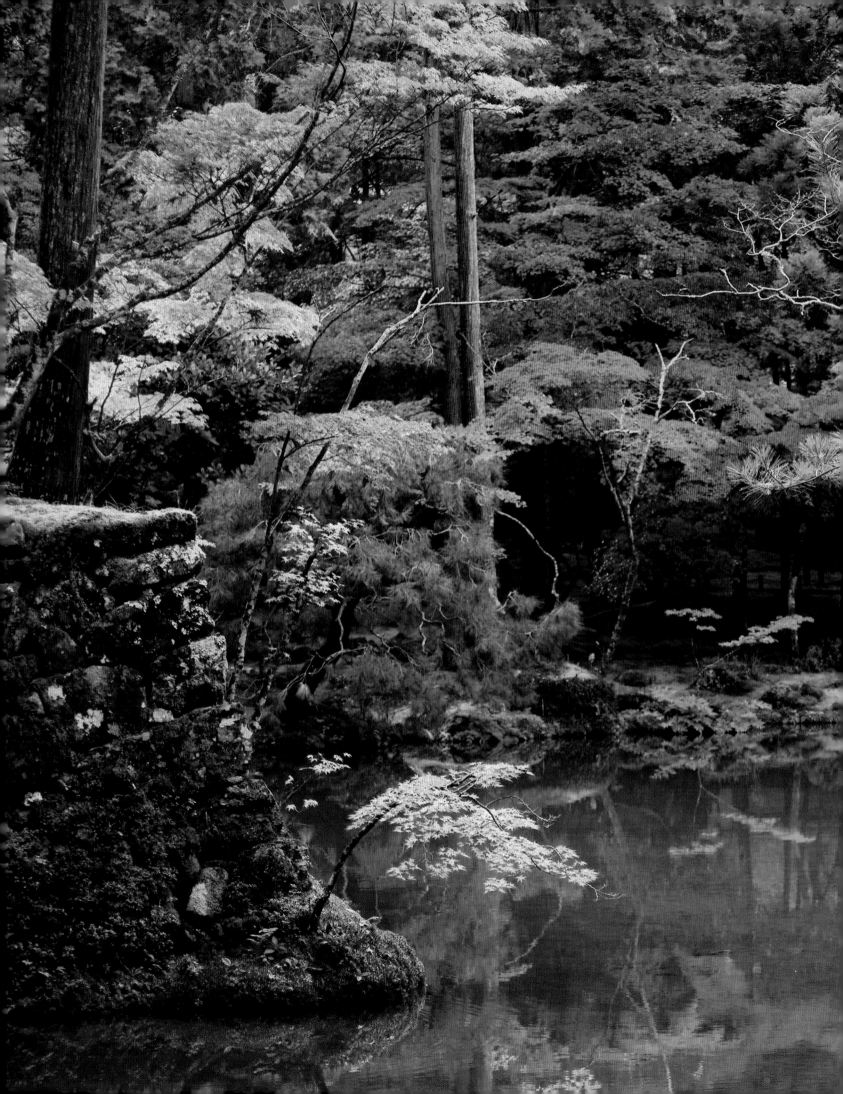

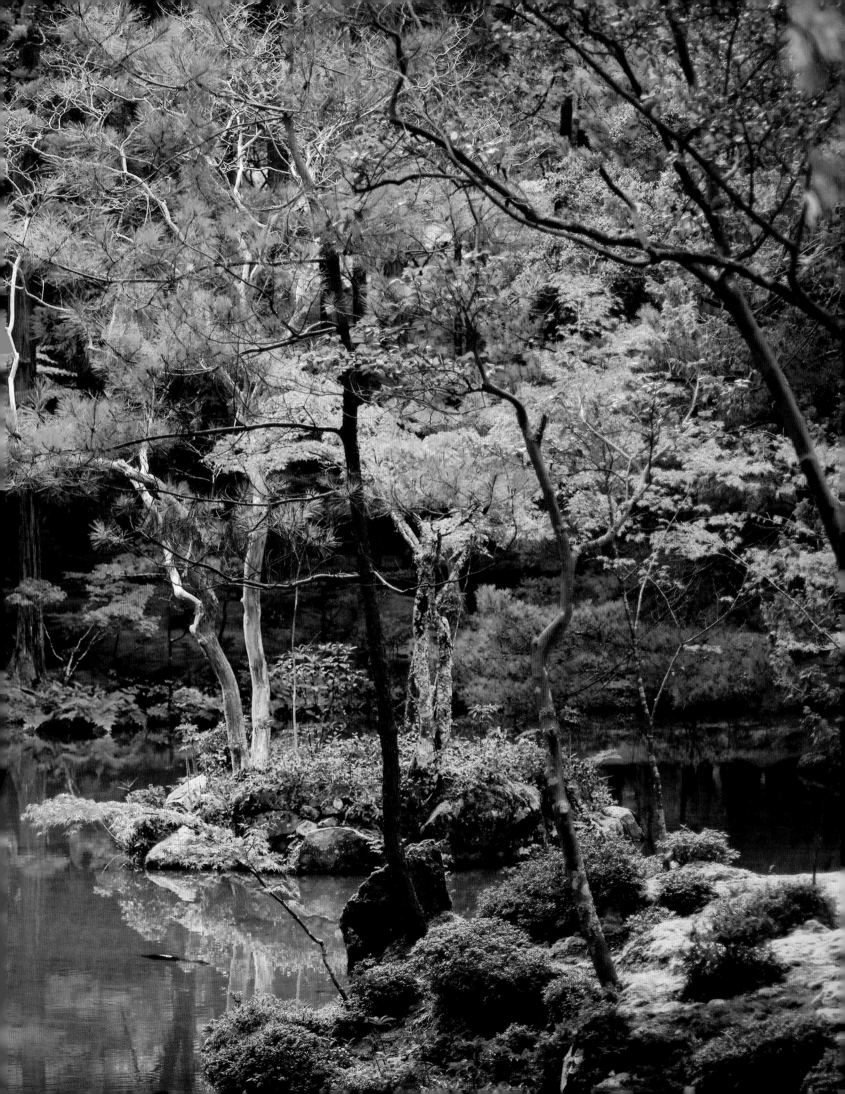

Index

236

Picture credits

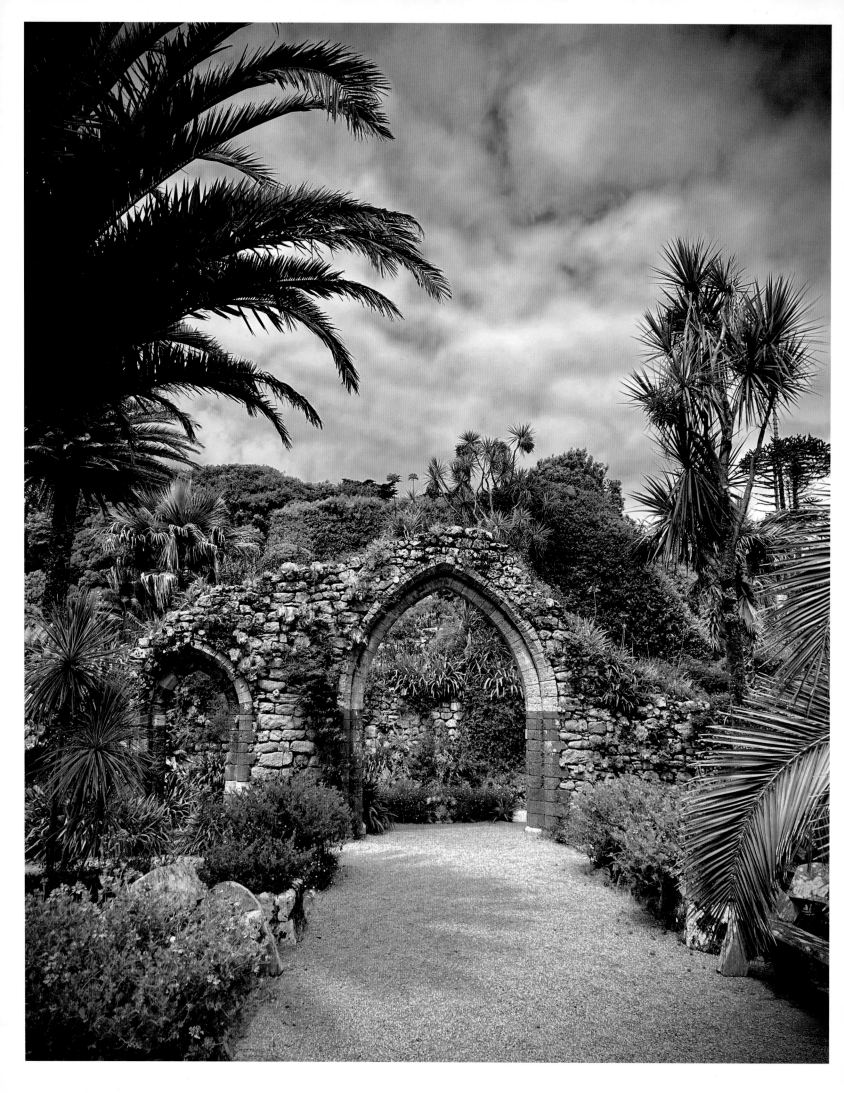

Author thanks

The selection of gardens in *Earthly Utopias* was shaped by numerous friends and colleagues who share my love of them, in particular Fran Paffard, Sarah Guy, Ruth Jarvis and Jan Fuscoe, who all contributed chapters to the book. In helping me to arrive at the final list of selections – no easy task, given just forty entries whittled down from more than a hundred – and write the book, they deserve huge thanks for making it more than the sum of its parts. As do the fantastic and always dependable team at Frances Lincoln: Alice Graham, who gave me such a delightful commission and had faith in my being able to realize it; Melissa Smith, whose calm and patient suggestions, research, editing and guidance were invaluable; and Michael Brunström, who worked hard to keep the book on track and make sure it would be the thing of beauty it is.

Lastly, and always, thanks and my undying love go to my husband Paul Murphy, my constant consigliere, best friend, and the person who is always there for me with help, advice, support, ideas, food, wine, laughter and love.

Opposite:
Tresco Abbey Gardens,
Cornwall, UK.

Quarto

First published in 2024
by Frances Lincoln,
an imprint of Quarto.
One Triptych Place,
London, SE1 9SH
United Kingdom
T (0)20 7700 6700
www.Quarto.com

A catalogue record for this book is available from the British Library.

ISBN 978-0-7112-8589-7
eISBN 978-0-7112-8590-3

10 9 8 7 6 5 4 3 2 1

Editor: Melissa Smith
Designer: Nicki Davis
Picture Researcher: Sarah Bell
Managing Editor: Michael Brunström
Art Director: Isabel Eeles
Production Controller: Eliza Walsh

Printed in China